Publisher's Acknowledgements
We would like to thank the following authors and publishers for their kind permission to reprint texts: **Paul Virilio**, La Rochelle, France, and **Jorge Orta**, Paris. Photographers: **John Akenhurst; Jacqueline Alos; Ar/ge Kunst Museum; Art Gallery of Western Australia, Perth; Marie Clerin; Contemporary Art Museum University of South Florida; COPIA The American Center for Wine, Food and the Arts, Napa, California; J.J. Crance; Denis Dailleux; Bernard Delorme; Dietch Projects, New York; The Fabric Workshop; Philippe Fuzeau; Bob Goedewaagen; Peter Guenzel; Pez Hejduk; Gary Kirkham; Florian Kleinefen; Harum Konishi; Roman Mensing; André Morin; Modern Art Museum Kyoto; Musée d'art et d'histoire de la ville de Cholet; Westfälisches Landesmuseum für Kunst und Kulturgeschichte, Munster; Marie Hélène Le Ny; Lothar Schnepf; Sillani; Oystein Thorvaldsen; Wiener Secession, Vienna; Anna C. Wagen.**

Artist's Acknowledgements
Jorge Orta, Jeremy Jenkinson, Amanda Jenkinson, Sophie Vieille, Marie-Luise Kesten, Yannick Roulec, Anne de Villepoix, Jerome Demissolz , Denis Lebaillif, Lycée Professionel et Technique de l'Assomption de Bondy, Jean Jean Crance, Pierre Restany, Philippe Piguet, Paul Virilio, Jean-Michel Ribettes, Jérôme Sans, Jean-Michel Place, Chiarra Lamonica, Jade Dellinger, Margaret Miller, Emma Shercliff , Béatrice Millot, Ildiko Korzelius, Serge Laurent, Maison d'arrêt de Metz, Yvonamor Palix, John Akehurst, Mark Sanders, Jen Budney , Association Jour de la Terre, Edith Doove, Danielle David , Lycée Sonia Delaunay Thiers, Arc-en-Ciel Thiers, Michel Aubry, Usindiso women's shelter Johannesburg.

All works are in private collections unless otherwise stated.

Phaidon Press Limited
Regent's Wharf
All Saints Street
London N1 9PA

Phaidon Press Inc.
180 Varick Street
New York, NY 10014

www.phaidon.com

First published 2003
© 2003 Phaidon Press Limited
All works of Lucy Orta are © Lucy Orta

ISBN 0 7148 4300 8

A CIP catalogue record of this book is available from the British Library.

Printed in Hong Kong
Designed by Ben Dale (Onespace)

cover, front, **Refuge Wear Intervention - London East End 1998**
2001
Original colour photograph
150 × 120 cm

cover, back, **Modular Architecture - Nexus Architecture x 3**
1997
Microporous polyester, diverse textiles, zips
170 × 80 cm

page 4, **Modular Architecture - The Dome**
1996
Microporous polyester, diverse textiles, zips, telescopic aluminium structure
300 × 220 × 200 cm
Installation, La Fondation Cartier pour l'art Contemporain, Paris

page 6, **Nexus Architecture x 110 - Nexus Type Cholet** (in progress)
2002
Intervention with 110 children from Cholet, France

page 30, **M.I.U. IV**
2001
Trailer, 6 campbeds, Kevlar, diverse fabrics, silkscreen print, telescopic aluminium structure
400 × 250 × 200 cm

page 88, **70 x 7 The Meal, Act III Innsbruck**
2000
Installation for 63 guests, Kunstraum Innsbruck

page 100, **Arbor Vitae**
2001
50 Royal Doulton bone china hearts, various objects, aluminium hoops, 50 light bulbs
350 × 150 × 150 cm
Collection, Staffordshire University, Stoke-on-Trent

page 144, **Lucy Orta**
2003

Roberto Pinto Nicolas Bourriaud Maia Damianovic

Lucy
Orta

Φ

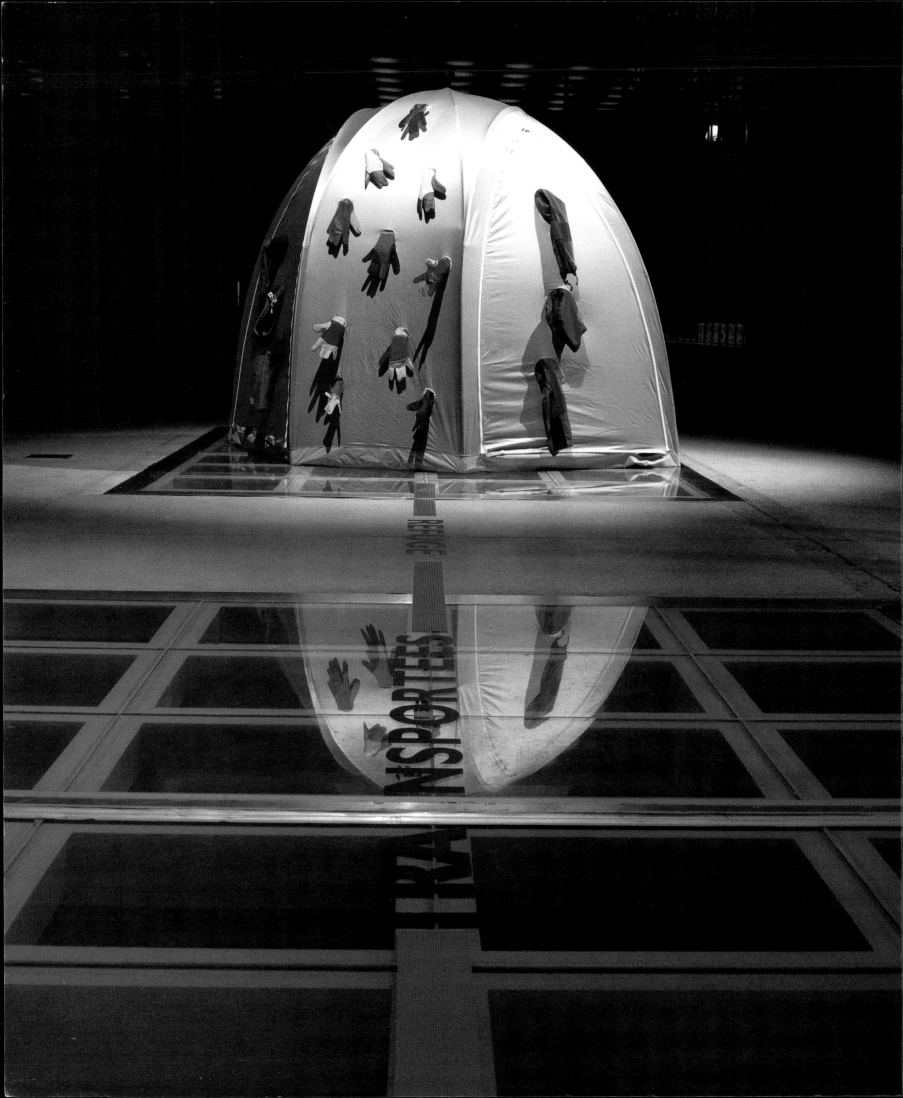

Contents

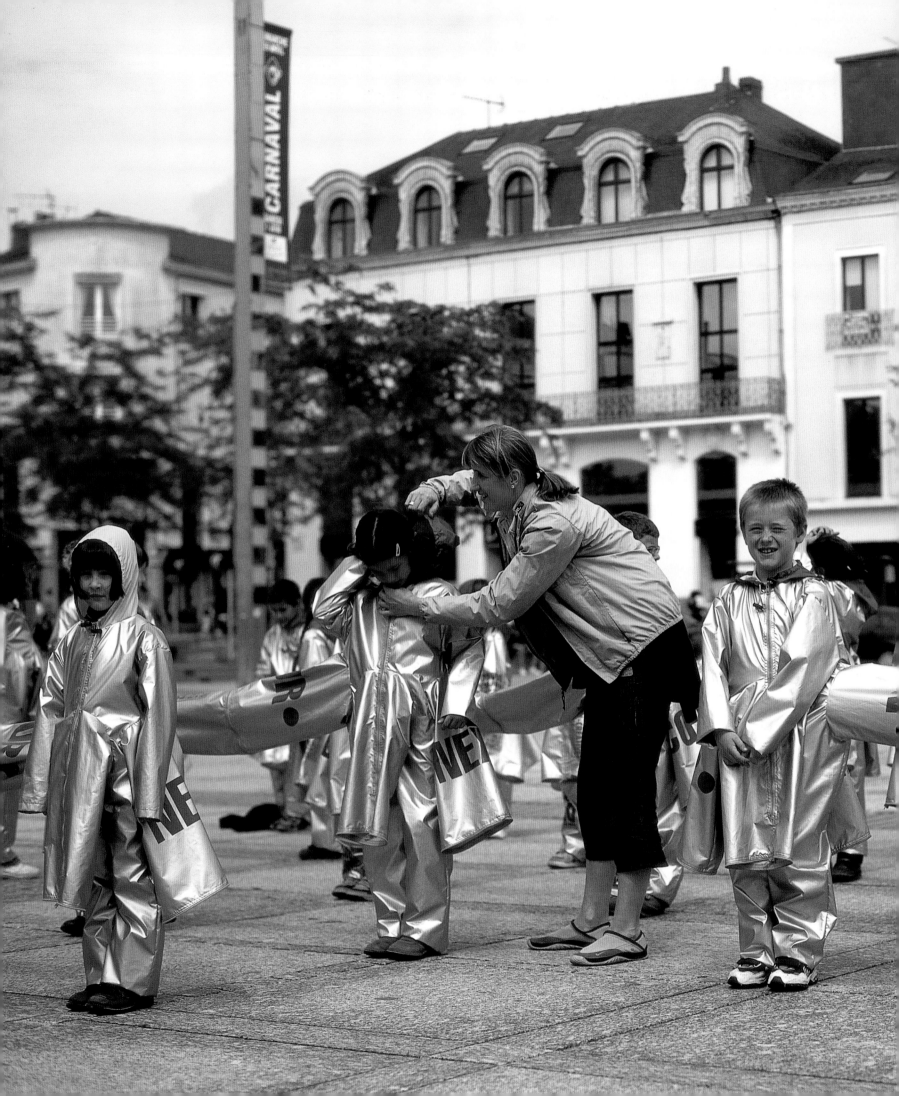

Contents

Nicolas Bourriaud We met at the beginning of the 1990s, a time when artists were beginning to question art's social usefulness in new terms. Artists such as Krisztof Wodiczko and Christine Hill made works for the homeless, for example. For artists including Rirkrit Tiravanija, Carsten Holler, Peter Fend or even Maurizio Cattelan – all artists who emerged around that time – art was about working well within social reality, not just about finding a means of representing that reality. A debate arose: how can art have a direct effect on reality when it is mediated solely through galleries and the art system? The ambiguity between the actual usage of the work and its aesthetics creates an interesting problem: what part is shaping and what part is operational in these works in these works that 'function'? Let's take for example your work, *Refuge Wear* (1993–96). Is the usage of this work integral to its form? In other words, can we speak of your work as a 'functioning aesthetic'?

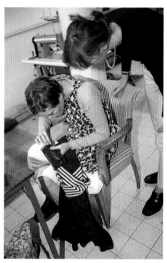

Identity + Refuge - Pilot Workshop
1995
Workshop, Le Cité de Refuge,
Salvation Army, Paris

Lucy Orta The context for my first work in the 1990s was the economic recession, resulting from the repercussions of the first Gulf War and the stock market crash. There was rampant unemployment, and you could feel the effects of such instability sweeping the streets. I was working as a design consultant for several fashion houses and having some financial difficulties myself. Although I could have remedied them relatively easily by taking on more design contracts, I felt that I needed to become more socially active and work creatively in a new visual medium. I had been assisting my husband, Jorge Orta, with the production of his artwork, which was highly engaged with the social and political climate. Together we had been organizing protests, fabricating objects for his activist gallery shows and initiating the large-scale light projection works for Jorge's Machu Picchu expedition in 1992. Jorge had lived through the 1970s military dictatorships in Argentina and had dedicated his work to exposing the contradictions in society, challenging structures of power and giving new visual forums to suppressed issues.

Jorge was incredibly supportive of my desire to develop a critical and engaged art form that could respond to the growing problems in society. As a result of the research and projects that we worked on together, I created the *Refuge Wear* series. This was the first visual manifestation of my work, and you were one of the first people to see the drawings, as well as *Habitent* (1992–93), exhibited at Galerie Anne de Villepoix in Paris in 1993.

The very first objects I created were shown outside the art system in the form of 'interventions', such as the *Refuge Wear* and *Nexus Interventions* in the Cité La Noue housing estate in Montreuil, east of Paris, or in the streets and abandoned outskirts of the city during Paris Fashion Week. The *Identity + Refuge* workshop (1995) with the residents of the Salvation Army was actually initiated by the director of the Cité de Refuge Le Corbusier shelter in Paris' 13th district; he believed that art had an important role to play inside the social reality of the shelter and totally supported the exhibition, 'Art Fonction Sociale!' (Salvation Army Cité de Refuge, Paris, 1993).

These interventions and actions did not attract any real interest from the art network in the beginning. I came to the conclusion that I would have to be active in two camps: both 'inside', in the museum and art centres – vitrines where I could confront and debate ideas – and 'outside', on the street. In this way I could engage with 'real life' situations and question the relationship between research and practice without making theoretical

Identity + Refuge - Work Bench
1995
Table, sewing machine, wheels,
laminated photographs, various
thrift materials
80 × 120 × 65 cm

assumptions beforehand. My encounter with philosopher Paul Virilio in 1994 was also fundamental to where I chose to position my work. The social reality at the time was demoralising; I realised that the street was the place to begin asking questions. It was here that the debate was heated and virulent.

Galleries and museums represent just a fraction of an active and complex system that I have put into place with Jorge, and the work functions differently in each scenario. I have initiated an artistic production and a communication medium primarily by fabricating objects conscious that the forms cannot just represent reality. On the contrary, they should be active, reactive, and also function as catalysts.

To go back to your question about what part is modelling and what part is operational, I try to work on four levels:

1. The work acts as a warning, an alarm bell or distress whistle to signal aspects of reality that the media ignore or simplify, before evacuating it completely.

2. The design innovations and the new materials I employ give the impression that they are operational, or functional. *Refuge Wear, Survival Kits* (1993–95), transformable and polyfunctional objects such as *Citizen Platform* (1997) or *Processing Units* (1999) are just some examples. Many manufacturers have approached me to re-appropriate such works into their own production lines.

3. The forms I model are poetic, and they raise questions. They are surprising, dream-like; maybe 'science fiction'. I employ *détournements* and metaphors – after all, they are art works!

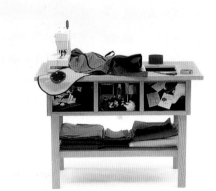

4. Finally, and the most importantly, each work or series acts as a release mechanism for a gradual transformation process. To become 'operational', each work triggers another work via a network system of 'acts'. Each object or project forms a link in the catalyst chain.

'Functioning aesthetic': the term seems right, and pertinent. Jorge and I are researching notions of 'operationalibility', and several projects could already be defined in these terms, the most successful being *Opera.tion Life Nexus* (2001). We are developing poetic actions closely linked to human, social and economic developments. We oppose a nihilistic vision of 'art for art's sake'. We are interested in an art form that crosses disciplines, integrating both the poetic and the functional. One of the most interesting consequences of this approach is my nomination, in 2002, as Head of a new Master's Program, 'Man and Humanity', at the Design Academy of Eindhoven. This is a direct outcome of the transversal projects and theories that we have been researching for several years.

Bourriaud You evoke the nihilism of 'art for art's sake'. Isn't this position similar to that of the Russian Constructivists after the October Revolution? At that time, for example, the critic Osip Brik, denounced Modernism as a bourgeois and socially useless art? Couldn't certain non-functional works today indirectly turn out to be more 'useful' than those that specifically aim at social efficiency? n other words, isn't art always useful?

Orta **Luckily, all points of view are permitted in art, leaving open multiple ways to invent alternatives according to each and every person's own certitude. What bothers me in certain artistic intentions is a nihilistic air that**

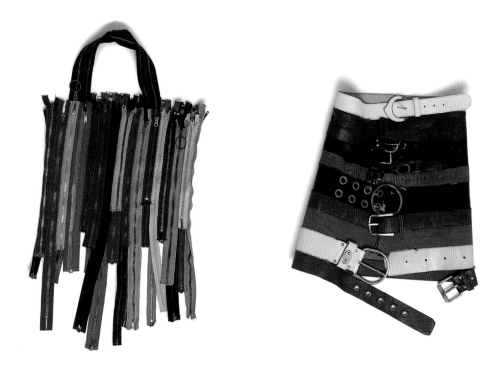

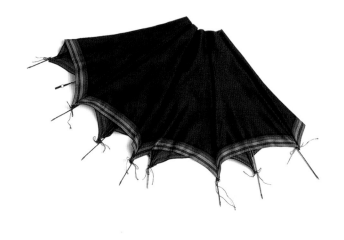

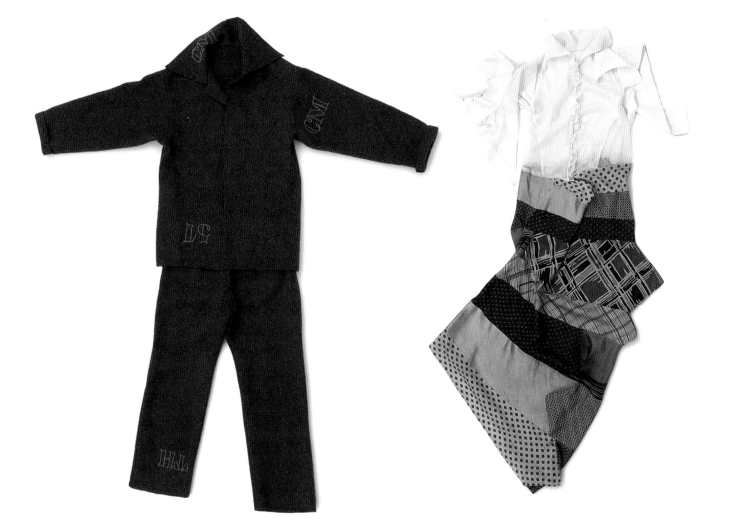

l. to r., top to bottom,

Identity + Refuge - Décolleté Américain
1995
33 metal teeth zips
85 × 45 cm

Identity + Refuge - Belt Miniskirt
1995
4 vinyl belts, 4 leather belts
60 × 50 cm

Identity + Refuge - Umbrella Skirt
1995
Silk umbrella c. 1950
70 × 140 cm

Identity + Refuge - Bolero
1995
24 pairs of leather gloves
45 × 80 cm

Identity + Refuge - Pull Chausette
1995
20 pairs of Burlington acrylic socks
65 × 45 cm

Identity + Refuge - Wool Suit
1995
Felted military blanket, insignia
160 × 120 cm

Identity + Refuge - Cocktail Dress
1995
11 silk ties c. 1970
150 × 85 cm

Identity + Refuge - Hipster Pant
1995
36 pairs of black leather gloves
95 × 65 cm

Identity + Refuge - Cocktail Dress
1995
Cotton jabot c. 1910, 11 1970s silk ties
130 × 65 cm

Identity + Refuge - Redingote
1995
27 tweed ties, 27 silk ties
170 × 130 cm

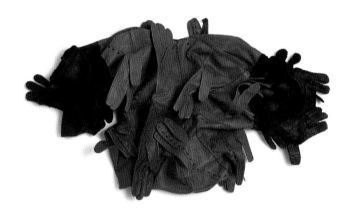

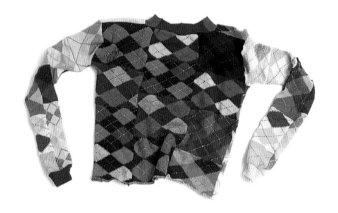

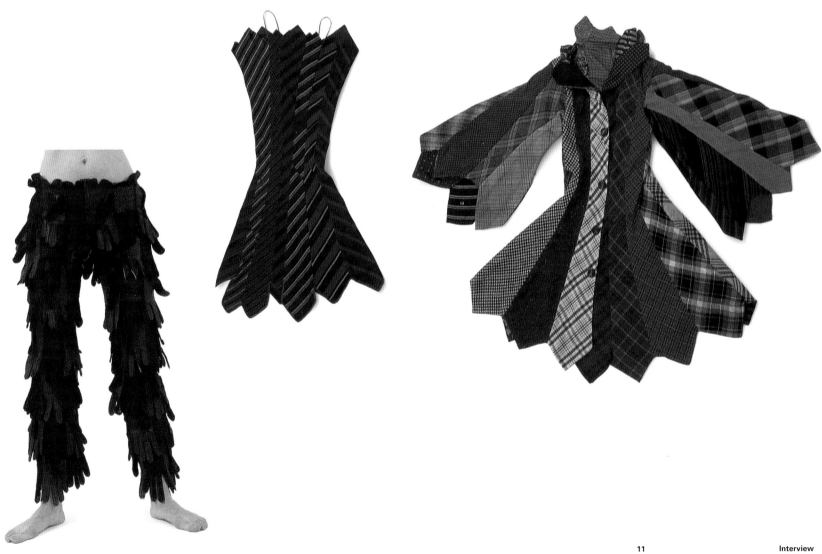

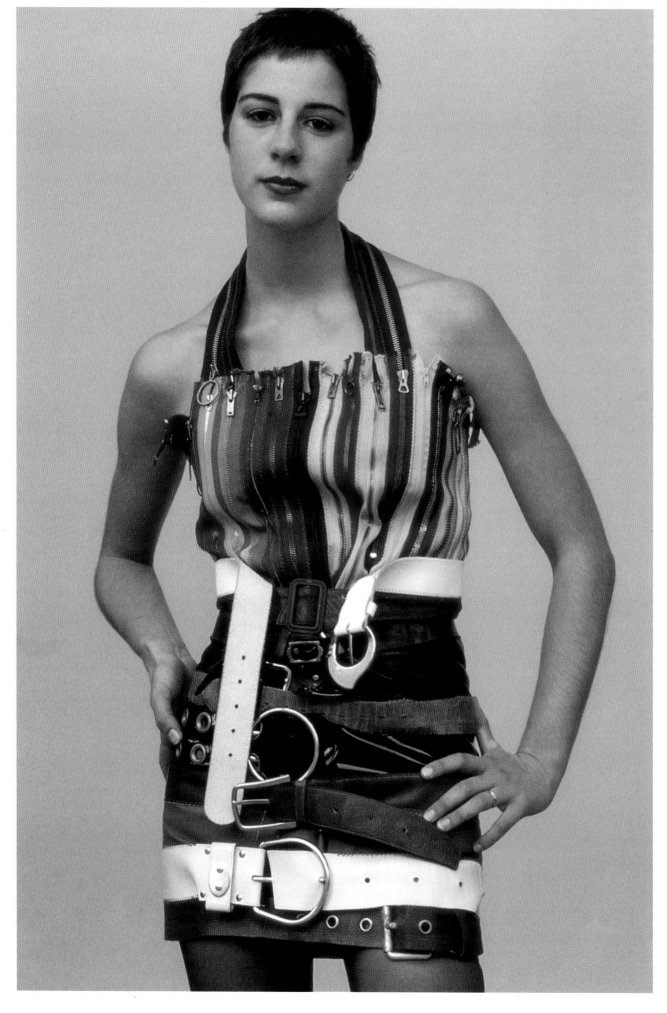

left, **Identity + Refuge - Outfit 1**
1995
worn by student from Lycée Bondy

opposite, **Identity + Refuge -
Experimental Catwalk**
1995
Le Cité de Refuge, Salvation Army,
Paris

often becomes a pose or a fashion, and the flippancy becomes a social reference. Cynicism becomes cool. Look at the lack of Utopian vision and the general level of apathy in youth culture today. Faced with manipulative globalization, how can one not react? I don't want to respond with a complacent or compliant work. Art-making is profoundly emotional, an expression of hope, a proposal for alternative living. It's a life project; it's a commitment with yourself as well as with society.

In my work I do not restrict myself to ideas of functionality or non-functionality. Concepts such as 'utility' or 'social effectiveness' are too complex to be answered in a few words without further debate and reference to specific examples. I totally agree that non-functional art can be useful, such as the work of Shirin Neshat, Mona Hatoum, Kendell Geers, Andrea Zittel, Peter Fend, n55 or Rirkrit Tiravanija. An obvious example in my work would be the *Nexus Architecture* where fabric tubes act as a metaphor for creating a social alliance. I try investigate many different art forms such as pilot enterprises, object-making, public interventions, interactive websites, workshops, museum installations, relational objects and educational programmes; each of these functions in a different way, and can also be potentially operational in another. The projects have varying levels of effectiveness depending on the audience addressed.

Bourriaud Most artists seem to consider 'the street' as a metaphoric space, a symbol or a backdrop for their social or political preoccupations: the city as a decorative element. Do you consider your practice to be a tentative move towards producing a specific urban 'grammar'? How do you organize your work between the street and the gallery?

Orta **The city is not décor; it is a vital space for interaction and a hub for social activity, a vector for exchange and an ever-changing scenario in which I**

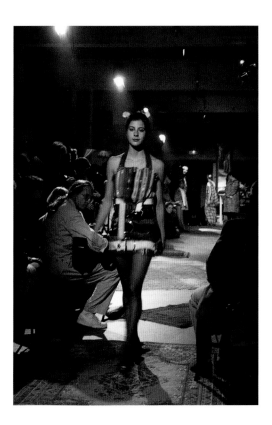
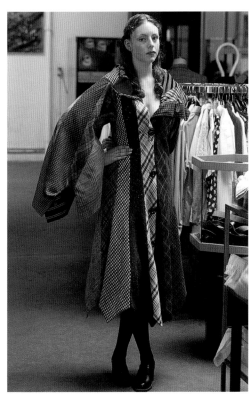
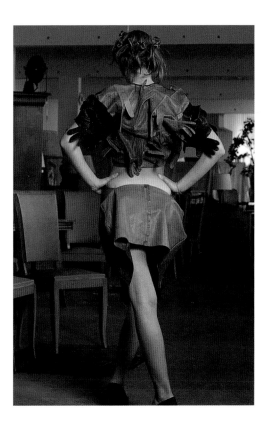

'intervene', employing new formats. In early investigations, such as the *Refuge Wear* and *Nexus Architecture* interventions, I utilized the street in an investigative manner, questioning the individual's right to occupy public space rather than becoming subsumed by the architecture. By reclaiming public space, these projects sought to empower marginalized individuals and render them more visible.

In more recent public works – such as the open-air fêtes, meals and picnics – I use the urban geography as a powerful tool to mediate dialogues between social groups. The buffet of surplus produce served up at the openings of *All in One Basket* (1997) and *Hortirecycling Enterprise* (1999) are a result of my dismay during French agricultural demonstrations. Each year tons of fruit are dumped onto the highways to protest against imported goods. My reaction was to act locally, and direct my demonstration of empowerment towards the tons of edible leftover produce, utilizing the urban players in the Parisian street markets – vendors, clients, passers-by and cleaners – to create micro-community gatherings and discussion forums. The tasty dishes of surplus food prepared by a famous French chef in these public projects lead quite naturally to large-scale public picnics and open-air dinners, such as the *70 x 7 The Meal* project in the French rural town of Dieuze (2001), with its 300 m-long table snaking down the main street. The whole town was involved in preparing this project. All demographic, social and religious groups then shared a meal, which assumed the role of social space.

I'm not sure what you mean by 'grammar'; this term would imply to me a controlled set of signs or codes, but I hope that it's more of a fluid language. Perhaps, however, it is a new discourse weaving in and out of different scenarios, moving from the public to the private, crossing over, raising questions, listening to different reactions and building from these responses into a nourishing experience.

Some of my recent concerns are less about the kinds of different spaces than about new methods of creating dialogue, such as the simultaneous workshops in Stroom Centre for the Visual Arts, The Hague, and The Dairy, my project space outside Paris. The workshops brought staff and students from the London Institute, the Design Academy in Eindhoven and the Decorative Arts School in Paris, together with professional artists in other countries. Here, the dialogue effects the actual work in progress, and this is made visible on the Internet (www.fluidarchitecture.net).

Bourriaud Usually, art in public spaces is perceived as the shaping of an intention for the public, more than a real relationship with a real public. Do you have examples of events that took place in the urban space that modified the content of a work, or how you look at it? What have been your strongest experiences with the non-art public?

Orta **In Florida I worked on a project during Art Basel Miami (2003), which strikes me as an interesting example of a symbiosis between the community, the street, the gallery and the art exhibition. In conjunction with a touring show at the Florida Atlantic University Gallery, we had the intention to develop the audience and education program in a new direction, creating new links using the geography and the dynamics of an international art show. I installed *Nexus Architecture x 110* (2002) in a temporary gallery – situated in a central exhibition site in the Miami design district – 60 km south**

Identity + Refuge II –
Experimental Catwalk
1996
Salvation Army Spring Street to
Deitch Projects, New York

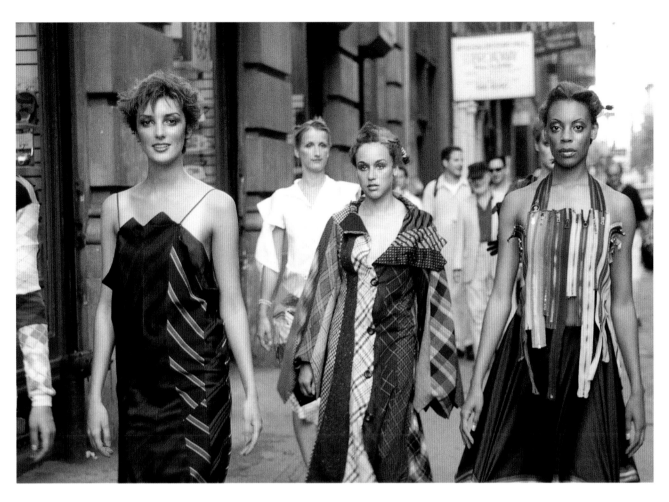

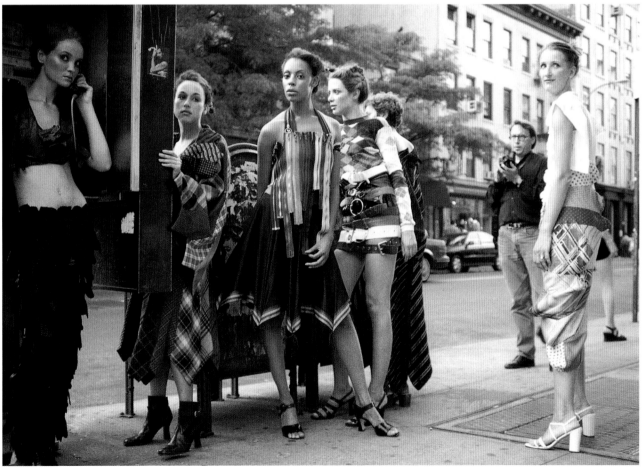

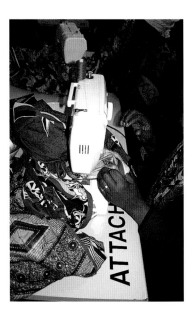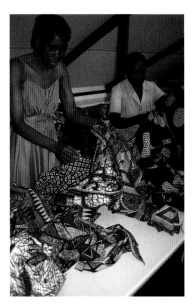

of the University Gallery and we orchestrated a series of projects for both the community and visiting art viewers. The installation is made up of 110 tiny overalls, suspended from the ceiling. Hundreds of children were contacted from different social and geographic zones around the county; with the help of educational staff and volunteers from the museum we engaged the children in a series of workshops to discuss notions of dialogue and connection. The suspended installation – without the small fragile human bodies – is a powerful image for connection, but the work took on a whole new meaning when hundreds of children come together from all over the county to inhabit the work. The image and the power of the two concord projects – the installation and the workshops – has set in motion a process of forging new community links for parents, educational staff and art visitors, and these links can be built upon even after my work has gone.

When the work evolves beyond the initial parameters it is an incredibly moving experience. *Identity + Refuge,* which I mentioned earlier, was a pilot project to engage Salvation Army residents, first in Paris and then in New York, in a series of creative workshops that would assist them in coming to terms with one of the many problems they face, that of identity. My brief was to deconstruct, transform and reconstruct the surplus clothes from the Salvation Army thrift store into more personalized garments without discarding anything. This process of revealing new forms, without changing the content, nurtured the confidence of the participants in a sustainable manner. These were the initial theoretical assumptions underlying the project, but only when working alongside the residents did *Identity + Refuge* really take form, and the results reached way beyond our expectations.

In *Identity + Refuge*, after a very difficult start coming to terms with the despair and lack of self-confidence of some members, I changed direction and brought in fashion magazines and young fashion design students. This unleashed a new set of dynamics between the individuals and the groups; the laundry where we were working became a dynamic hub that resonated throughout the hostel. The project transformed some of the participants' self-perceptions, it redefined my practice, and after our experimental catwalk show, which received major media coverage, hopefully altered the general public's misconceptions about the Salvation Army hostel itself.

above, **Nexus Architecture - 2nd Johannesburg Biennale**
1997
Workshop with women from the Usindiso Shelter
Community Workshop, 'Trade Routes: History and Geography', 2nd Johannesburg Biennale

opposite, **Nexus Architecture - 2nd Johannesburg Biennale**
1997
Wax-printed cotton kangas, zips
175 × 130 cm

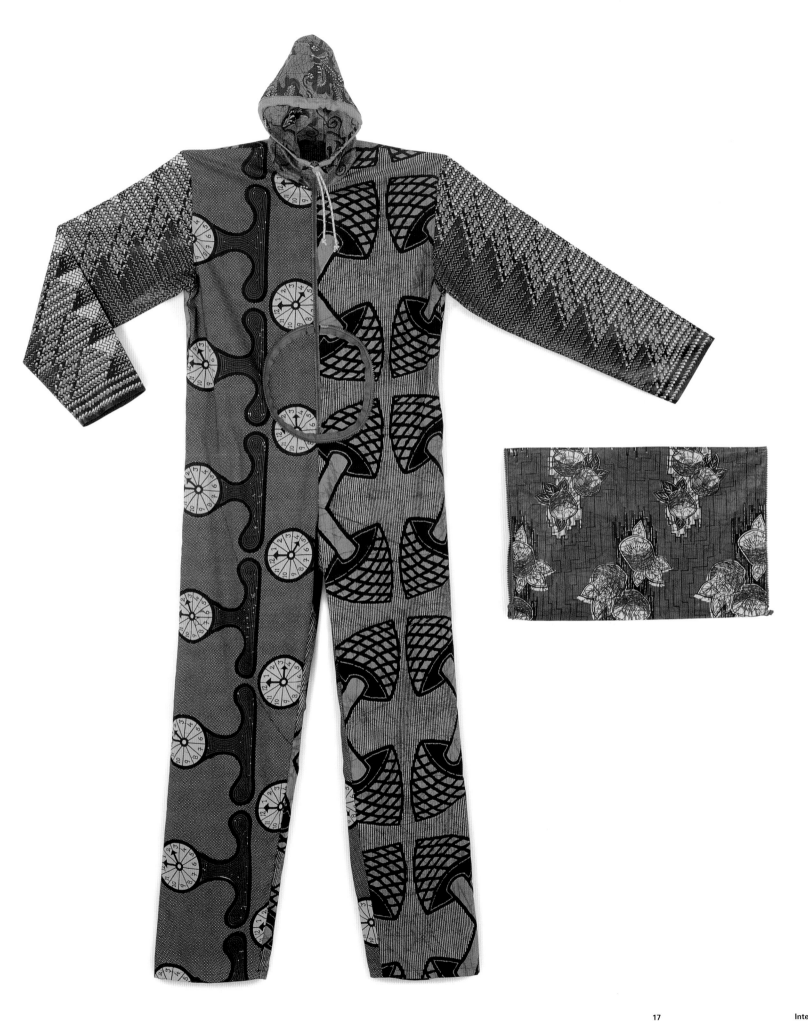

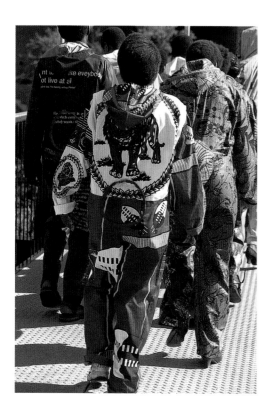
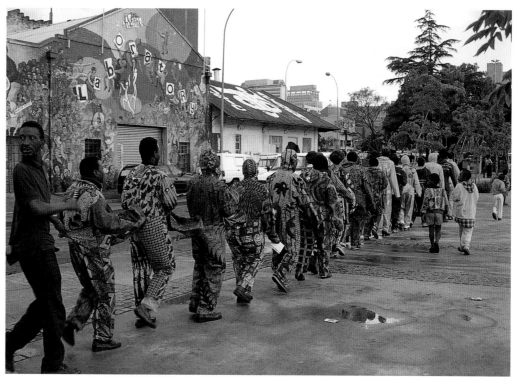

The initial intentions of the enterprise were never realized and the project is, effectively, unfinished. It will be completed, perhaps, when this kind of pilot enterprise becomes a functioning business proposition and can really contribute to assisting marginalized people to re-engage with society. A discussion I held with an art critic after the event perturbed me greatly; he simply refused to believe that the Salvation Army residents had the capacity to project beyond their present state and achieve results. The video, the photographs and the twenty-four outfits produced have been re-interpreted by many fashion designers since then and still remain a pertinent legacy to 'functioning aesthetics'.

I recently edited the sound recordings of the *Nexus Architecture* workshop held during the 2nd Johannesburg Biennale (1997). Even though the discussions are in Zulu, Xhosa or Africaans, the verbal gestures are so emotional that they transcend the premise of the workshop. That work resulted from a site visit I made to Johannesburg prior to the Biennale. I visited the Usindiso women's hostel, located on the opposite side of the city to the exhibition venue. Between these two poles, thousands of micro communities live on and from streets – streets that no white person dares to walk. My initial instinct was to link the city symbolically, as well as physically, by drawing the women living in the hostel into the exhibition space with the work *Nexus Architecture*. A couple of weeks before the event I recruited women to form the core of the workshop, which was to be installed in a worker's library adjacent to the main exhibition hall. They were supposed to be skilled labourers, but the community was so desperate to work that I took on unskilled women as well and trained them to be totally autonomous. Each woman was able to cut, sew and assemble an entire suit, rather than being a segment in a production line, dependant on the non-existent factories and rampant all-male unions. By the end of the workshop each participant could produce beautiful *Nexus* suits, and the women kept the templates complete

Nexus Architecture - 2nd
Johannesburg Biennale
1997
Intervention with women from
Usindiso Shelter
'Trade Routes: History and
Geography', 2nd Johannesburg
Biennale

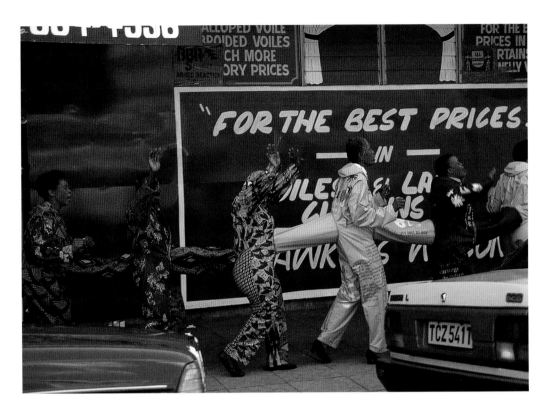

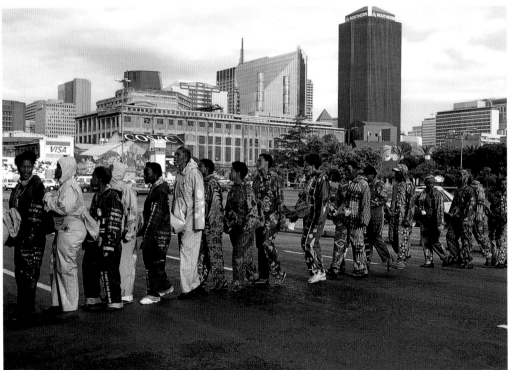

with the social link, the tube that joins the suits together. I had insisted that
the garment could be manufactured for sale on the street without this
umbilical element, but the women were adamant, claiming it was the most
important part of the design. The proof was the public intervention that we
staged for the opening of the Biennale, which formed a defiant chain linking
the city and exhibition venues, with passers-by, children, men and teenagers
tagging on shoulder to shoulder. The women began spontaneously singing
an improvised chorus version of *Nkosi Sikelel' iAfrica* (*God Bless Africa*),
which stopped everybody in their tracks and resonated so powerfully. This

song had been outlawed under apartheid. The songs, hymns and rhythms chanted by the women were extremely poignant and epitomized the social and political climate in the new South Africa.

Nexus Architecture x 50 - Nexus Type Opera.tion
2002
6 mannequins, 50 Nexus suits, Jacobean Cloisters, Le Printemps du Septembre, Toulouse

Bourriaud Let's talk about experiences you have had with cultures other than your own. In my opinion there is no absolute beauty, rather there are situations that generate different ratios of activity and thought. A work of art in a certain context could be insignificant, dull or repetitive; in the same situation another work could raise a whole new set of questions.

All aesthetics are circumstantial. We shouldn't look for a global aesthetics in a false universalism or a patchwork of specifics, but rather in the study and the discussion of circumstances, what could be called 'jurisprudences'. If I condemn political repression in a given country, I start from a set of universal values. I believe that the rights to democracy and freedom of expression apply to all the human beings, whatever their cultural tradition. Do you think on the contrary that absolute values exist?

Orta **I totally agree that we should not globalize aesthetics, nor look for absolute beauty. Each person and culture has individual values, beliefs and knowledge. Unfortunately even though absolute beauty does not exist, a universal aesthetic has already been imposed by more dominant cultures and, for the most part, has been assimilated by others resulting in a severe loss of their traditional cultures. A small example is my experience in Johannesburg. The yellow and purple 'raincoat' *Nexus Architecture,* which travelled to South Africa, was at first far more appealing to the Zulu and Xhosa women than the West African Dutch wax print Kangas that I bought in the local market. Initially I regretted that I had not brought the 'white man's raincoat' fabric with me. It was only when we began experimenting with printed fabric associations that the women were able to personalize their expression and rediscover an aesthetic that, although it was not all their own, they could identify with.**

The loss of cultural identity and a dominant aesthetic are things I oppose, and this stance is fundamental to my postgraduate programme Man & Humanity at the Design Academy in Eindhoven. The first assignment for our students is the development of a new 'global' awareness devised around an eight-week design period in a developing country. Here we coach our students through the experience of working together with the local population – artists and artisans – before we even consider what aesthetic could be 'exported' for Western consumption. The students gradually re-define their notion of beauty by living alongside the people they are working with, and discovering their skills, images, textures, gestures, smells and tastes; most importantly there is an exchange of emotions. As with all new experiences, the difficulty is in discovering how to transform these sensations into ideas that can be brought back to the West. When re-situating or re-enacting that special experience in a totally different context, the viewer – or in the case of my students, the customer – is not attuned with a capacity to project themselves into the original situation and often does not even have the time, or the will, to do so. So yes, there is a great need to discuss, and also to act, in a way which opens windows to other cultures, increases awareness of the poverty of spirit in our own lives, and educates us through the beauty of experiencing others.

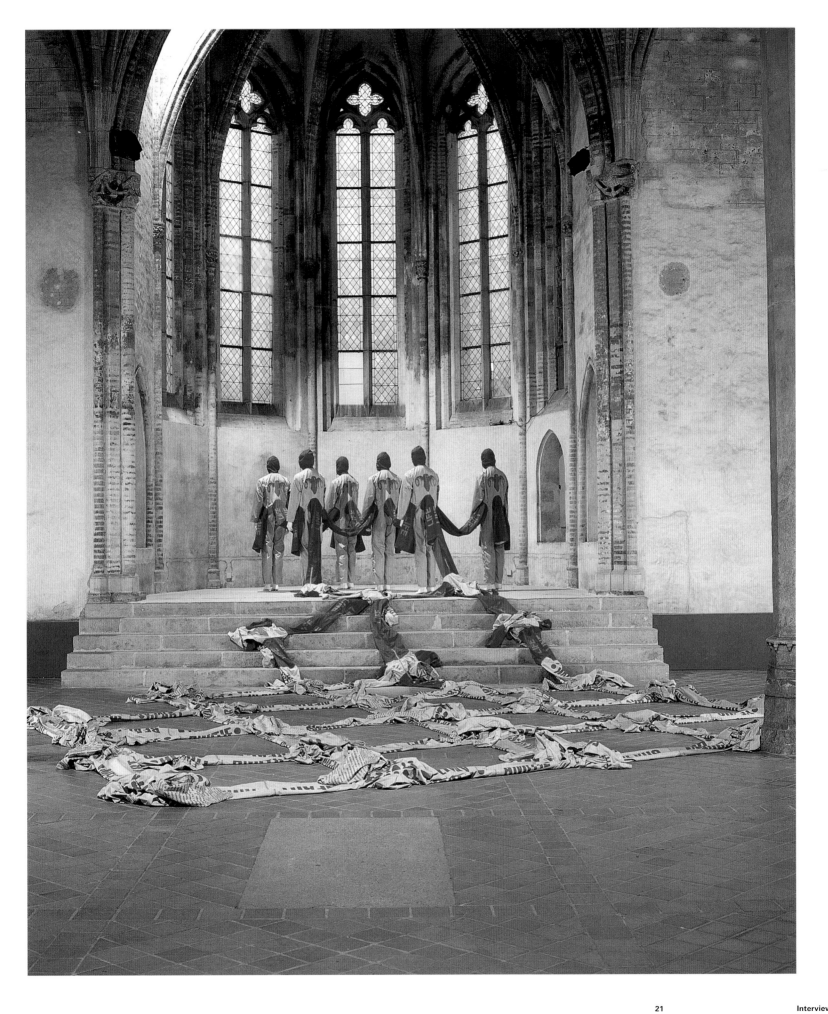

Connector Mobile Village (2000–03) and *Collective Dwelling* (1998–2003) are examples of 'templates' that I use as a basis for initiating dialogues and stimulating awareness on a small and intimate scale with very diverse cultures and age groups. Over the past three years well over twenty groups have participated in the *Connector Mobile Village* project. The participants have come from far afield and from culturally diverse locations. They have included young children from the Metropolitan Ministries Care Center in Tampa Florida, and art and design graduates at Mushashino Art University in Tokyo. The *Dwelling* workshops have been running for five years and ten groups have been involved world-wide, including teenagers in Sydney, unemployed adults in Glasgow's notorious Gorbals estate, and young design students at a Design Camp at Minnesota University. The participants can investigate the idea of a collective membrane that envelops each person's body, yet forms the walls of a larger enclosure. Although the workshop briefs in both of these projects are common to all the participating groups and the methodology for the investigations conducted are the same in each location, each person is encouraged to express their individual identity and culture through various mediums. The children with whom I worked on the Lower East side in New York, for example, live in an amazing multi-ethnic community and in their responses this is expressed through colour associations, use of bold patriotic cultural signifiers and a fascination with branding and logos. In the same way the Glaswegian adult groups could transpose opinions and ideas inspired from their social and cultural heritage, such as a coat of arms, or designs related to their daily activities. In Freidrikstad, Norway, the response from the teenagers differed: an Iraqi refugee depicted a helicopter bombing a city and a local Norwegian talked about mythical emblems and symbols of cultural importance. Many of these signifiers are perhaps not obvious at first glance and the unusual compositions are fully understood only when explained. I merely give groups a framework for their ideas to become visible.

Beauty is circumstantial; an example would be the *70 x 7 The Meal* project for the rural town of Dieuze in the north east of France in 2001. Jorge and I took up the proposal of the director of the local Maison de Jeunesse et Culture (Youth Club) to unite the all inhabitants of the sleepy town. We believed that the *70 x 7* picnic meal could succeed in bringing disparate communities together, and that Royal Limoges Plates would be worth the costs of production despite resistance from a local association. We were not sure if the artichoke design on the plates would 'please' the inhabitants. However, the hard work of contacting each and every citizen, along with their personal contributions to the design of the plates, resulted in the successful sale of over 750 plates on the day of the picnic. I can imagine these plates now hanging above fireplaces in Dieuze and that they probably do not resemble any other design motif in the house. The circumstance of the meal evidently moved the inhabitants, and the memory and emotion of the event is conveyed through the object.

A more personal experience would be the unforgettable expedition to Peru in 1992 with Jorge, to realize his project to paint the Andes Mountain range with light for the 500th anniversary of the discovery of the Americas. Before leaving we filled the projector fly-cases with pens, pencils and exercise books for Peruvian school children. A sponsor had donated shirts to the team and hanging from each shirt was a tag filled with confetti. I instinctively kept for the children the tags that Jorge had discarded so as not

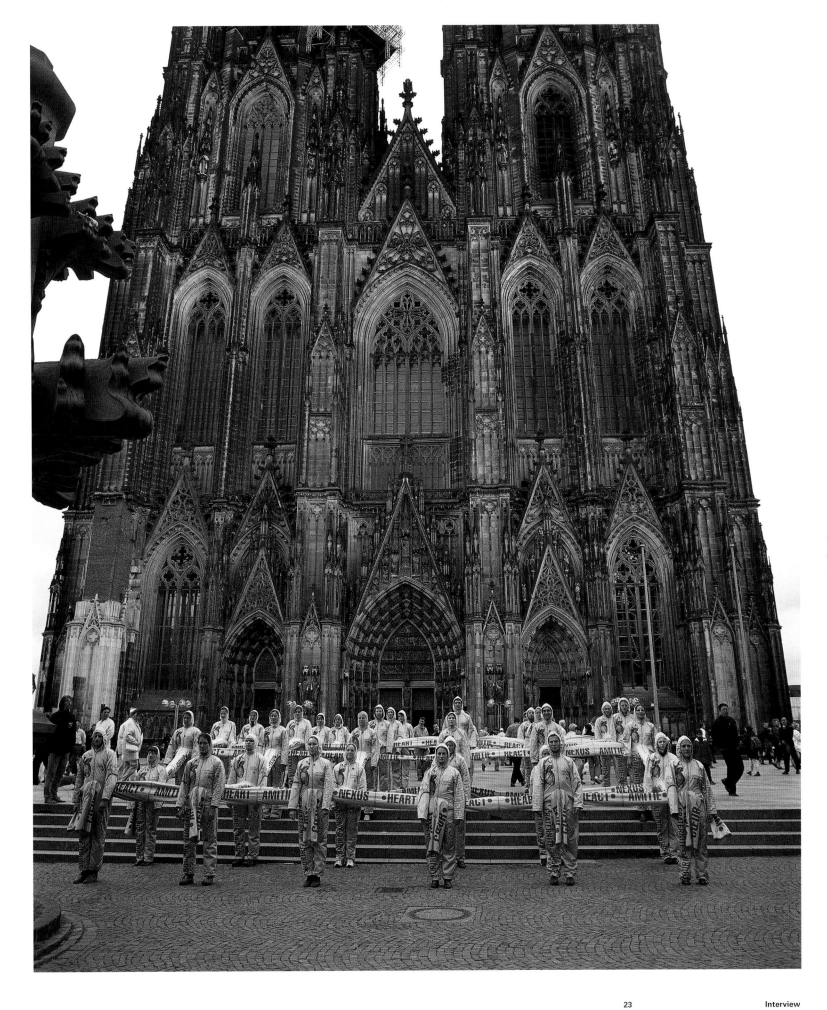

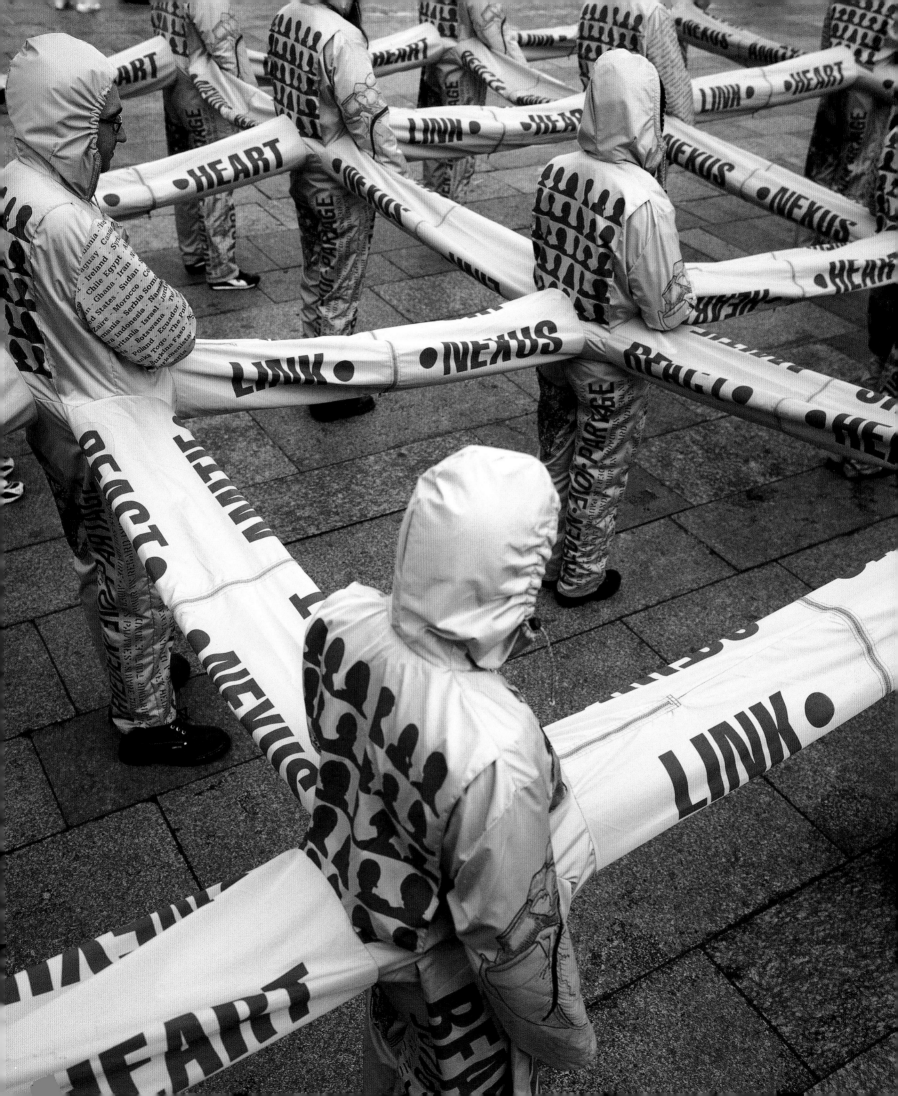

to be too encumbered during the arduous trip. On the journey from Cuzco to Aguas Calientes local children clambered on and off the train. As well as the school books, we gave out the tags to as many children as possible. I have never seen such awe before. Confetti, which is used during ritual offerings, is a rare commodity in the rural villages. These insignificant minuscule, multi-coloured paper discs were an offering from Heaven. More transfiguring experiences followed throughout our expedition and culminated in the light projections in Cuzco for the Intiraymi festival. We had already inscribed many Inca monuments with Jorge's light symbols over the weeks of the expedition. A statue of Christ nests in the valley about a 1 km from Cuzco, the colonial citadel. As the light projectors paned the city, one of the technicians accidentally changed their light to a stroboscope effect, what happened next was beyond anything we had imagined. The beams struck the statue and that immediately began an incredible ascent to heaven. The thousands of Peruvian Indians assembled in the main square were witnessing a miracle. No project since has moved an audience to such an extent or left me as incredulous. These are rare moments that are lived in a personal and divine way.

You cited universal values in a political context, values that save human lives and strive for liberty, these are dominant values, we should be sharing them and striving to implement them. It is too difficult to define absolute values, because values correspond to the human condition and are

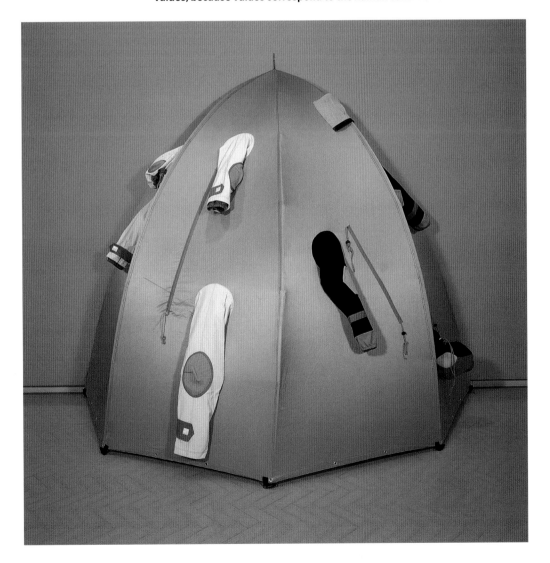

Modular Architecture - Igloo
1996
Microporous polyester, diverse textiles, zips, telescopic aluminium structure
160 × 210 × 120 cm

following pages,
Body Architecture - Foyer D
2002
(Dome) aluminium-coated polyester, 3 telescopic aluminium armatures (6 units), Clerprem Solden Lycra, various fabrics, silkscreen print, zips, 6 armatures
160 × 510 × 510 cm
Installation, 'Connector Mobile Architecture IX', Musée d'Art et d'Histoire, Cholet, France

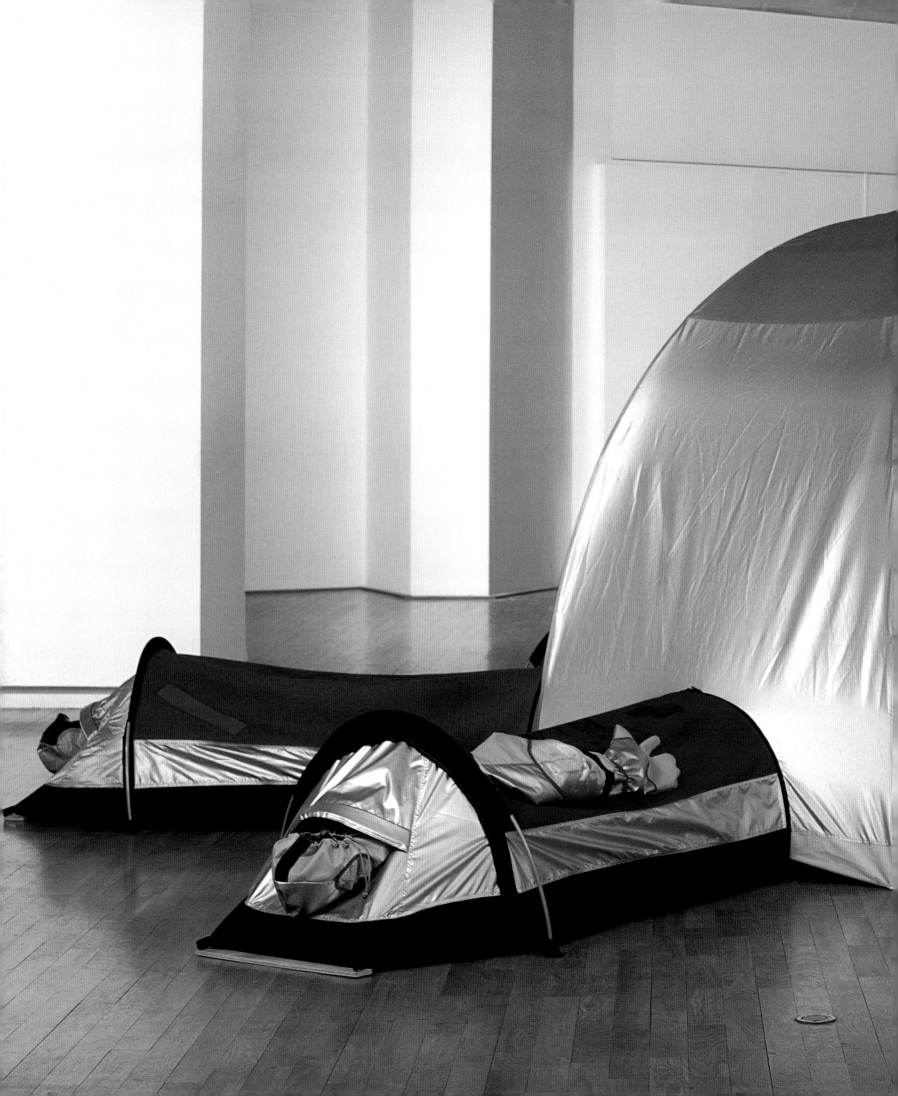

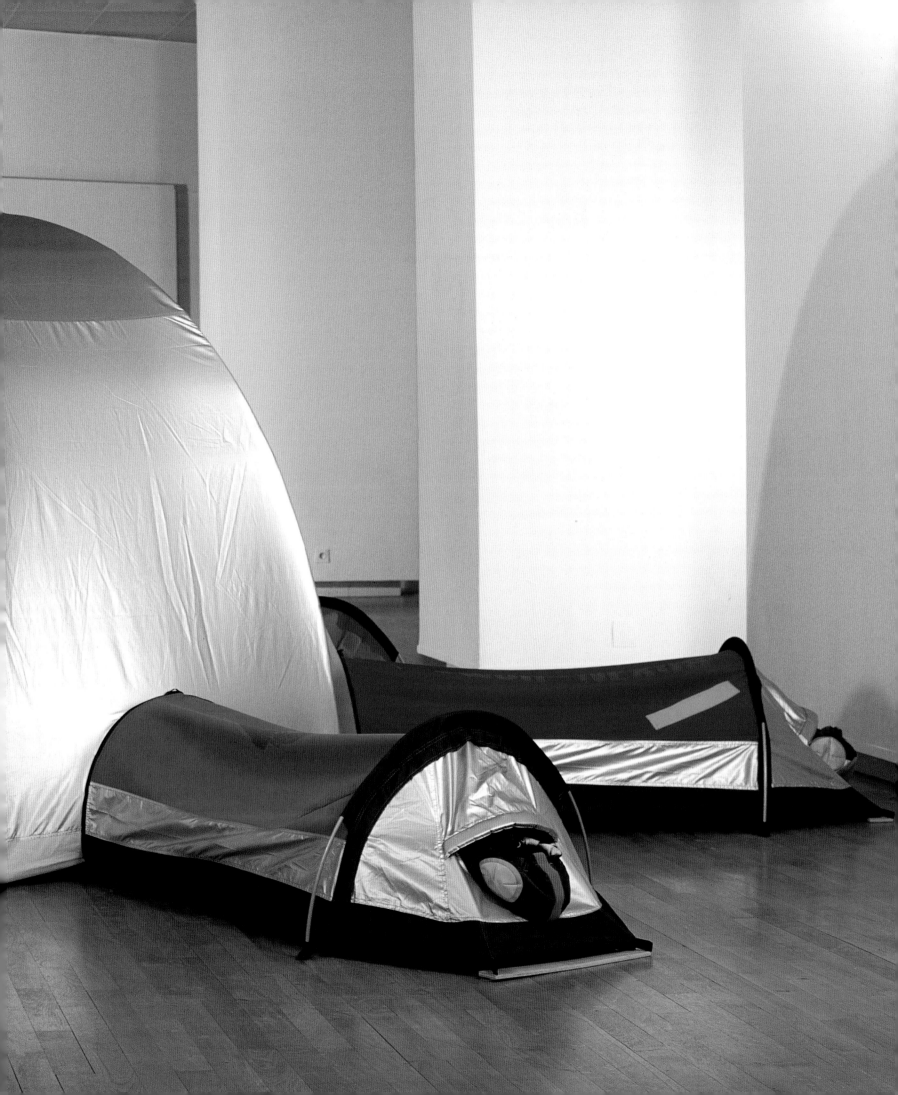

represented by current thinking. Each era has values, and we should continue to elaborate and re-define them. The more we progress, the more values should evolve. These values should transcend our beliefs, our thoughts, and what we have built, like human rights. Values should be universal, respect life and combat repression.

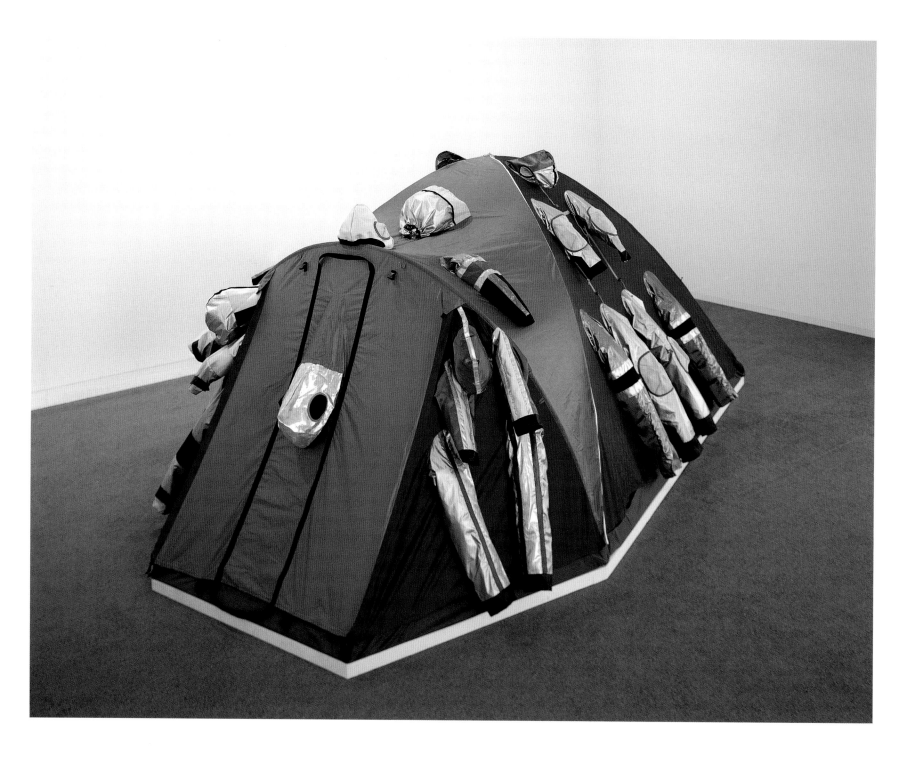

Body Architecture - Collective Wear x 8 (6 adults 2 children)
1998
Membrane, aluminium-coated polyamide, various textiles, 3 telescopic aluminium armatures
120 × 400 × 260 cm

**Body Architecture - Collective
Wear Soweto**
1997
Membrane, second hand clothes,
telescopic carbon armature, 5
aluminium poles, 6 copper joints
130 × 400 × 300 cm

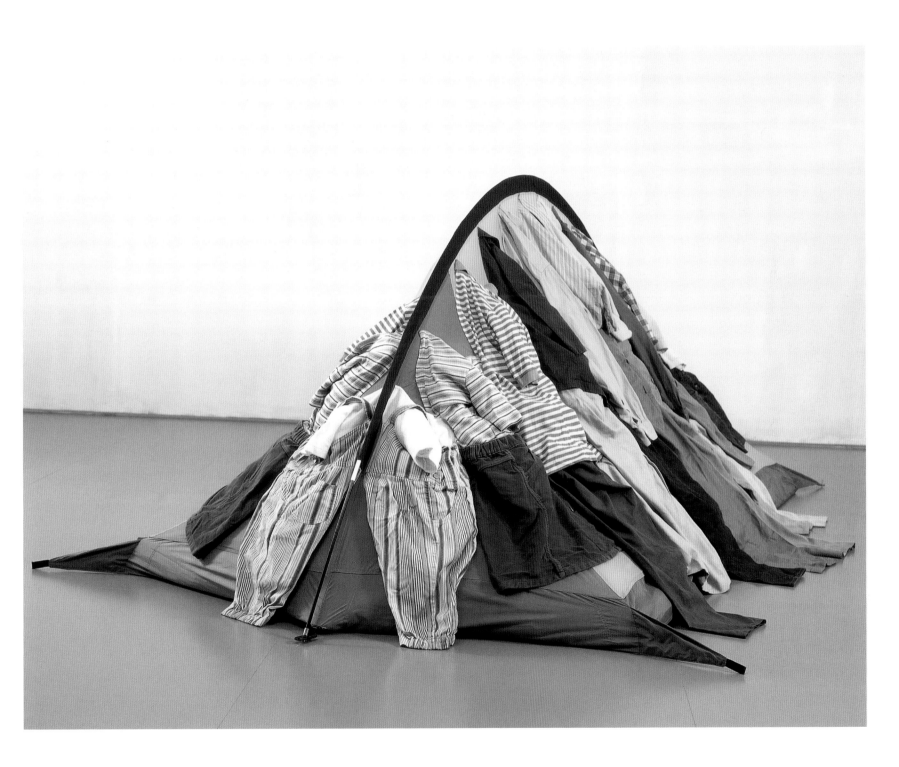

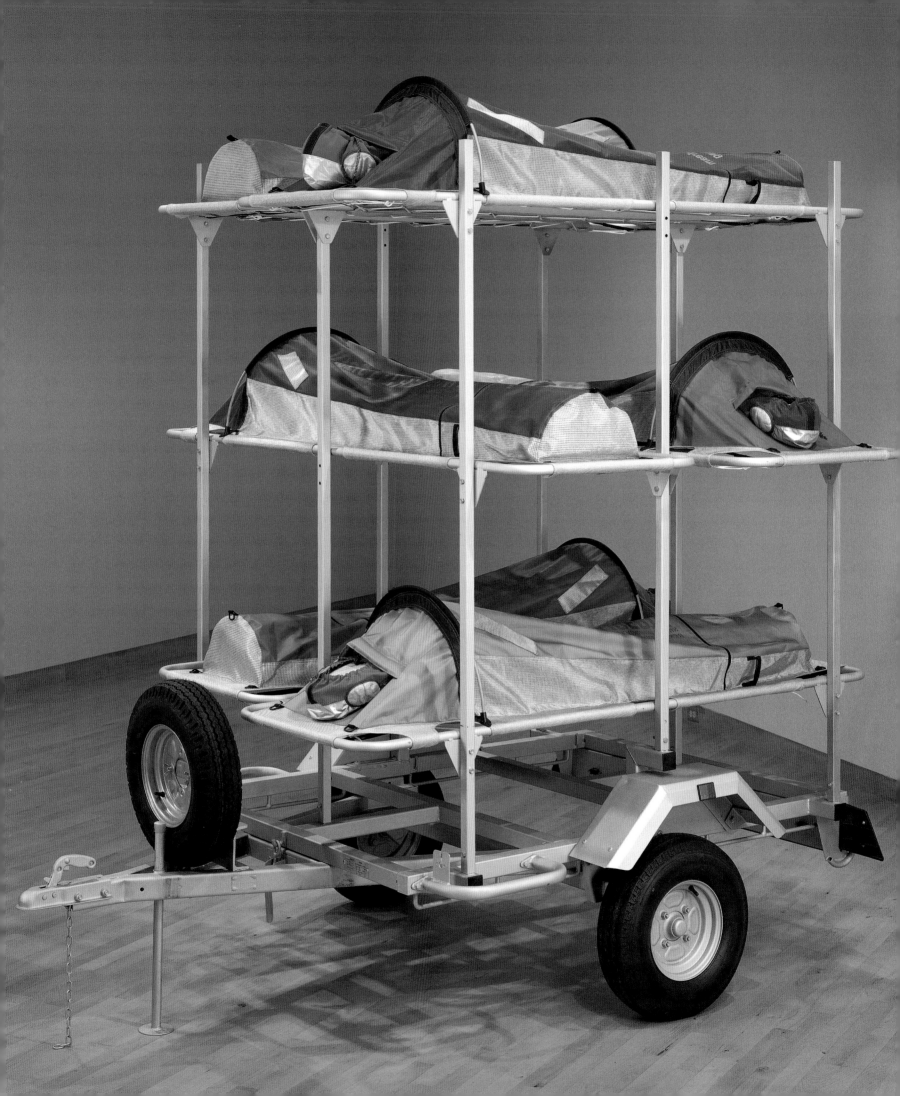

Contents

**Nexus Architecture - Venice
Biennale**
1995
Waterproof microporous
polyester, silkscreen print, zips
180 × 130 cm

Introduction

'We have learnt to fly the air like birds and swim the sea like fish, but we have not learnt the simple art of living together as brothers.' These words, taken from a 1963 speech by Martin Luther King, were silkscreened onto one of the many garments constructed by Lucy Orta. On another, we find the affirmation: 'Me, I've got a lot to say', borrowed from a participant in her *Identity + Refuge* project of 1995. With these phrases we can begin an initial analysis of the themes underlying the work of an artist who has sought to create connections, stimulate contacts and institute collective effort through her work. Orta's art is often the result of collaborations with specialists and others, and always seeks to underline the importance played by the social in our lives. This is based on the conviction that each of us, even the most marginalized, has 'a lot to say'.

Orta was born and studied in England, but her first artistic interventions took place in France, where she now lives. Her earliest works emerged between the end of the 1980s and the beginning of the 1990s, when the Cold War was coming to an end. Gorbachev, who had attempted to introduce a democratic model in the Soviet Union, would soon be overturned by his own reforms, and the fall of the Berlin Wall became the symbol of unstoppable change. But the 'victory' of the West, and of its economic model, had by no means solved all of society's problems, and the goal of becoming competitive in terms of production often had as its consequence (or maybe its premise) the abandonment of social guarantees. This single model has given a free hand to those who, through an aggressive economic plan, wish to impose their own paradigm of development, which often simply represents a more efficient model of exploitation. At the beginning of the 1990s, the Gulf War ushered to a close a period of incredible economic euphoria and brought to the surface the fragility and precariousness of an economic and cultural system no longer threatened by political uncertainty or by possible alternative systems of power.

These great events, paired with her experiences in the field of political activism and her marriage to the South American artist Jorge Orta in the early 1990s, are the background against which to view Orta's work, along with other elements that contributed to her development and maturation. All of her works seek to investigate the complexity of the present reality, to bring to light some of the harsher internal contradictions in contemporary society, to analyze its problems and question stereotyped social conventions. Orta operates on a plane where ethics and aesthetics find themselves sharing the same territory. And the rigid division separating these disciplines is not the only one to be called into question in her practice: fashion, design, architecture, theatre, urban planning and the visual arts are all summoned simultaneously. In each work we find the presence of a well-blended mixture of elements which stimulate an analysis of language and of the semantic borders between disciplines. Even our judgement of these works cannot rest on the usual parameters or the normal, reassuring boundaries.

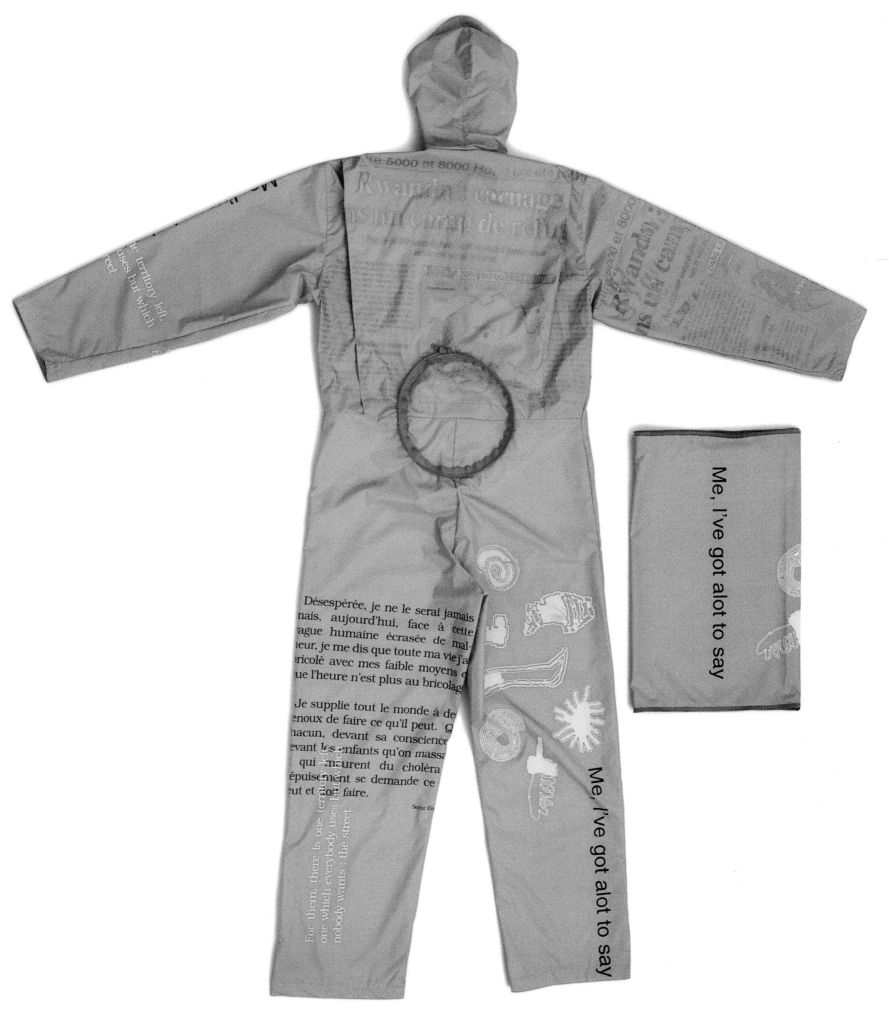

Me, I've got alot to say

Me, I've got alot to say

Refuge Wear - City Interventions
1993−1996
2001
Original colour photographs
60 × 90 cm

Orta's training as a fashion/textile designer naturally linked her first works to that second removable and transformable skin − clothing. Clothing is a film; it is the surface that people see and touch. It is a means of relating to and communicating with others; it is the 'face' we present to the outside world, our personality. At the same time, it is protection, it is stability, it is safety. Obviously, Orta's work does not simply constitute items of clothing; rather it becomes a series of transformable 'refuges', collective garments, displays used to publicize issues and pose questions. Her clothing series are therefore portable architectures, wearable objects located midway between social commitment and the post-atomic science-fiction imagination.

Orta's work draws the spectator's attention not only to the object but, above all, to the network of internal and external relationships and references of which her installation-performances consist. They speak of a lack of social involvement and a sense of solitude, and, at the same time − going back to the phrase, 'I've got a lot to say' − the need to listen to each single voice as an individual expression, obviating the hegemony of slogans, ideologies and homologation. Along with the serious unresolved problems that affect the whole planet, most of us deal each day with individual uncertainty and insecurity, problems that cannot be lumped together and that cannot therefore be ascribed to a homogeneous whole or reduced to a single point of view. The search for an all-satisfying solution seems utopian, and the awareness of this is reflected in a general lack of faith in politics. This lack of faith leads us to deny

the poverty and marginalization that we see around us. Increasingly in big cities extreme wealth and extreme poverty accumulate in the same territory. It is a phenomenon that is more evident in the so-called Third World, but which has become endemic even in the West. Big cities are being transformed into great concentrations of solitude and marginalization, and the extent to which individuals personally suffer from this is the object of investigation and at the same time the active subject behind Orta's projects.

Orta seeks to overturn the methods and procedures of our consumer society and the images that deny an identity to those who do not consume and cannot identify with the models proposed through the advertisement of merchandise. In this way, she opposes that 'unwritten' rule of behaviour according to which those who are unable to buy must make themselves as invisible as possible. With her artworks, she intervenes to restore visibility to that which is invisible, to bring attention to people, phenomena and things that are not usually deemed to possess the necessary appeal to become images: the homeless, political refugees, or (in later works) discarded food stuffs collected in city markets and recycled.

What Orta proposes is therefore a form of re-socialization that acts on various levels. One of her works entitled *Refuge Wear* bears the words: *'Living without a shelter for prolonged periods rapidly destroys physical and moral health. The lack of adequate sleep increases stress, weakens the immune system and accelerates the loss of identity and desocialization'*,[1] a sort of manifesto for her work. These garments/architectures are not only

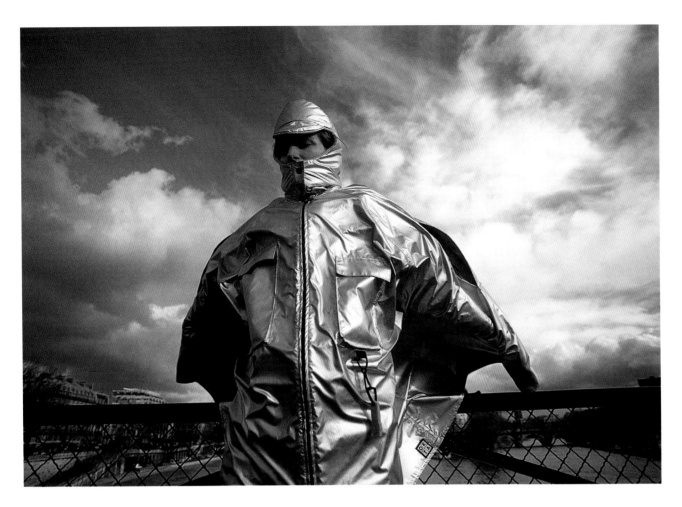

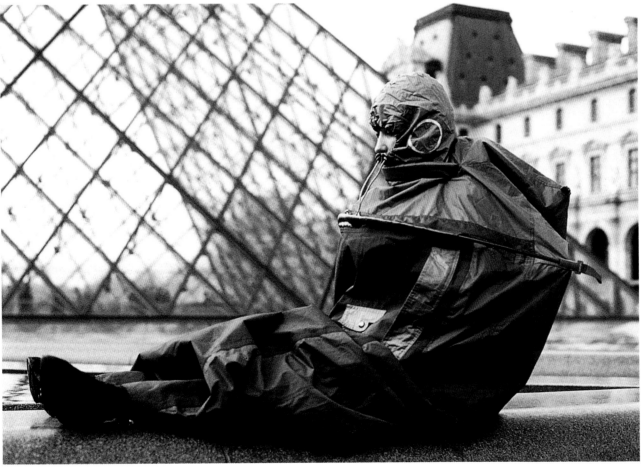

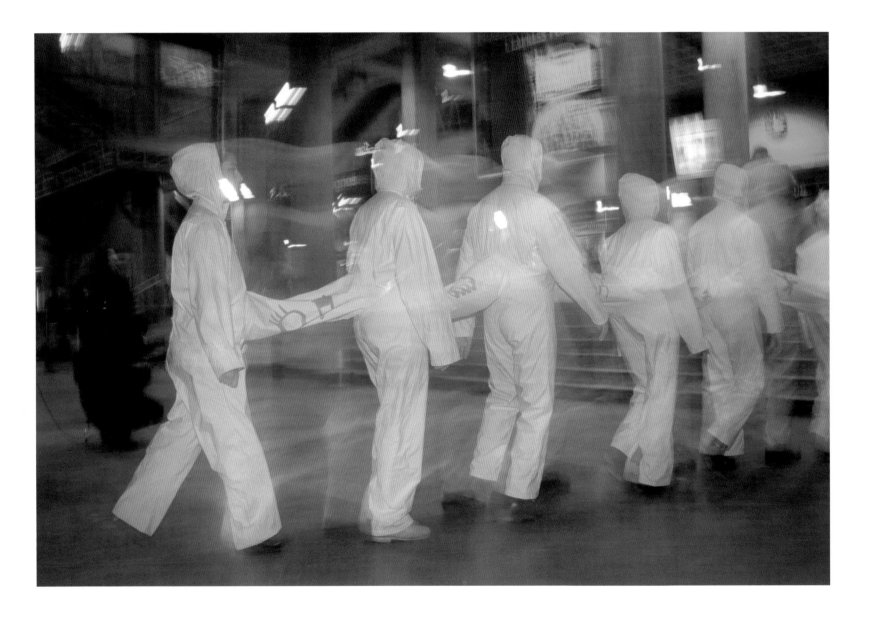

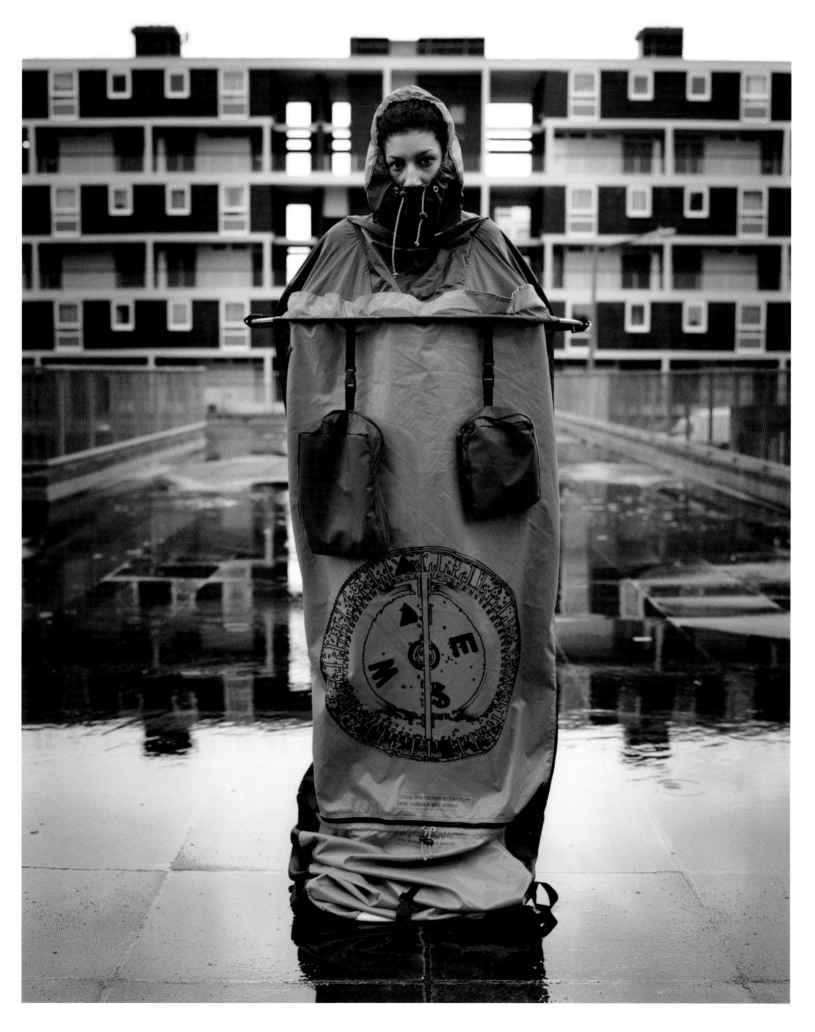

covered with such texts, but are also used as a new type of 'itinerant painting', bearing, for example, a compass and a map of Rwanda, a pair of begging hands or stylized drawings. The images silkscreened onto these garments/houses are like tattoos: they express ideas, sentiments, identity, values, but they are always presented in the form of a question.

Through Orta's works one discovers poverty and marginalization. At the 2nd Johannesburg Biennial in 1997, for example, she presented a piece in collaboration with the Usindiso Women's Shelter; in Paris, and subsequently New York, she has worked with the Salvation Army. These were works that underlined how the ability to obtain an identity is consequential on the re-elaboration and reinvention of garments given to poor people.

Orta's work, however, cannot be reduced to mere condemnation of the state of maginalization; most of it reflects situations that involve us all. Solitude and isolation affect everyone directly, and Orta's attempt at resocialization is brought into practice in works that aim to operate at a more general and symbolic level. In *70 x 7 The Meal* (2000–), for instance, people were invited to participate in a ritual lunch, which, since each invitee was called upon to involve seven more guests, generated a sequence of connections with other individuals.

Another common element in much of Orta's work is the centrality of the body, which of course, links us all. Her use of the body does not connect with artistic movements of the recent past; she does not focus attention on the body to push limits and sensations, but rather analyzes it in its vital processes, where survival and the capacity to communicate co-exist. Clothing and architecture are structures built around the body, and the body is also the protagonist in the works centred around food, which highlight the fact that this essential function can also be the basis for relationships. The body is not only understood as the measure of one's own space and world, but also as a fragile structure to be preserved in a great diversity of ways; the body is seen as both a producer of sensations and as a builder of relationships. Seen in this light, Orta's works are also about identity.

It is worth repeating that the ethical and conceptual aspects of Orta's work are never disconnected from the aesthetic ones; she is attentive to the external details as well as to the internal aspects of the objects to be exhibited/used. This characteristic is never missing even in the more concretely social works, or in the workshops, where the freedom given to participants is essential to their successful operation. Orta is aware that the efficacy of interventions, above all their capacity for penetration into the collective imagination, is dependent on the images we create. Any uncertainty in this area would automatically lead to their defeat, not only with regard to the art world but more generally in relation to everyone who comes into contact with her work. All too often, intelligent and potentially interesting works of art come undone because of a lack of attention to these aspects, rendering their artistic/social functions completely redundant.

Refuge Wear - Intervention
London East End 1998
2001
Original colour photograph
150 × 120 cm

We can approach Orta's works through arranging them into a series of chapters or cycles to facilitate their further examination, but these are not meant to reflect actual internal divisions between them. Each theme is fluid, closely related to and in harmony with the others.

Refuge Wear and Body Architecture

Refuge Wear (1992–98) was the first of Orta's works to become known in international artistic circles. The initial drawings for the series were made in 1992 and can be considered a response to the problems and suffering experienced during the first Gulf War. The series was conceived in order to confront situations of discomfort and/or the lack of protection by social structures.

Refuge Wear is clothing that transforms textiles, fibres and fabric membranes into portable architectures. It is therefore at the intersection of dress and architecture – two different levels of contact that the body has with the outside. The first covers and stays in contact with our body and the second, more solid in structure, defines the place in which we live and spend most of our time, constituting our refuge. *Refuge Wear* takes on both of these tasks, affirming that our body is in complete and indispensable interaction with that which surrounds it. Dress and architecture are also the limits – psychological and structural – between the individual and society, between the personal and the public. Perhaps because these are limits that coincide in the life of the homeless, Orta makes these two layers of protection overlap, favouring an interchange of roles between dress and architecture.

The first work of this series is entitled *Habitent* (1992–93). The word naturally calls to mind the idea of the habitat,[2] and these particular clothes can be considered habitats that travel along with those who wear them. The other versions of *Refuge Wear* have subtitles that usually denote specific possibilities for their application, and give some clue to the context in which they were originally presented: *Habit Bivouac, Osmosis with Nature, Mobile Cocoon, Ambulatory Survival Sac, Survival Sac with Water Reserve*. For example, *Survival Sac with Water Reserve* was made during the most intense phase of the crisis in Rwanda. Following this, Orta created a version with the welcoming of Kurdish refugees in mind, or, by equipping these structures with sacks for water reserves or medicine, she created prototypes especially for the victims of natural disasters like the earthquake in Kobe, Japan.

A fundamental role is given to the pockets and pouches that enrich the various versions of this work, elements that personalize the use and specific function of each version of *Refuge Wear*. As the artist herself explains: '*The pocket, pouch, or bag of diverse forms are appendages that define the personality of each shelter and of the individual that inhabits it. They can be transparent, often filled with meditative objects. The pockets can be accessed from the interior and contain personal objects for daily utilization. They are detachable and can be folded with the aid of the instruction manual silkscreened on to the surface, and change form or function according to need: transportation of water or merchandise, sheltering a person, dressing a body. These pockets are both transport utility bags*

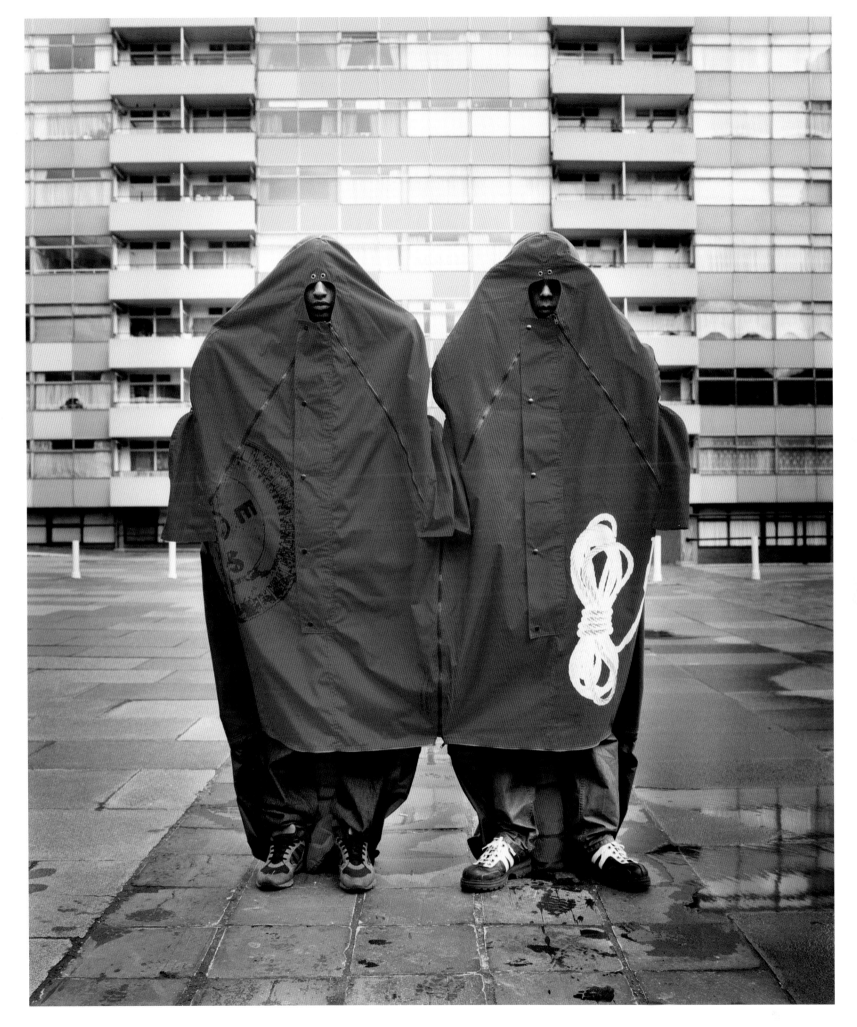

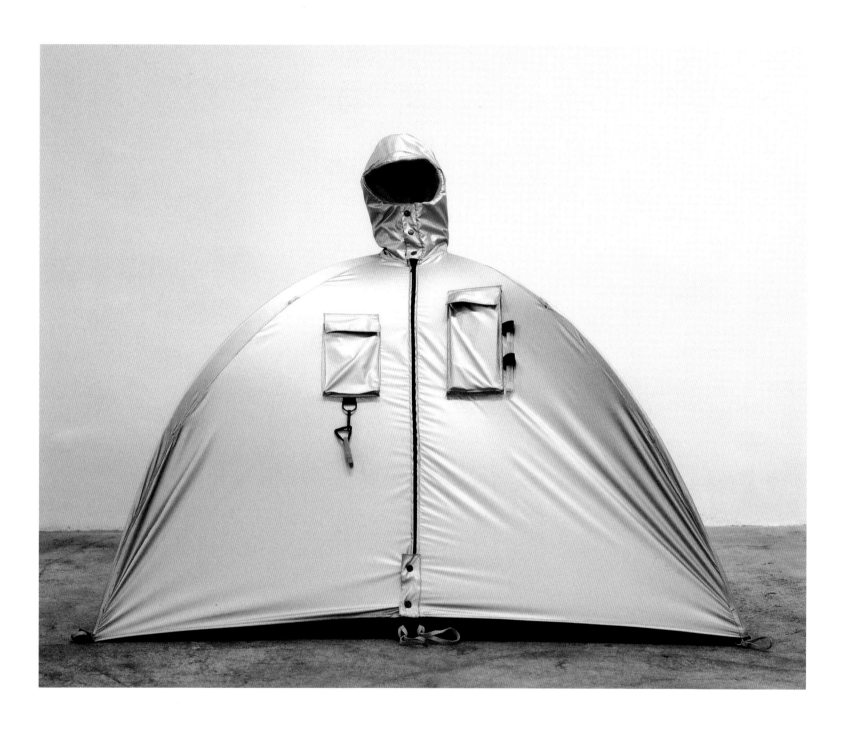

and the packaging for Refuge Wear.'³ *Refuge Wear* is therefore a truly personalized environment that can be transformed according to demands, needs and situations. Its value, once again, is in its symbolic and utopian capabilities.

The familiarity with the world of fashion visible in this series can also be found in many of Orta's subsequent pieces. A founder member of the Paris-based fashion house Casa Moda – a group of designers and artists interested in creating links between experimental design and fabric research – she has a growing interest in creating new fabrics and has studied alternative uses for existing ones. Even with her numerous collaborations in the fashion world, however, Orta has never had the desire to be totally absorbed by it. Often, she has found this environment too limiting, alien to the social and poetic meanings towards which her work has tended.⁴ Above all else, Orta has always tried to dedicate herself completely to the invention and creation of pilot projects or unique pieces, without having to justify them against the specific demands of the fashion industry.⁵

From her initial training, a taste for seeking out new materials remains. This experimentation itself often becomes the bearer of meaning: *'Materials that have a microporous membrane coating are of particular interest as they attempt to mimic certain characteristics of the skin, such as the transfer of body humidity from the interior to the exterior. This micro-process is fundamental to our well being and, even though the viewer may be unaware, it's part of the poetry of the object.'⁶* The process of fabrication reflects the concepts that unify the work. Like our body, the material is in complete contact with that which surrounds it. The work as a whole also reflects the capacity for interchange between function and metaphor. *'Thermochromic-coated fabrics used for* Mobile Cocoon with Detachable Baby Carrier *change colour with temperature fluctuations enabling the mother "unit" to react and control climatic variations.'⁷* The fabrics are organic, in order to conserve contact with nature, but they are also as tough as their function requires. The profound reflection on and search for materials also extends to colours. These have a highly important function; Orta always chooses vibrant colours in order to increase the visibility of the wearer. They can therefore be considered to be like spotlights pointed on people in order magnetically to attract the viewer's gaze.

Another element that becomes immediately evident is the transportability and multi-functionality of these clothes/architectures, which underlines how our society, based on computer connections and virtual reality, is completely borderless. The notion of territory and stability has been taken over by a concept of the nomadic that works on various economic and geographic levels. There is the touristic nomadism of capital, but also the shift of population from the country to the city and from the south to the north. We have arrived at a condition in which territory has become global, and nomadism has taken the place of rootedness.⁸

Since 1993 Orta has been creating *Refuge Wear City Interventions*, a series of happenings in which *Refuge Wear* is shown and used in public situations. Squats, railway stations and housing

Refuge Wear - Habitent
1992–93
Aluminium-coated polyamide, polar fleece, telescopic aluminium armature, whistle, lantern, transport bag
150 × 150 × 150 cm
Installation, Galerie Anne de Villepoix, Paris
Collection, FDAC Seine Saint Denis, Paris

l. to r., **Refuge Wear - Osmosis
with Nature**
1993
Membrane: Waterproof cotton,
netting, silkscreen print
Structure: telescopic carbon
armature, transport bag
250 × 150 cm

**Refuge Wear - Collective Survival
Sac x 2**
1996
Microporous polyester, PU-coated
polyamide, silkscreen print,
transformable rucksack, zips,
transport bag
200 × 200 cm

**Refuge Wear - Ambulatory
Survival Sac**
1993
Waterproof cotton, polyamide,
translucid PVC, grip soles,
meditative objects, transport bag
200 × 85 cm

estates become spaces for interventions, bringing to light situations of discomfort removed from their usual context. Establishing contact with reality, and presenting her work in the midst of that reality, is one of the fundamental veins of Orta's research. Her interventions have the objective of reconnecting private and public, artistic and real spaces, art and life, never choosing nor abandoning either environment, but acting as a bridge between the two. In analyzing context and social dynamics, Orta has created an extraordinary laboratory in which, although it may be situated in the white cube of a gallery or museum, the 'real' experimentation in an everyday context is even more important.

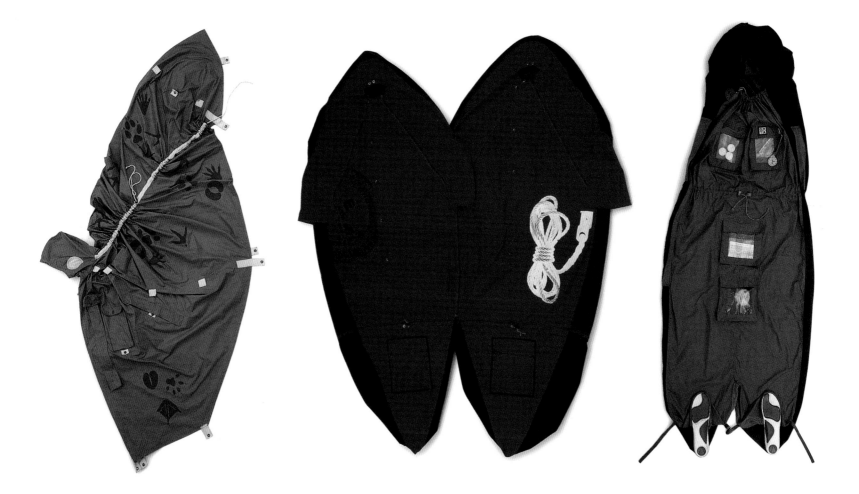

l. to r., **Refuge Wear - Mobile Survival Sac**
1996
Microporous rip-stop, PU-coated polyamide, telescopic aluminium armature, detachable kits, silkscreen print, transport bag
210 × 90 cm

Refuge Wear - Mobile Cocoon
1994
Polar fleece, quilted microfibre, fastenings, transport bag
210 × 210 cm

Refuge Wear - Mobile Cocoon with Detachable Baby Carrier
1994
Thermochromic-coated polyester, PU-coated polyamide, silkscreen print, fastening
205 × 80 cm

Collective Wear

Since 1994 (the year Orta met philosopher Paul Virilio) the artist's interest has been moving from individual space to the shared environment and her *Collective Wear* series was first exhibited that same year. This shift is indicative of Orta's growing interest in the collective in general, in mechanisms of inclusion and exclusion, in the models of collaborative interaction that go from the microcosm of the small community to the macrocosm of a planet governed by politico-economic and environmental laws. Orta's research on *Refuge Wear* continued until 1996, when its more insular theme was overtaken by the need to concentrate on constructing these plural contacts and connections.

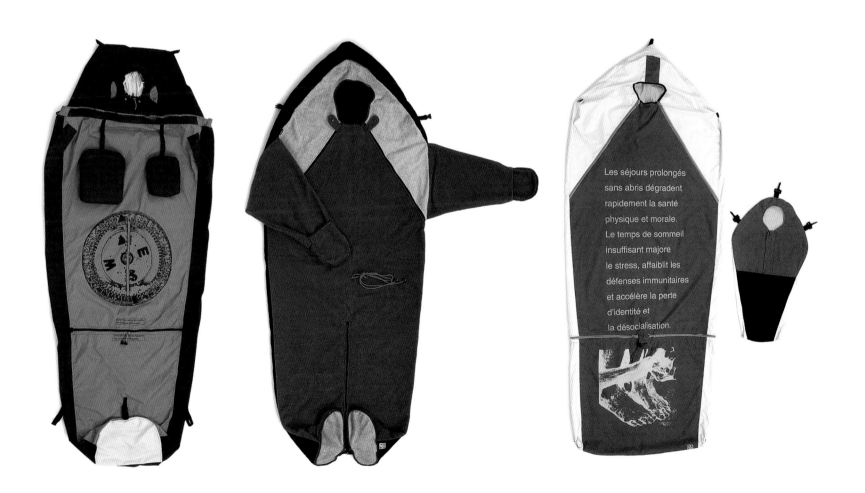

Les séjours prolongés sans abris dégradent rapidement la santé physique et morale. Le temps de sommeil insuffisant majore le stress, affaiblit les défenses immunitaires et accélère la perte d'identité et la désocialisation.

**Body Architecture - Collective
Wear 4 Persons**
1994
Aluminium-coated polyamide,
microporous polyester, telescopic
aluminium armatures, grip soles
150 × 180 × 180 cm
Collection, FDAC Seine Saint
Denis, Paris

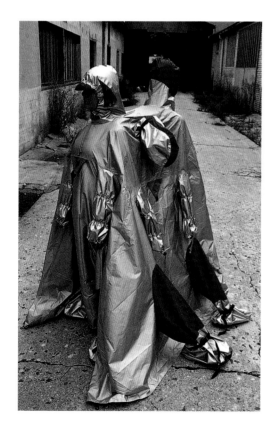

Collective Wear reminds us that we need other people in order to construct our own refuge; we need contact with the bodies of others. It affirms that man, like other social animals, owes his survival to the collective.[9] But if on the one hand it seems that Orta is drawing attention to a primary animal instinct, on the other she is affirming that we need to tap all our rational resources in order to respond to the emergencies towards which we are headed. We live in a world in which ecological balance is under great strain and only by planning a strategy and common rules, valid for all nations and populations of the world, can we hope to avoid a crisis from which it might be difficult to escape.

The passage from the single to the collective also involved the shifting of the intervention from the individual to the more generic, which introduced performative and theatrical elements. This evolution allows us to read Orta's work not only as concrete responses to unresolved social problems, but also in an intrinsically prophetic light,[10] where a typically 'artistic' capacity to investigate and reveal the hidden is favoured over concrete solutions. This process becomes gradually more evident throughout the development of her work, as can be noted in *70 x 7 The Meal* and *Nexus Architecture* (1995).

From *Nexus* to *Modular Architecture*

Nexus Architecture is perhaps Orta's most famous project and in many regards the most representative of her work. This piece is composed of a series of uniforms, similar to those worn by industrial workers, or to the white boiler suits worn by activists during recent protests. Their principal characteristic is that each can be connected to the next in such a way as to create a long snake of people, united by a kind of gigantic umbilical cord that is attached with a zip to the belly of one uniform and clasped to the posterior section of the next. It is an outfit/structure that can be infinitely extended, involving hundreds of people, or can be limited to just a few individuals.

Nexus Architecture has been repeated and reinvented many times, precisely because its meaning and results are always different depending on the people and places involved. The idea of the physical connection between people was employed in order to allude to religious links, sexuality, age, social status or, more frequently, to create a symbolic nexus of common intentions, mimicking the structure of computer networks such as Internet communities.[11] The capacity of *Nexus Architecture* to transform itself and interact within different contexts – from Mexico City to New York to Sydney – brought about its inclusion in many solo and group shows and a number of biennials. Orta has also created specific versions for dancers in order to investigate the intrinsic choreographic possibilities in her work. Additionally, it has been used on 'non-artistic' occasions, for example at environmental demonstrations such as the Parisian anti-pollution protest in 1988.

Nexus Architecture x 16 was exhibited in Venice as part of the show 'On Board', curated by Jérome Sans during the XLVI Venice Biennale (1995), a project that included Jorge Orta's intervention for

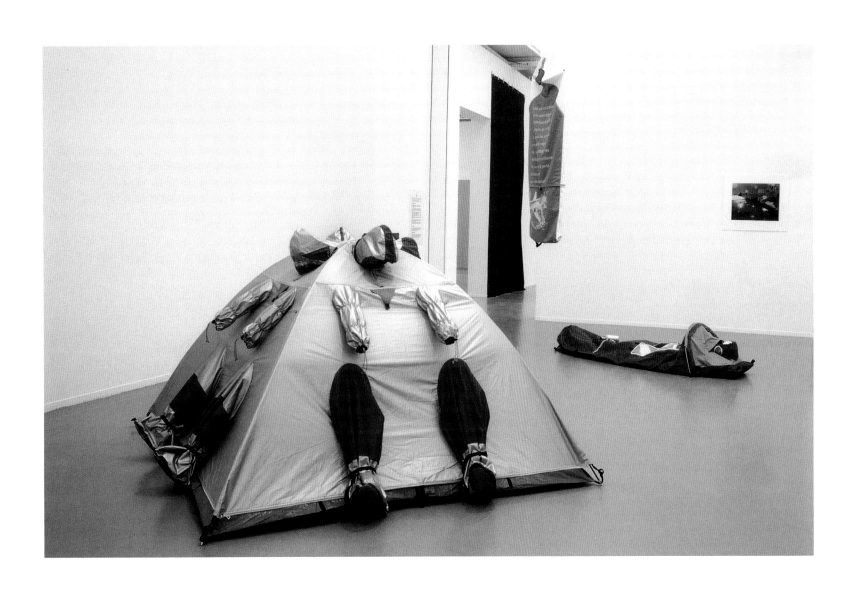

Body Architecture - Collective
Wear 4 Persons
1994
Aluminium-coated polyamide,
microporous polyester, telescopic
aluminium armatures, grip soles
150 × 180 × 180 cm
Installation, Musée d'art moderne
de la ville de Paris
Collection, FDAC Seine Saint
Denis, Paris

Nexus Architecture -
Intervention Uyuni Salt Desert
1998
2003
Original colour photograph
120 × 150 cm

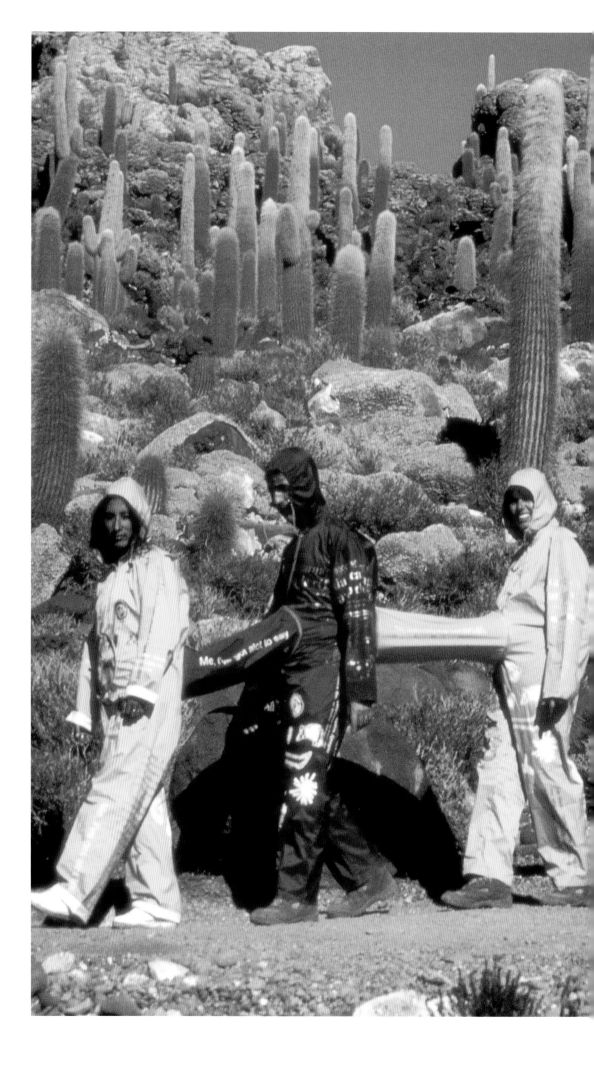

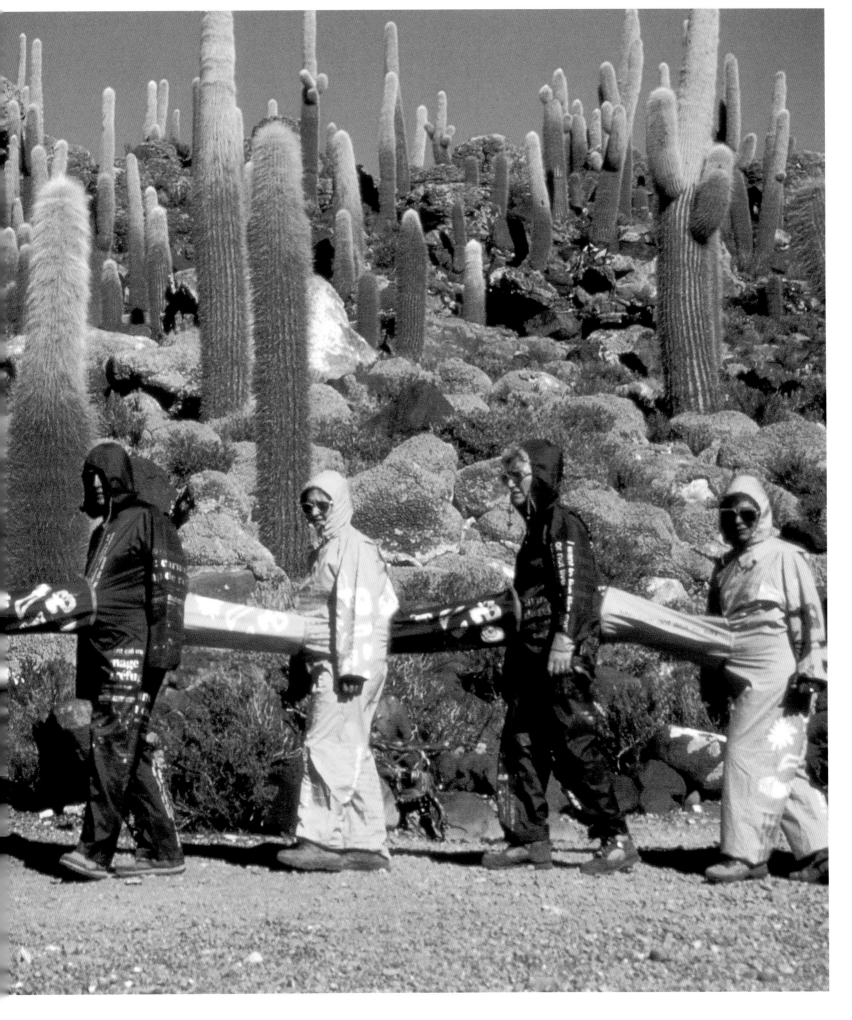

Nexus Architecture -
Intervention Uyuni Salt Desert
1998
2001
Original colour photograph
120 × 150 cm

the 'Argentinian Pavilion'.[12] Its staging at the 2nd Johannesburg Biennale in 1997 was perhaps more significant (at least in terms of the wide range of physical, emotional and cultural connections it created). On this occasion, Orta took on the role of co-ordinator for a work created in collaboration with thirteen women from the Usindiso Women's Shelter, an organization that helps women from the countryside find the resources to live in the city. Together with these participants, she selected and bought hundreds of metres of kanga fabric at a

local market. Each woman involved, most of whom had never used a sewing machine before, was paid to construct a section of *Nexus Architecture* in a labour of co-creation that, over time, took on an ever more precise system of working practice. Once created, the clothes were used for a public intervention during the inauguration of the Biennial. The work's performative aspect connected strongly with the city,[13] since the long human chain that had formed inside the local exhibition space reached the city's outer streets,

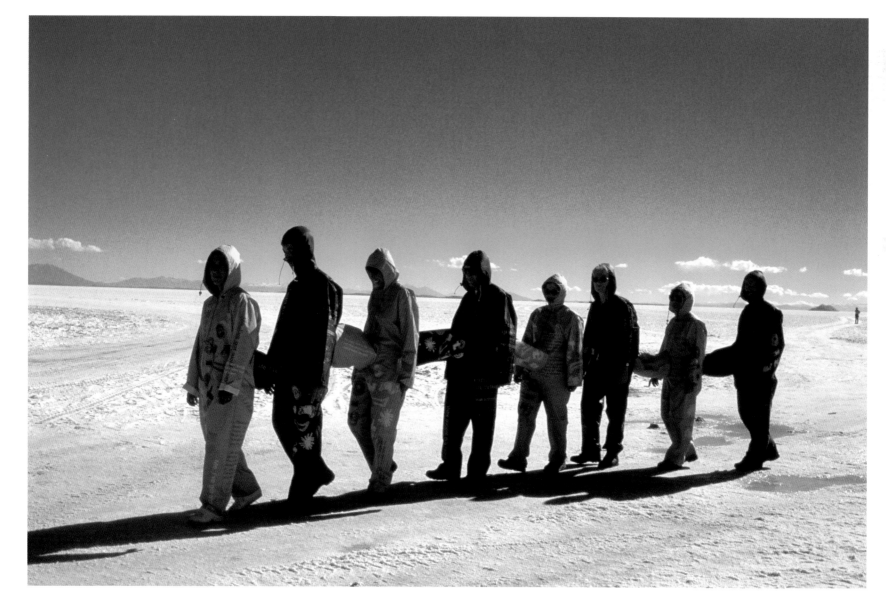

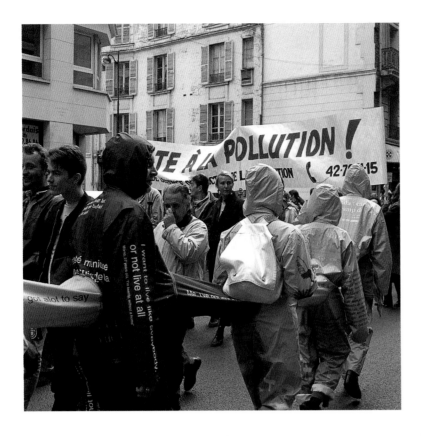

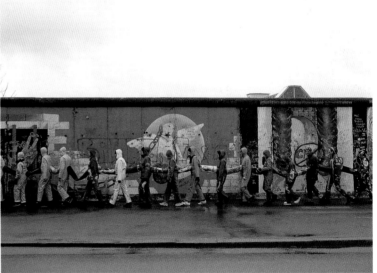

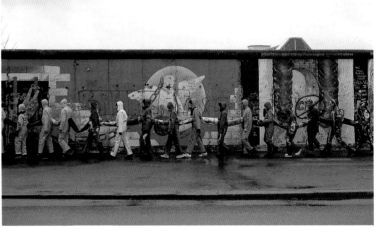

clockwise from top left,

Nexus Architecture x 16 Paris
1998
Anti-pollution protest march,
Paris

Nexus Architecture - Sydney
1998
City intervention

Nexus Architecture - Berlin
1998
City intervention with students
from Technischen Universität
Berlin

Nexus Architecture - Lyon
1998
Global March Against Child
Labour, Lyon

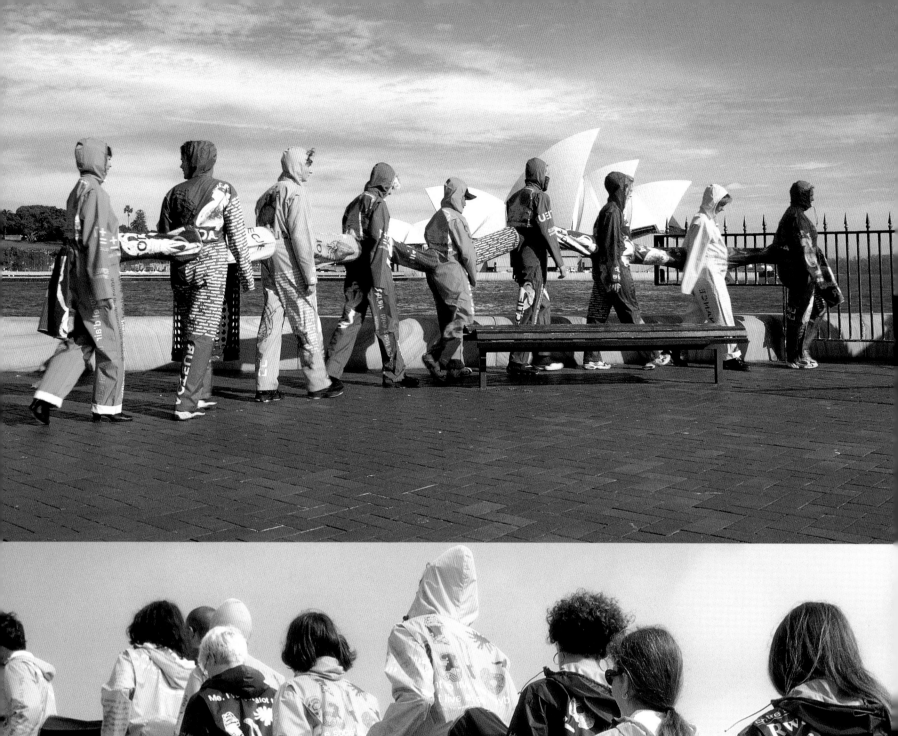
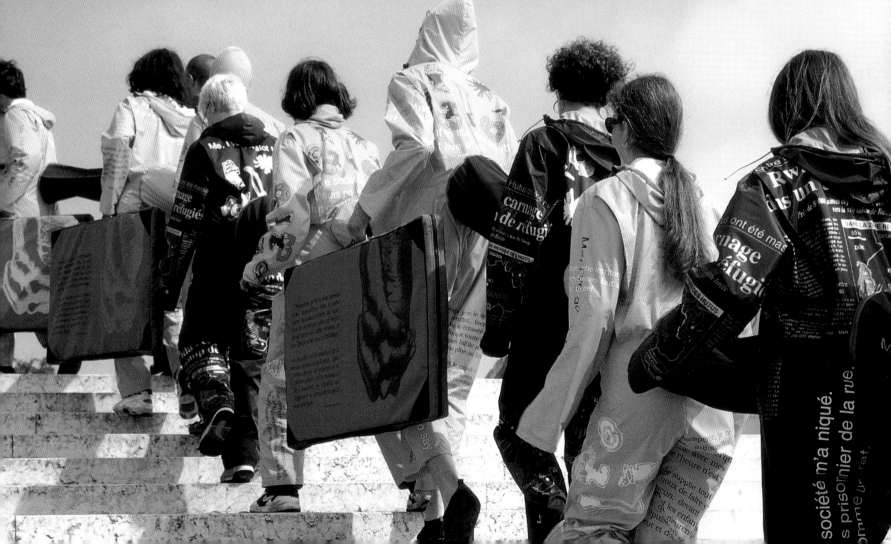

Nexus Architecture - Sydney
1998
City intervention

Nexus Architecture x 16 - Venice
Biennale
1995
Intervention with students from
the Istituto Universitario di
Architettura di Venezia, Venice
XLVI Venice Biennale

where the participants spontaneously began to sing 'God Bless Africa', one of the songs outlawed during the recently overthrown apartheid regime.

More recently, *Nexus Architecture* has been created in versions where groups of children have participated as actors/models, protesting at the 'Global March Against Child Labour' (Lyon, 1998). Another version, *Nexus Architecture x 110*, created especially for 110 children, was presented at Cholet, France, in 2002.

A characteristic aspect of *Nexus Architecture*, present throughout Orta's artistic production in many different forms, is its strong inclination towards the creation of a structure. In a sense this is a sort of 'search for order', but not for control – a concept that is often associated with order. Structure, with its evident and symbolic connective quality, highlights our intrinsic nature as social animals. It creates the possibility of building a physical connection between diverse individuals that gives them something in common. This search for order can, on the one hand, be a product of a classic aesthetic model of rationality, but on the other – apparently paradoxically – it can be read as a subversive act. Since today there is greater flexibly and an absence of rules – the only sure rule of the free market is that there are none – creating an organized chain of common interest becomes subversive and revolutionary.

Order, or, better yet, the dream of a modular architecture, rational and perfectly multipliable, also grips Orta's imagination in *Modular Architecture* (commissioned by the Soirées Nomades at the Fondation Cartier pour l'art contemporain in Paris in 1996). In this case, she uses it in order to stretch the limits of a modular collective living space. *Modular Architecture* is a portable, nocturnal refuge that is collaboratively built by individuals whose sum is greater than their parts. During the day, each piece is completely autonomous and can be worn by anyone. At night the outfits transform themselves architecturally, according to the number, needs and characteristics of the project's individual participants. For example one of the pieces, *The Dome*, is composed of four demi-bodies with arm and hood appendages, that can be detached from their structure to create separate entities.

Life Nexus Village Fête (1999–2000) has similar characteristics.[14] Here, architecture is seen as a meeting point, as a collective project: *'The inter-connective dome structures form a temporary nomadic tent village and the pre-determined connective protocols allow for numerous configurations all articulating around a central hexagonal foyer, a meeting place for larger groups. The network of tubes and passages serves as arteries to the smaller domes, hubs for fête activities and vectors for dialogue and exchange. The villagers become active participants, not passive recipients of yet another art show.'*[15]

An architectonic infrastructure for social spaces also plays a part in the series of works entitled *Connector Mobile Village*. These works take the form of transformable sleeping bags, tents, ground sheets and rucksacks which can be attached and detached from each other and form the basis of a sort of portable village. Here, independence and interdependence are equally important. In a statement about this work, Orta

following pages,
Nexus Architecture x 110 - Nexus
Type Cholet
2002
Intervention with 110 children
from Cholet, France

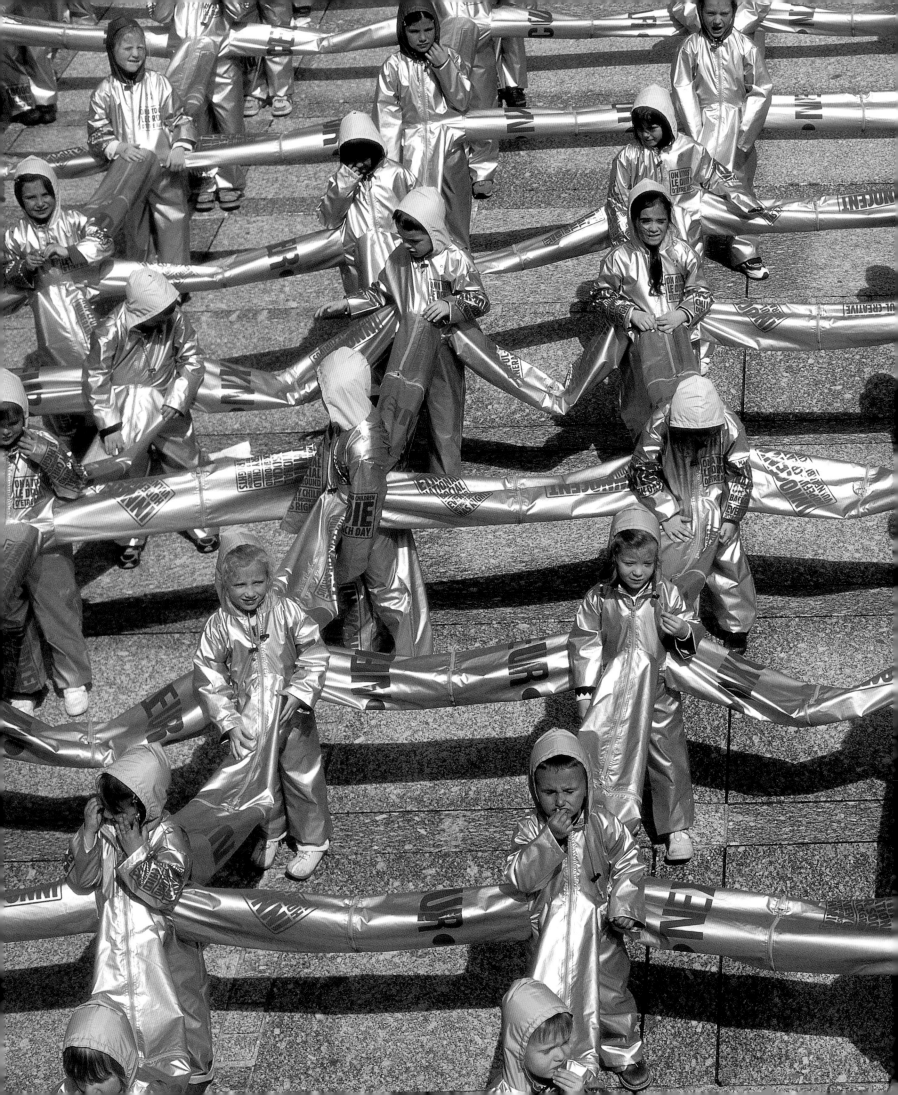

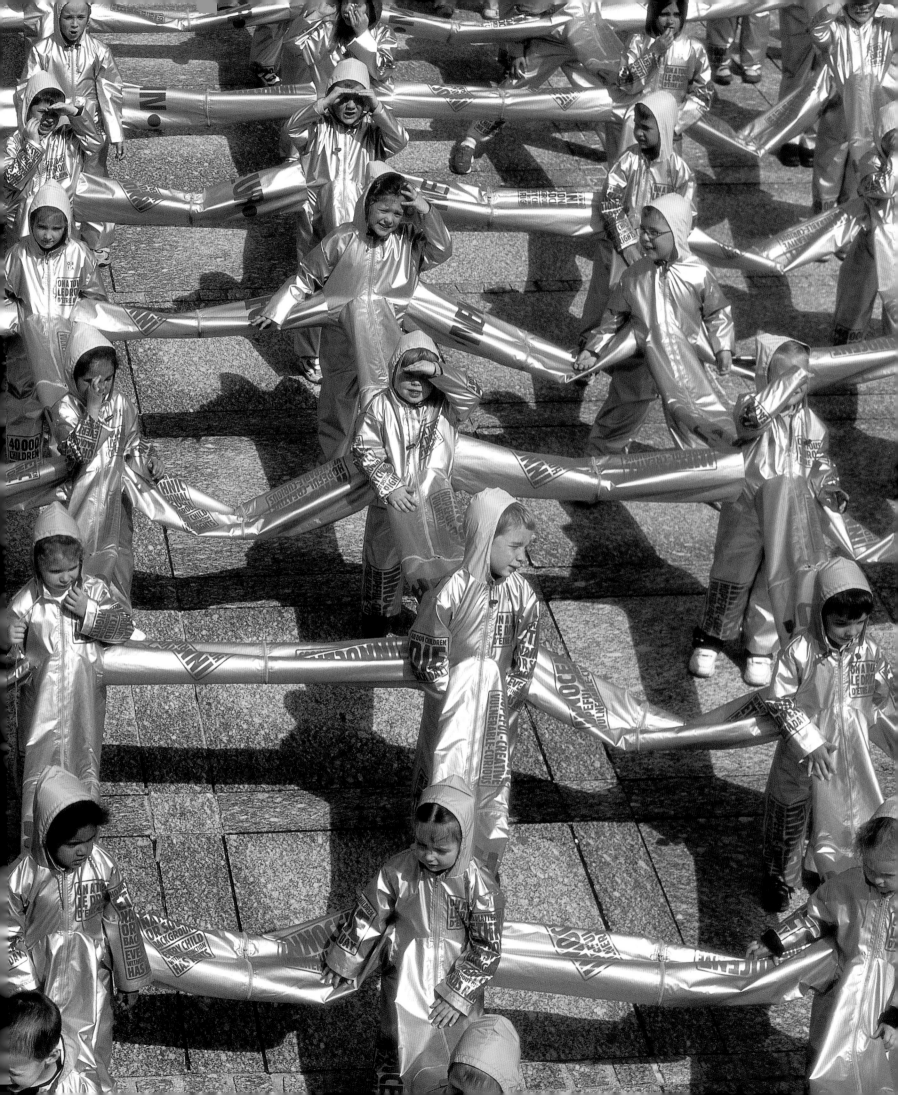

Life Nexus Village Fête
Bournville Village Green
1999
'In the Midst of Things',
Bournville Village Green,
Birmingham

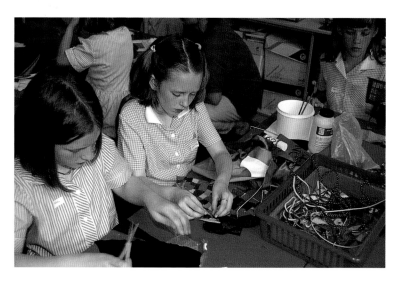

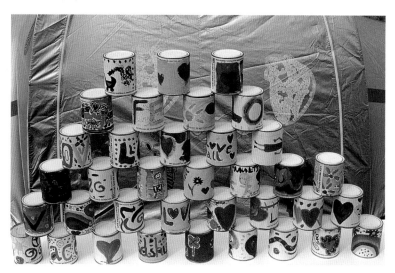

speaks of a 'rhizome-like architectural configuration'. The term 'rhizomatic' defines her collaborative approach, where the premise is to produce new configurations and developments of initial ideas and prototypes. The image of the rhizome could be seen as a model for all her work, and its social impact can be explained by borrowing this image of a root from which grow new roots and therefore new plants. It suggests a vision in which all vital manifestations are connected to one another but individual identity is preserved (as is the case with each new plant); a network of support in which every link, even the weakest, can serve to create new plants and flowers.

The contamination between art and architecture is not new in the history of art, but we can, at any rate, consider it as a recent rediscovery. In this area of investigation we can place the work of Dan Graham, Atelier van Lieshout or Andrea Zittel. However, Orta's work can best be compared to some of Vito Acconci's works like *House of Cars* (1983). What Acconci does with old cars – using each as a unit (halfway between clothing and house) in order to create connectable structures – Orta does with her avant-garde fabrics, from membranes to clothes. That which Acconci foretells in his work with cars, Orta brings to extreme consequences in her environmental works, to the point of displacing the romantic myth once constructed around cars as symbols of independence and freedom, and underlining their triumph over civility. After all, we are now forced to live in a world created more for cars than for man, where it is difficult to walk through the streets, interact with people and even breathe clean air.

If one wishes to continue along these lines, analogies can be drawn between Acconci's *Mobile Linear City* (1991) and Orta's *Modular Architecture* or *Life Nexus Village Fête*. Both intend to marry public and private space, living space and the body, architecture and art; both speak of shelter and refuge. However, there are important characteristics that distinguish the two artists from each other. First is Orta's attention to technical aspects on the one side, and environmental ones on the other. This pushes her to choose totally different materials from those that might be selected by an American artist. Above all, in much of Orta's work collaboration becomes an integral part of the work. This is true of Acconci only on the level of production (both artists attribute their work to a team by signing it Acconci Studio and Studio Orta respectively). In Orta's case, it is also true on the level of functionality. This may be more evident in her work connected with food, but even her uniforms acquire meaning and take on a communicative charge with the participation of only a few individuals.

Dans le même panier (All in One Basket)

The daily practice of sitting down to a meal is surely the most personal action in which we take part socially. Almost every culture dedicates time to eating with friends and family. It is a ritual, and it is interesting to note how food, so important for survival, is placed within that ritual. The maternal aspect – the intimate act of caring for people and alleviating their hunger – co-exists with the collective aspect of sharing the same experience

Vito Acconci
House of Cars
1983
Junk cars, paint, vinyl, steel
1.8 × 12.1 × 3 m
Installation, 'Urban Site', 80
Langton Street, San Francisco

Acconci Studio
Mobile Linear City
1991
Truck and flatbed, corrugated
steel, grating, chain
3.9 × 39.6 × 6.7 m

following pages, **Life Nexus Village Fête**
2000
Aluminium-coated polyester,
microporous membranes, eyelets,
silkscreen print, telescopic
armatures
Dimensions variable
Installation, 'Home', Art Gallery
of Western Australia, Perth

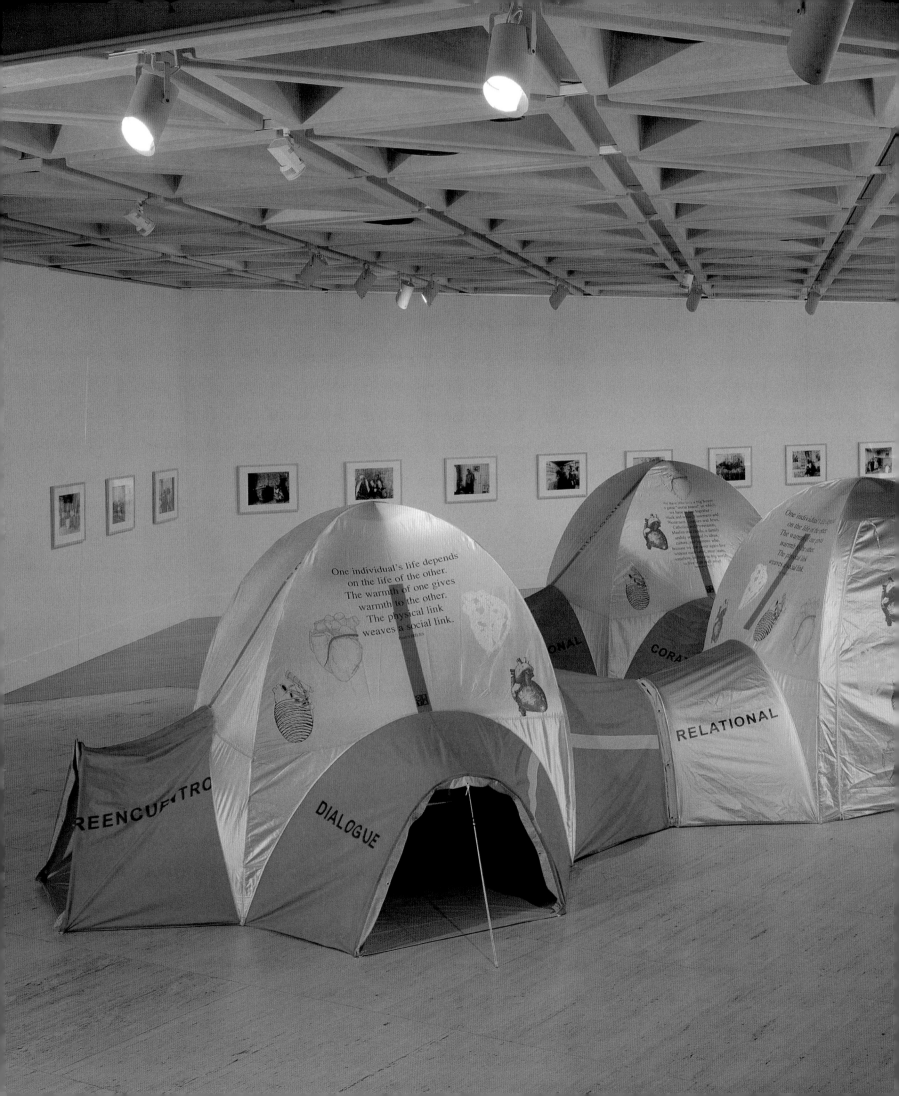

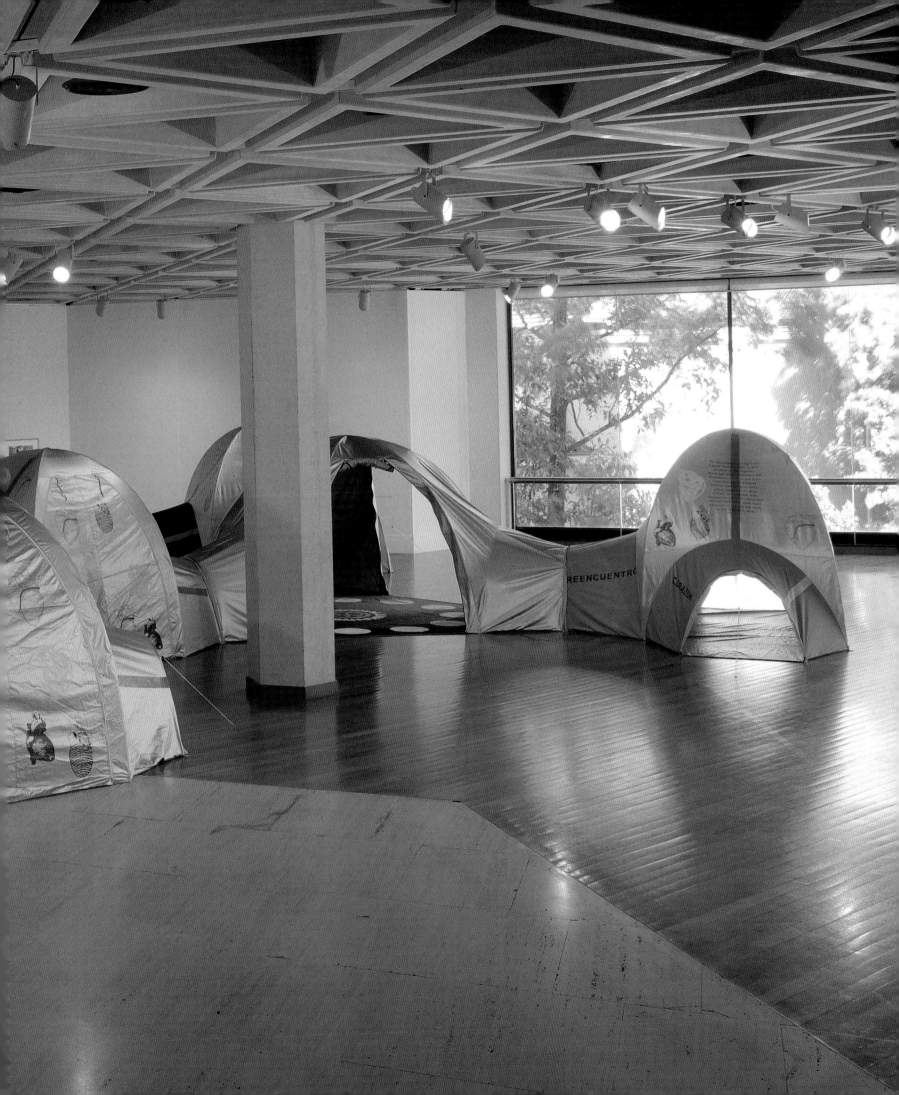

Connector Mobile Village I + II
2001
Aluminium-coated polyester,
reversible Solden Lycra, open cell
polyurethane, silkscreen print, zips
570 × 700 cm
Installation, University of South
Florida Contemporary Art Museum,
Tampa

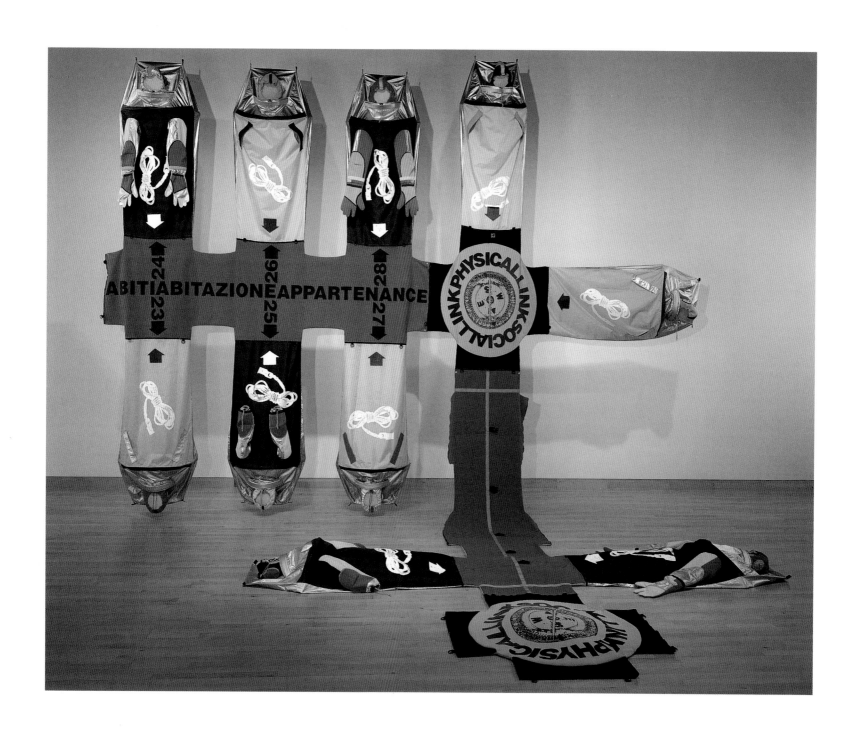

opposite,
Connector Mobile Village IX
2002
Aluminium-coated polyester,
reversible Solden Lycra, open cell
polyurethane, silkscreen print, zips
400 × 350 cm

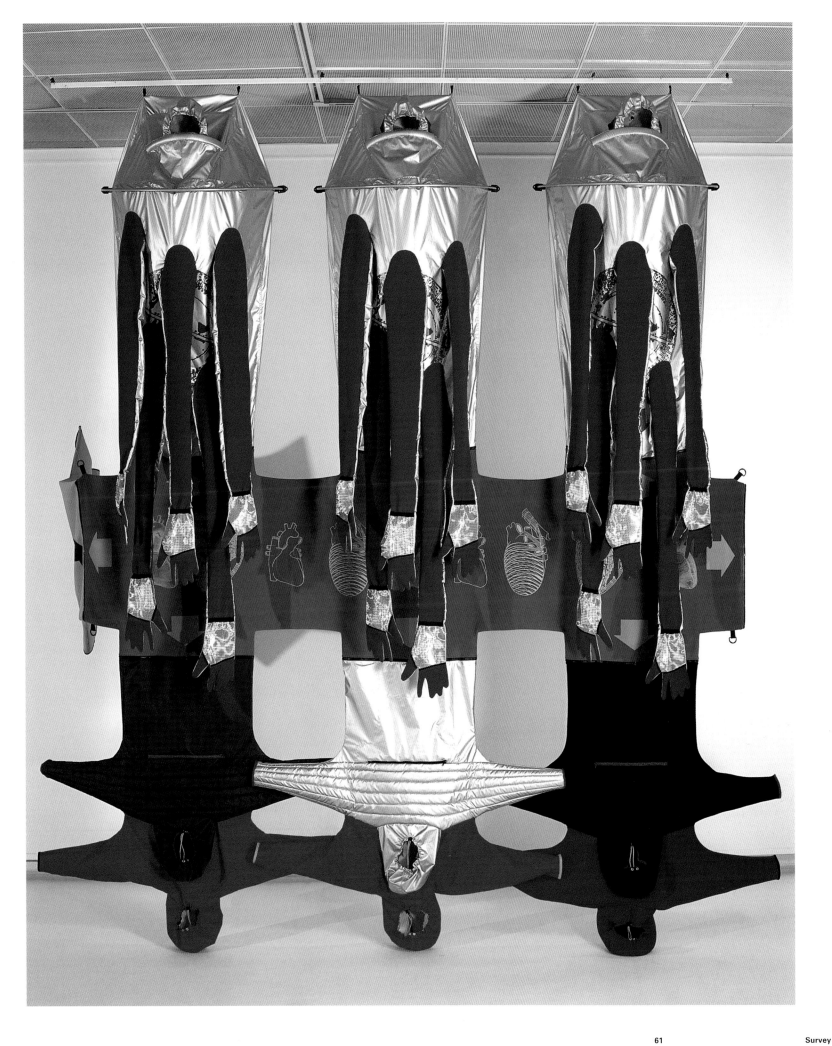

Connector IV - Bunt City
2001
Collage
50 × 100 cm

right, **Connector IV - Bunt City**
2001
Workshop, Metropolitan
Ministries, Tampa, Florida

and sensations with others. In addition, food is often the best way to begin integrating and communicating with a culture different from one's own.

Dans le même panier (*All in One Basket*, 1997) was created in reaction to a television report in which French farmers were filmed dumping tons of fruit onto the streets during a protest against the European Union's agricultural policy. From this alarming episode, Orta made a more general reflection on the waste surrounding us daily, which has come to seem so normal that we are no longer even aware of it. Perhaps in opposition to the shock tactics employed in the farmers' protest (and maybe even to the practice of sensationalism that has become the mainstream in contemporary art), Orta prepared an event that was low-key but profoundly allusive and efficient. She chose as a site for her work a familiar location, fitting to her scenario: the old marketplace of Les Halles in Paris. Once a week over a period of six months, Orta went to this market with a team of volunteers in order to collect fruit and vegetables that would otherwise have been discarded. This produce was brought to new life by being transformed into syrups, jams and preserves, stored in labelled and dated jars. These events were photographed and filmed on video, and customers of Les Halles were interviewed.

Each of these interviews tells us something important about our society, highlighting the diverse relationships that different people have with food. One woman declares: 'A full basket is enough for me for one week; if I took more it would only go to waste', while a homeless person reveals

a disturbing reality: 'Salvaging fruit, that's for rich people. You need a fridge to keep it in and an oven to cook it in.' Each of us must at some time in our lives have seen someone collecting food amongst the wooden crates and cardboard boxes left by vendors at the end of the market day, but we have probably never thought of such people as rich or privileged.

All in One Basket was presented as an exhibition,[16] where the video and sound recordings were incorporated, and where Orta showed a series of the jars of preserves, which thus become part of the ritual. The sale of the preserves was a way for the project to pay for itself, but more importantly to offer a symbolic synthesis: in the process of producing these small jars, preserving, valuing and redistributing something that had previously considered waste, the thought that went into this work was also collected. As another component of the work, an outdoor buffet was organized at Les Halles market, for which the famous Viennese chef, Stoher, created elegant dishes made from all the leftovers collected and recycled during the six months of work.

This intervention, like many of Orta's other works, has its roots in the political artworks of the 1970s and 1980s, but it distances itself from these by refusing to travel roads already taken and, above all, in its resistance to any attempt to affirm some fixed truth. Instead it allows for public participation, provoking discussion and bringing to light issues without aiming to resolve them.[17] Orta's interventions are not closed, determined or paradigmatic, but instead attempt to stand up to future reflection on and analysis of the reality

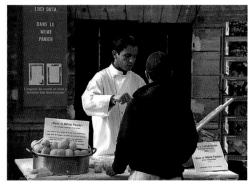

that surrounds us.

A few years after the Parisian happening, a similar work *Hortirecycling Enterprise - Act II* (1999), was created at Secession, Vienna. Objects were produced for the project (*Conservation Unit*, *Reliquaries*, *Stirer,* etc.), and on this occasion the work was also presented more formally in the gallery in through the exhibiting of bags, containers and the mobile *Processing Units*. These *Processing Units* – a cooking surface with a refrigerator and storage underneath – were not only a functional structure but a symbol for the transformation and use of food. The investigation was created through the 'Ortian' procedure of discussing and investigating every aspect with the gallery staff, as well as '*visiting and discussing issues of the enterprise with the Naschmarkt vendors, contacting a renowned Viennese chef, Staud, who composed the recipes for the rejected fruit preserves.*'[18]

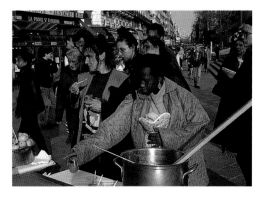

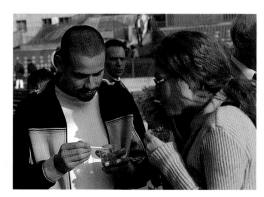

All in One Basket - Les Halles
1997
Action, Les Halles, Paris

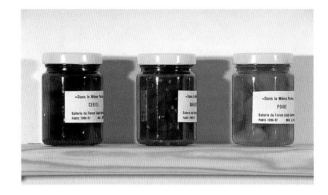

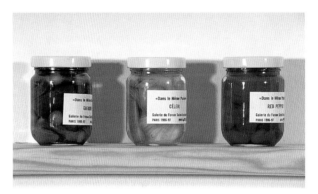

left, **All in One Basket - Les Halles, Conservation Unit**
1997
Salvaged fruit crate, laminated Cibachrome, iron trolley, amplifiers, hi-fi, Walkman
280 × 80 × 48 cm
Collection, Caisse des déports et consignation, Paris

above, **All in One Basket - Les Halles, Reliquary Jars**
1997
Wooden shelf, 28 labelled and signed jam jars
240 × 10 × 10 cm
Collection, Caisse des déports et consignation, Paris

**Hortirecycling Enterprise - Act
II, Processing Unit**
1999
Iron structure, wheels, sink, jam
jars, laminated C-print, vinyl
adhesives, shopping caddie
120 × 270 × 65 cm
Installation, Secession, Vienna

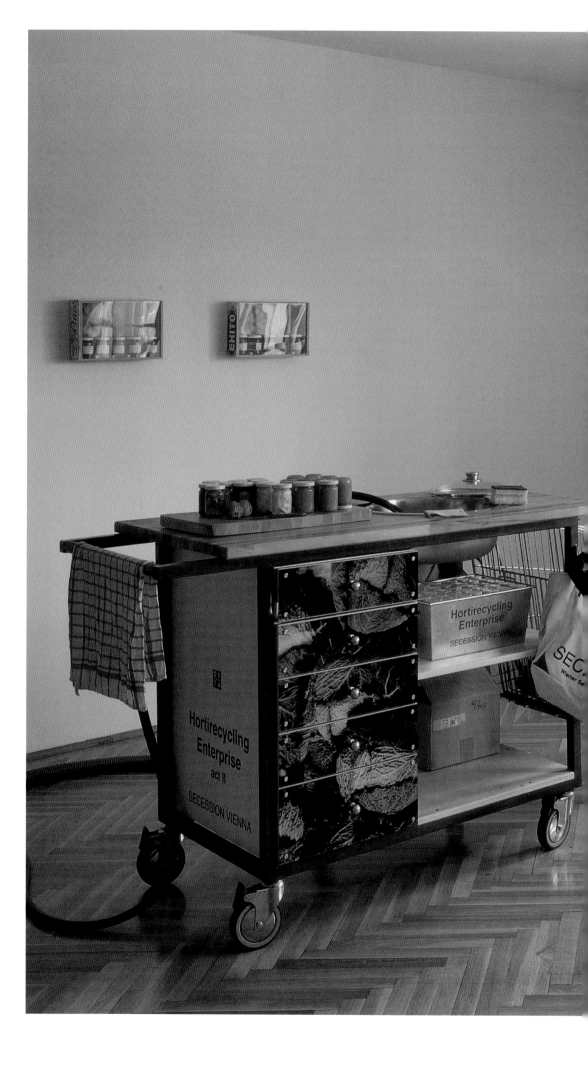

Hortirecycling Enterprise, Act II
1999
Action, Naschmarkt, Vienna

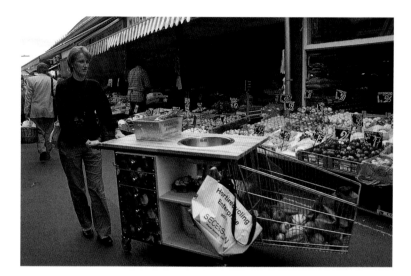 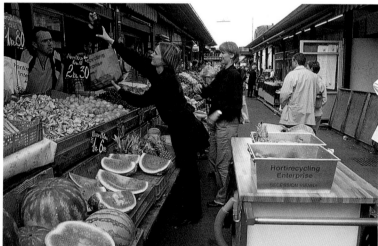

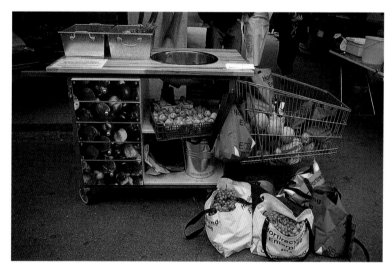

70 x 7 The Meal

As we have seen, it is not only the phenomenon of the waste and recovery of food that is important for Orta, but the emblematic, collective liturgy connected with its consumption. *70 x 7 The Meal* was a series of lunches organized by Lucy and Jorge in which this ritual component was under-lined in various ways, from the use of the number seven, chosen as the amount of initial invitees, to the production of the tablecloths and plates, to the choice of colours and the arrangement of people and objects. Even the mechanism of involvement by proxy – the artist's invented formula whereby they invited seven people who, in turn, invited another seven – becomes a new way of inventing a ritual that can extend, practically without control, the diversity of people invited. Once again, a human chain of knowledge and contacts is formed. In the exemplary work *70 x 7 The Meal, Act IV Dieuze*, nearly the entire population of Dieuze, a tiny French town of roughly 2,000 people, sat down at a 300 metre-long table to share the same meal. This event, the seeming antithesis of intimacy, symbolically took on the role of the public square or street.

It is evident how important food is as a cultural vehicle for reciprocal understanding. The act of eating together brings about a physical sharing, a spontaneous and free socialization. These aspects have been highlighted over the last few decades by other artists (Rirkrit Tiravanija's invitation to gallery visitors to share a Thai curry, for example, or Felix Gonzalez-Torres' endlessly replenishable piles of sweets), but in *70 x 7 The Meal* they are more ordered and ritualized.

In an analogous way to the choice of fabrics, forms and colours for works like *Refuge Wear* and *Nexus Architecture*, in this piece the design particulars of the objects are important. Plates become containers with content; tablecloths become surfaces to paint, 'tattoo' and utilize symbolically. As Orta herself has put it: '*[T]he aesthetic content is very important to all my work. Take for example the Royal Limoges dinner service in a small rural town in the north of France. There were complaints from local associations that we were wasting money on the china. "Why not use paper plates?" I am particularly sensitive to offering an original design and quality to all people and it was clear that the Limoges signature and their comments on the graphics enamelled on the plates were an important part of the whole event.*'[19]

The Environment Again: Mobile Intervention Units

In 2001, participating in the show 'Transforms' in Trieste,[20] Orta proposed *Vehiconnector (M.I.U.)*, an installation in which she transformed old military field ambulances into civilian survival units, decorating them with images representing themes connected with survival. On one side of the vehicle were images of mad cows and recycling, on the other images of the plight of Rwandan refugees and the lack of drinking water. In a similar way to her fabrics, the external surfaces of these vehicles (which by their very nature force us to think of situations of emergency and danger) become public spaces for the posing of questions. The two *Vehiconnectors* installed in Piazza Unità d'Italia (Trieste's main square) acquired a

M.I.U. I
2002
Reconditioned military Red Cross
ambulance, adhesive digital
photograph, adhesive lettering
260 × 490 × 200 cm

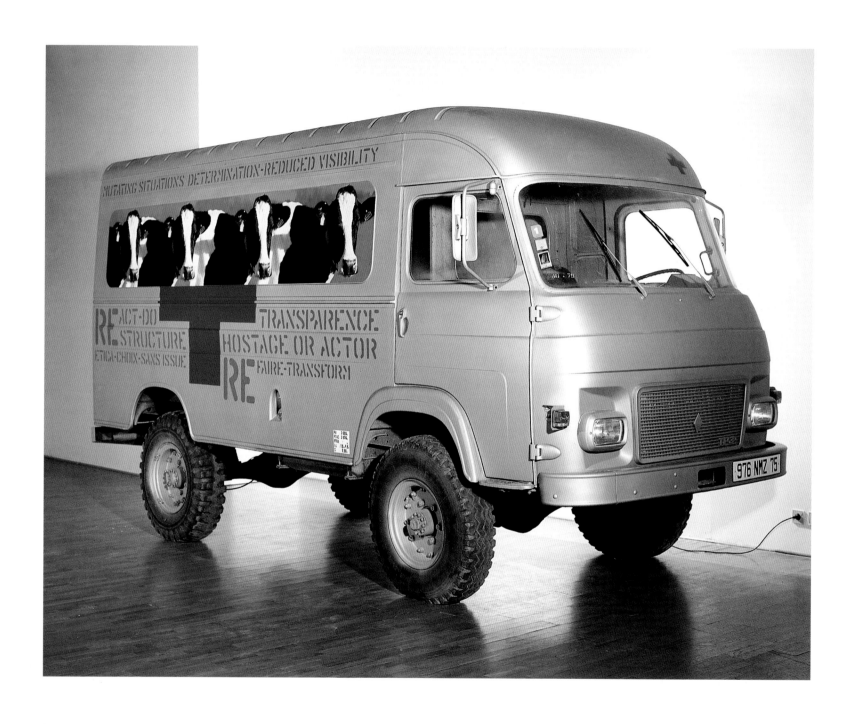

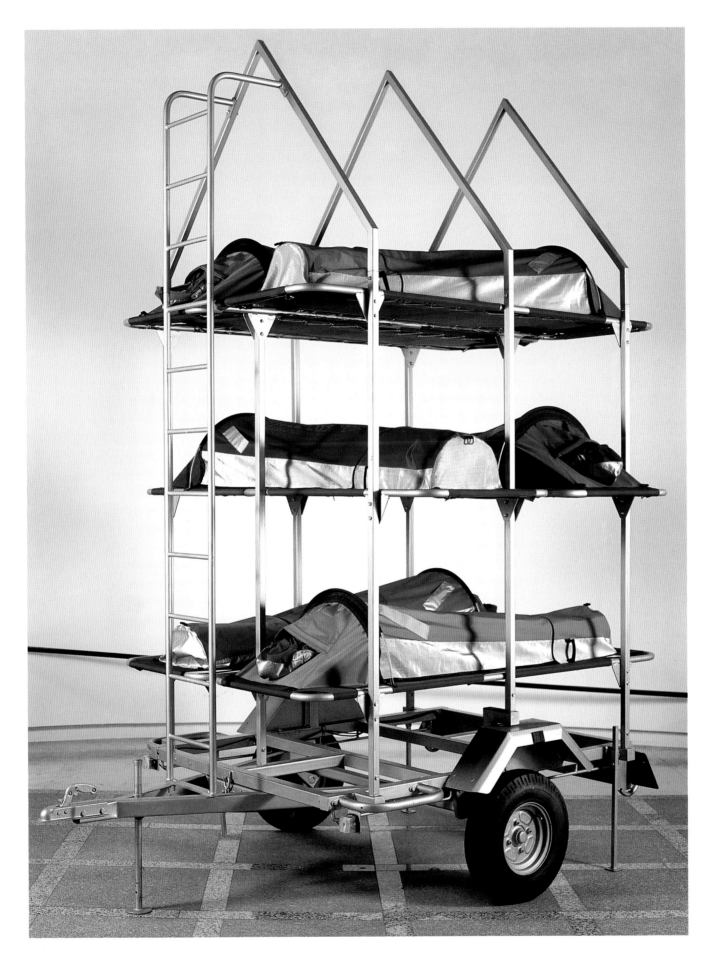

left, **M.I.U. VI**
2002
Trailer, 10 campbeds, Kevlar,
diverse fabrics, silkscreen print,
telescopic aluminium structure,
number plates
400 × 250 × 200 cm

following pages, **Connector
Mobile Village + M.I.U.**
2001
Reconditioned military Red Cross
ambulance, military trailer,
Connector Mobile Village I
260 × 860 × 260 cm
Installation, Westfälisches
Landesmuseum für Kunst und
Kulturgeschichte, Munster

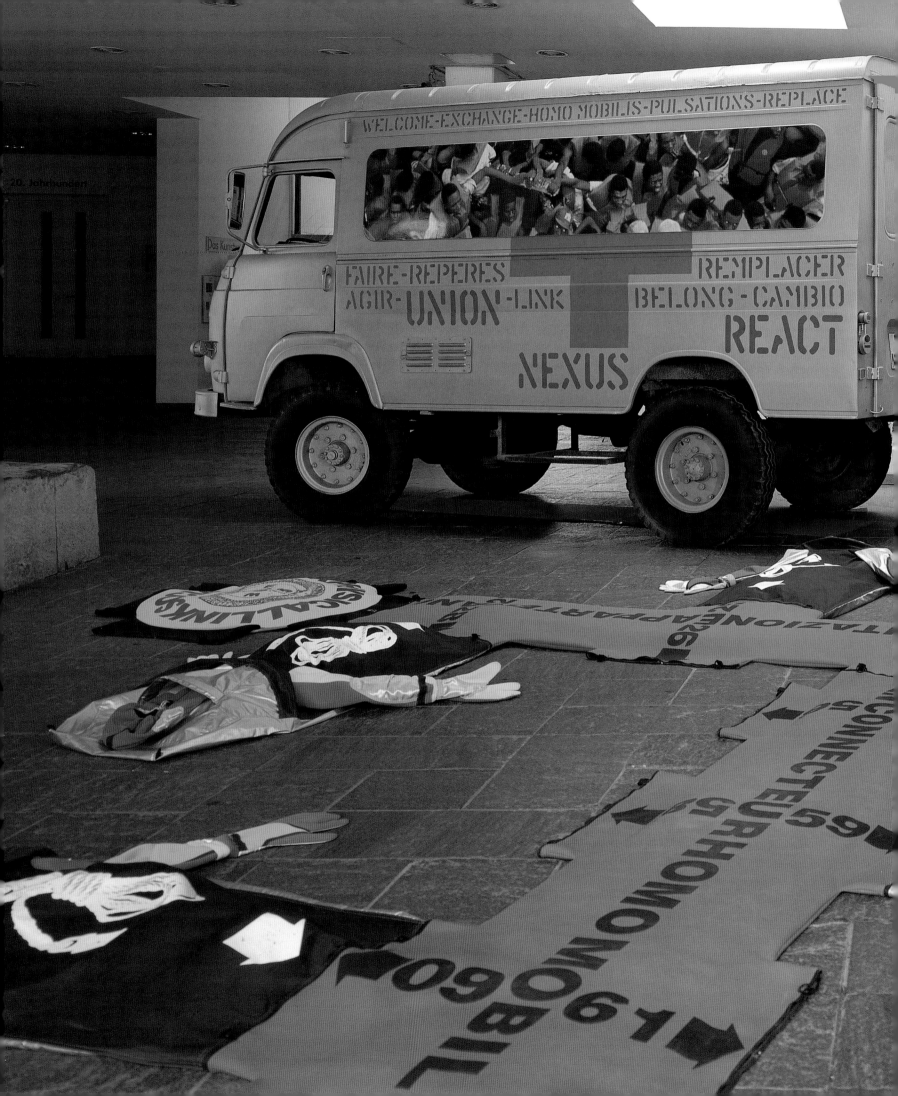

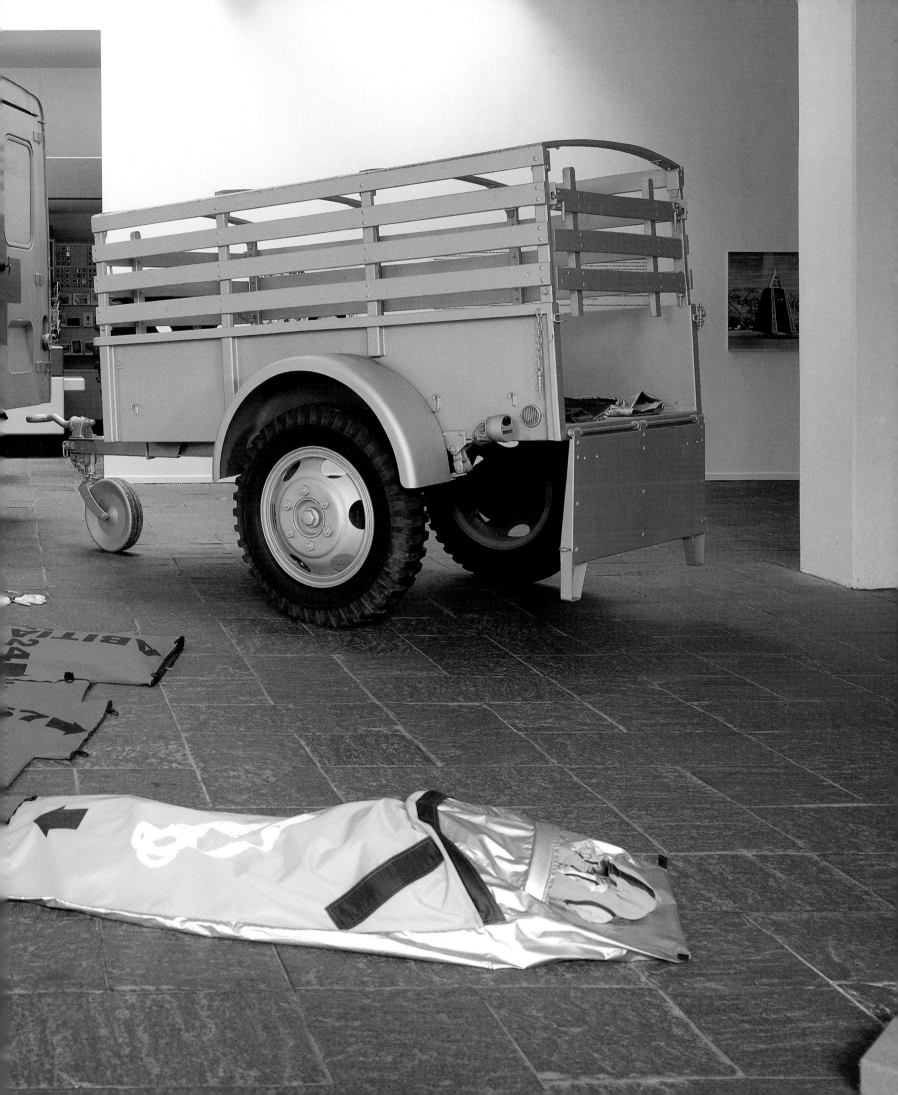

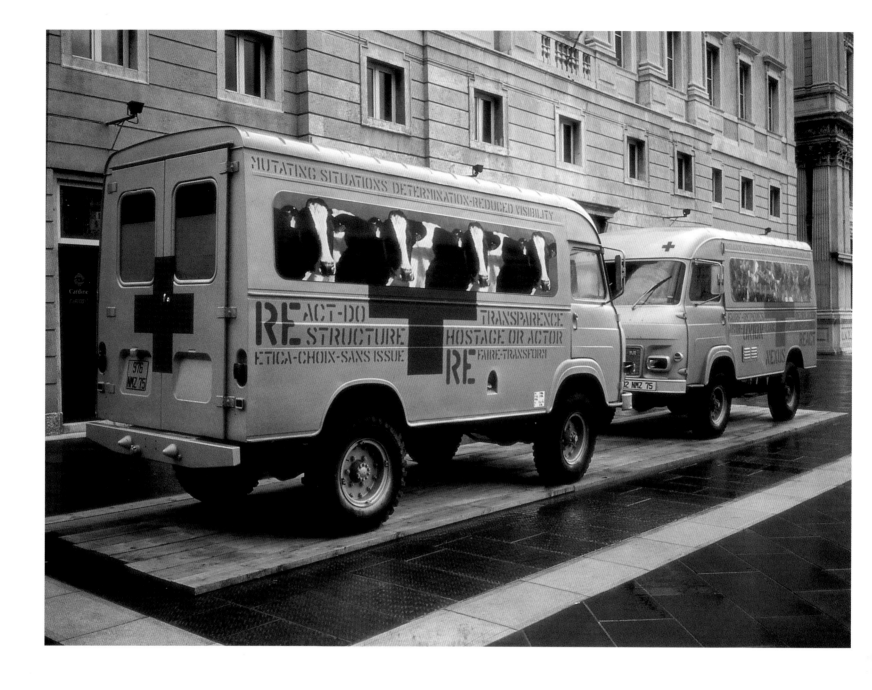

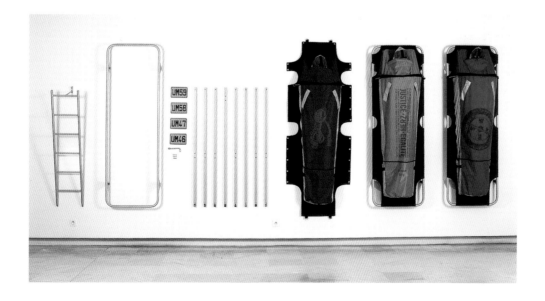

above, **M.I.U. I + II, G8**
Environment Summit Trieste
2001
Reconditioned military Red Cross
ambulances, adhesive digital
photograph, adhesive lettering,
wooden plinth
260 × 250 × 1200 cm
Installation, 'Transforms', Trieste

left, **M.I.U. VI - Kit**
2002
Trailer, 10 campbeds, ladder,
Kevlar, diverse fabrics, silkscreen
print, telescopic aluminium
structure, number plates
Dimensions variable

particular significance because the show was organized to coincide with an important public event: the G8 Summit dedicated to the environment. Parked right in front of the hotel where the ministers of the world's 'big eight' were staying, the two *Vehiconnectors* offered themselves as monuments to the problems to be dealt with.[21]

Orta's use of public space in this context encourages us to reflect on the way in which the concept of the monument came into being, whether images can represent a local community's shared values, and on which images will have impact when symbolically placed in the middle of a town square. In this instance, the topicality of the event may have distracted somewhat from this issue, but it did not deprive of significance the fact that Orta's proposal placed itself squarely in contrast to the celebrative tradition of the monument, which normally praises power and authority in general. Her work is bound to the opposite concept: usable, transformable, non-assertive, but simultaneously emotional and interrogative.

This event can be seen as another strand in the investigation of the environmental problem, expressed in many works – most notably in *All in One Basket*. *Commune Communicate* (1996) an urban happening created in Metz, France,[22] can be read from a similar perspective. Here Orta organized a workshop with a group of prisoners in the Metz jail that dealt with their daily life, and problems. She then passed messages collected during the workshop to the inhabitants of Metz. At the same time passers-by were encouraged to write messages to the prisoners on postcards created specially for the project. Public Space was used in

these works to establish a dialogue on diverse levels: between people and political leaders during the G8 summit, between jailed and free people, and between inside and outside.

In *Citizen Platform* (1997) at the Parc de la Villette in Paris, another dialogue was established, this time between citizens and figures of authority where, by way of postcards, the three 'R's of environmentally friendly development were supported: 'Reduce, Re-Use and Recycle'.

Our eyes have become accustomed to the alarming data broadcast by the many organizations that deal with environmental problems, and this myopia keeps us in a state of semi-indifference that prevents change. Orta's works cause us to reflect on how rarely environmental damage inflicted by our actions is taken into consideration, and how the environmental cost of the things we buy is seldom considered. A perfect example can be seen in the global attitude to energy: only the costs of its production and distribution are taken into consideration, never the additional environmental costs. According to this logic, products made of carbon are cheaper than solar products, even if the collective costs – the greenhouse effect, the melting of the polar caps and diseases like cancer – are extremely high.[23]

All Orta's works have a foundation in these problematics, even if at times they are only hinted at. The processes are consistently laid open for discussion, though she may not always take up a specific position 'against'. Her works are poetic and aesthetic responses to the emergencies that our society is facing with diverse gradations of complicity.

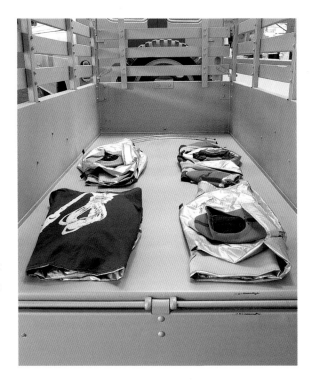

M.I.U. III (detail)
2001
Military trailer, tarpaulin,
Connector Units
180 × 180 × 370 cm

top three rows, **Collective Dwelling Workshop - Thiers**
1991–98
bottom left, **Collective Dwelling Workshop - Lower East Side New York**
1991–98
bottom right, **Collective Dwelling Workshop - Sydney Australia**
1991–98

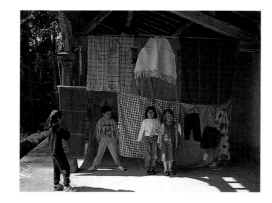

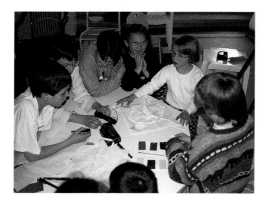

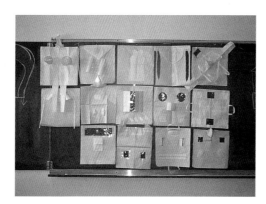

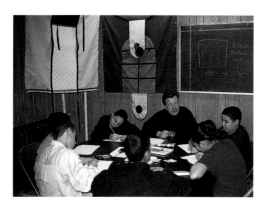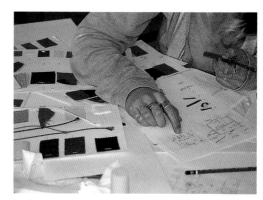

Workshop and More ...

When one writes about the work of an artist, one is often inclined to imagine what its future development might be, underlining the aspect that currently seems to be the central issue. Unfortunately, in doing so one risks re-reading the text later only to find that the artist's work has developed in a completely different way. It seems obvious, however, that in the past few years Orta's work has been more and more dedicated, even in the planning phase, to collaboration. Both the greater role of the workshop and the habit of increasingly attributing the work to Studio Orta seems sufficient evidence of this constant tension. These two aspects are therefore worth addressing.

The works flowing out of the many workshops that Orta has created around the world are so interwoven with that already discussed that it is difficult to separate them. That said, at least some of them should be mentioned specifically, in so much as their procedure and results become in some way paradigmatic and can be considered autonomous projects.

The workshop organized for the Salvation Army in Paris (*Identity + Refuge*, 1993) and replicated in New York (1996) as part of the group exhibition 'Shopping' at Deitch Projects was exemplary in its premise and results. Orta asked visitors at the Cité de Refuge de L'Armée du Salut (the Salvation Army hostel, which is housed in a building constructed by Le Corbusier in the 13th Arrondissement) to make garments out of old clothes and accessories like gloves, belts, ties, zips, etc. in order to twist their 'conventional' use towards a new function and identity. One of the

work's conceptual nuclei was the reappropriation of the identity of people who are marginalized, without history and have no possibility of being integrated into the community. There was affirmation of identity even in the choice to construct garments, rather than simply accepting donated clothing.[24] This workshop aimed to give back visibility and, consequently, individuality to this group of marginalized people.

Some fashion designers even put themselves to work reassembling and regenerating the clothing, combining garments of different types and functions. Others used an apparently 'homeless' style. The main objective of the work, which was curious enough to attract the attention of the public and the media, was, however, to research the situation it explored. Otherwise it would have revolved around the packaging of a 'sellable' product that neglected, or left unexplored, the social fallout of the project, a vision diametrically opposed to Orta's.

Another important series of workshops is *Collective Dwelling*, created for the first time at the contemporary art centre, Creux de l'Enfer in Thiers, France, during the show 'Touch pour Voir' (1997), which focused on audience collaboration. This piece involved the participation of teenagers from the Arc-en-Ciel foster home and the Sonia Delaunay high school. With these children Orta attempted to investigate the idea of the body as a shared and mobile space. They also addressed the axioms of works like *Refuge Wear* and *Collective Wear*, which were discussed through the vision of the adolescents, who were asked to create a modular section of the work.

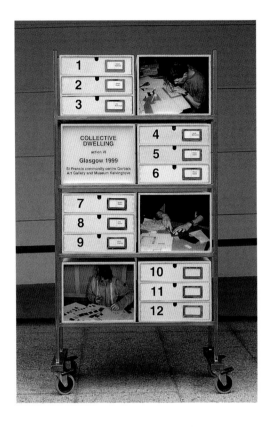

above, **Data Drawer**
1999
Iron structure, wheels, wood, laminated photographs, labels, documents
180 × 90 × 50 cm

following pages,
Collective Dwelling Cicignon
2003
Aluminium-coated polyester, various textiles, telescopic aluminium armatures
160 × 240 × 240 cm each

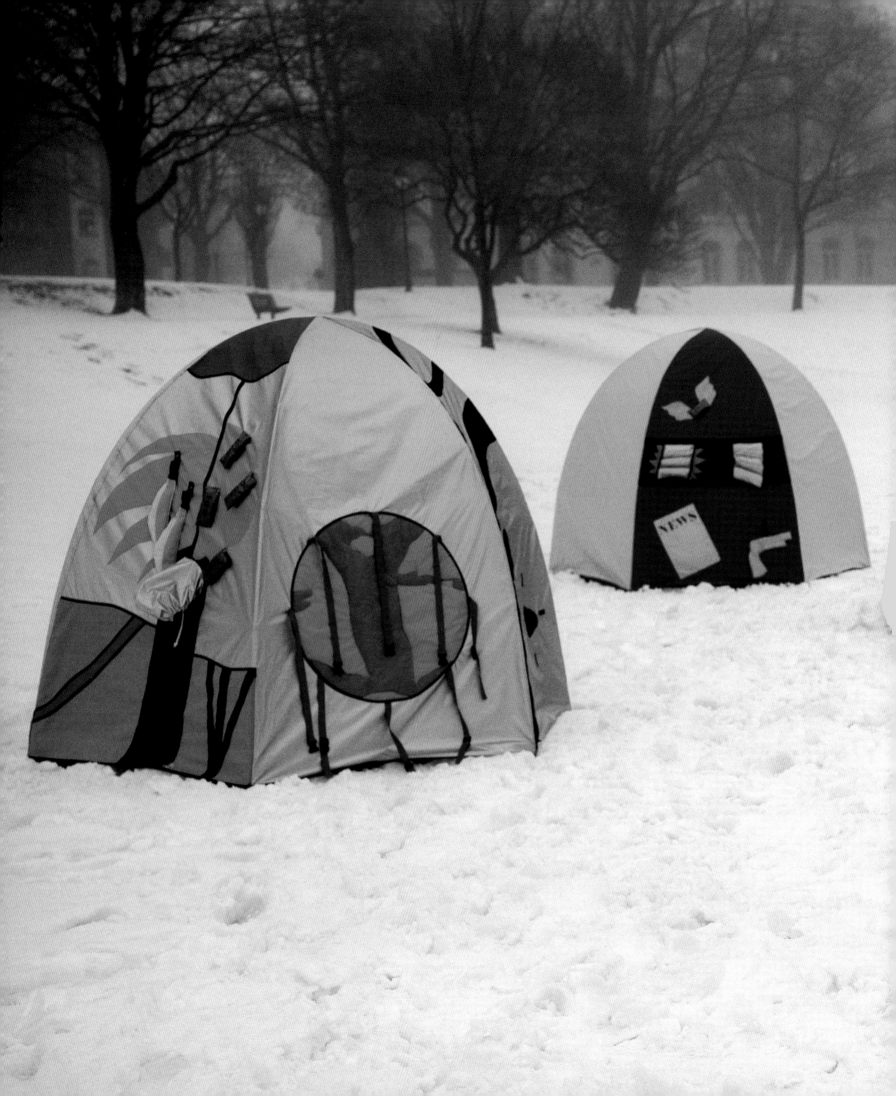

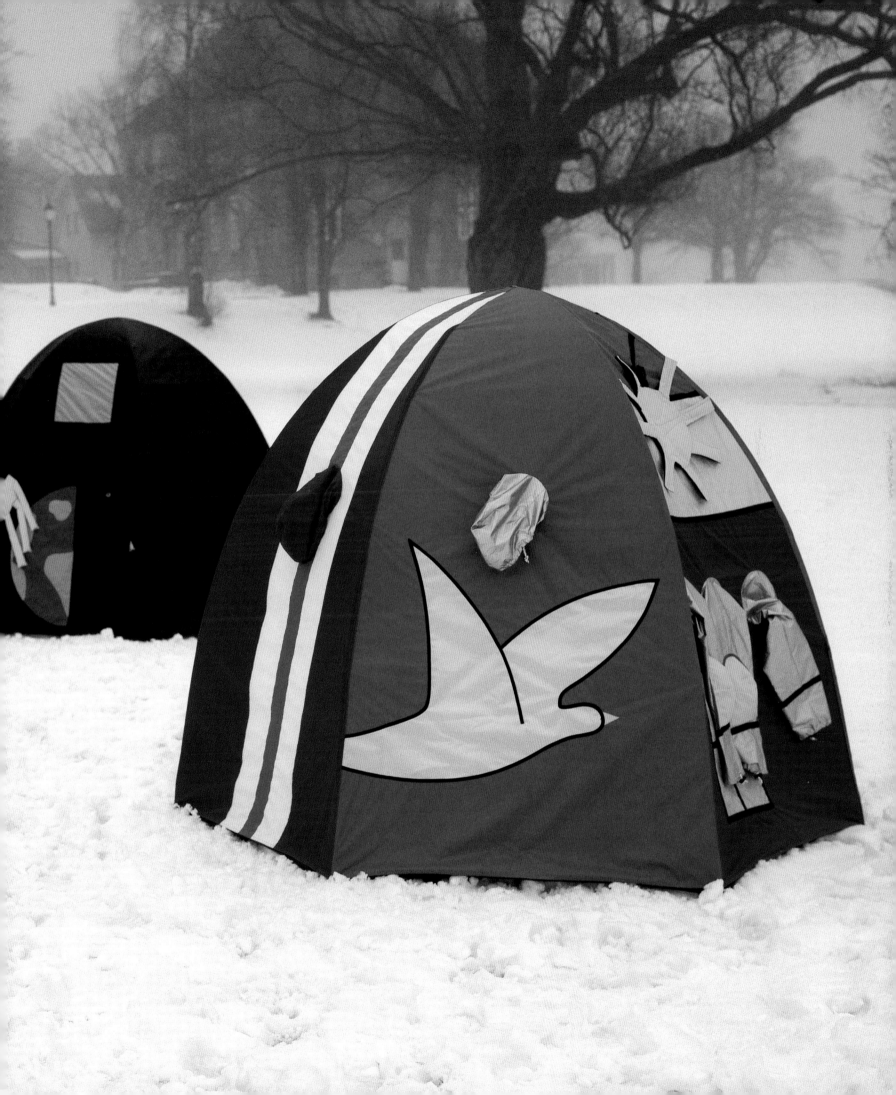

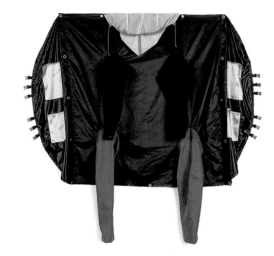

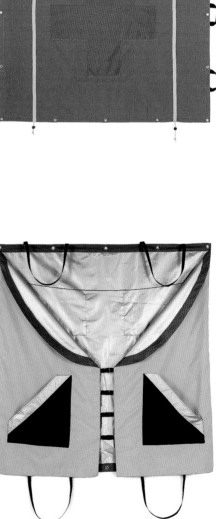

l. to r., top to bottom,

**Collective Dwelling Module
Lower East Side**
1998
Diverse technical textiles, eyelets
120 × 120 cm

**Collective Dwelling Module
Gorbals**
1999
Diverse technical textiles, eyelets
120 × 120 cm

**Collective Dwelling Module
Gorbals**
1999
Diverse technical textiles, eyelets
120 × 120 cm

**Collective Dwelling Module
Lower East Side**
1998
Diverse technical textiles, eyelets
120 × 120 cm

**Collective Dwelling Module
Gorbals**
1999
Diverse technical textiles, eyelets
120 × 120 cm

**Collective Dwelling Module
Gorbals**
1999
Diverse technical textiles, eyelets
120 × 120 cm

**Collective Dwelling Module
Thiers**
1997–98
Diverse technical textiles, eyelets
120 × 120 cm

**Collective Dwelling Module
Gorbals**
1999
Diverse technical textiles, eyelets
120 × 120 cm

**Collective Dwelling Module
Thiers**
1997–98
Diverse technical textiles, eyelets
120 × 120 cm

**Collective Dwelling Module
Thiers**
1997–98
Diverse technical textiles, eyelets
120 × 120 cm

**Collective Dwelling Module
Gorbals**
1999
Diverse technical textiles, eyelets
120 × 120 cm

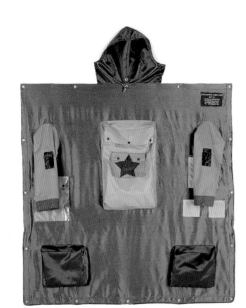

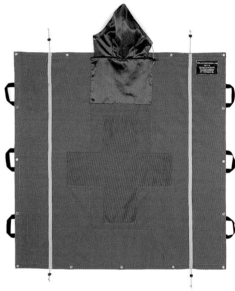

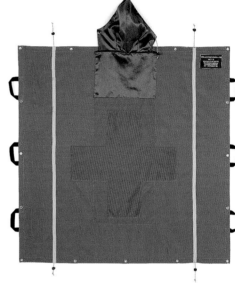

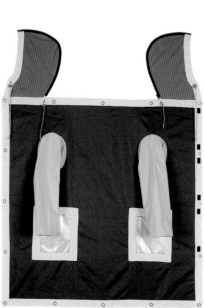

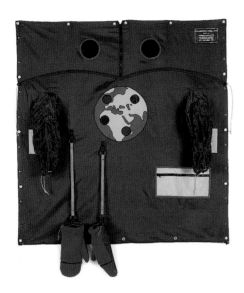

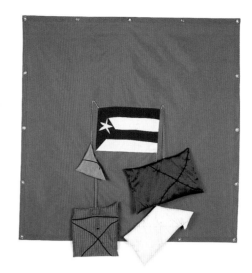

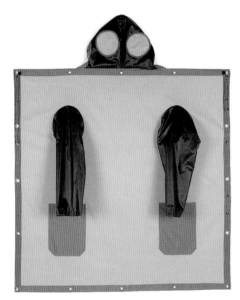

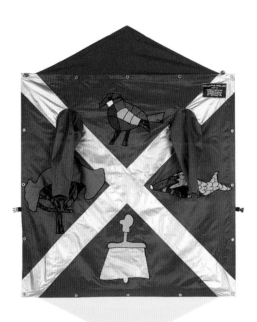

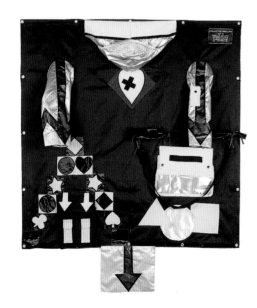

Urban Life Guard Ambulatory
Sleeping Linen
2001
Folding campbed structure, linen,
aluminium-coated polyamide,
Kevlar, PVC, various fabrics, zips,
silkscreen print
195 × 70 × 65 cm each

The element that runs through all these works is the nature of the artistic project, no longer seen as the inspiration of the solitary genius, but as the product of a collective intelligence,[25] in which the participants – Deleuze would call them 'intercedents'[26] – are the co-authors. Pierre Restany speaks of an 'aesthetic relationale' and – although Orta has never worked with Nicolas Bourriaud, who originally coined the term[27] – this vision lends itself perfectly to her credo.

At this point it is permissible to wonder what remains of the artist in a workshop or studio situation. The answer is, a good deal. The artist's role is in configuring a new road in order to interpret an ancient role, whereby he or she becomes a true motor, a generator of initiatives, a stimulator of creative energies and analyses of problems; a sort of director who puts in gear situations that do not limit themselves to speaking an artistic language or to reflecting on the beauty of the image created. This is Orta's role within Studio Orta, in which the other important figure is Jorge Orta, with whom she is developing a series of works in progress. The first of these is *Opéra.tion Life Nexus*, which came about following an idea conceived by Jorge Orta in 1996 for a work that will grow and evolve until 2006 in an attempt to build a territory of experimentation and research, a common space for workers of diverse disciplines. The artists involved are invited to create a module, around the theme of 'giving', over a period of ten years, composed of music, dance, sculpture, lights, video projections or any other medium deemed useful to continue the project. *Opéra.tion Life Nexus* shares the methods

and underlying philosophy of previous works, and Studio Orta models itself on the same projects. Orta herself defines the enterprise as a 'spiral' that retracts or expands according to the importance and complexity of the project. The studio in Paris is a centre for production but, above all, for co-ordinating the activities of numerous categories of people (architects, craftsmen, fashion designers) who all dedicate themselves to research of data or to the co-ordination of activities.

When Studio Orta's pieces return from exhibitions, they go to a final collection point, The Dairy, La Laiterie Moderne, a rare example of the regional industrial heritage located in Brie, 60 kilometres from Paris. This immense workshop with beamed ceilings, vaulted brickwork and typical Briard-style outhouses is the centre for a new episode. Rooted firmly in the belief that the creative disciplines should debate and rethink the traditional principles of social structures, introduce new ideas that have a profound engagement with society, urban planning, cultural heritage and political and ecological policies. The Dairy is to be host to an unfolding series of residences and collaborations that can be viewed online at fluidarchitecture.net. It is here, fittingly, that our trip comes to an end, to take off later for some other part of the world. These newly created works are held here in the hope that eventually they too will act as 'interceders' for the works and reflections of others.

Translated by Shannon Pultz

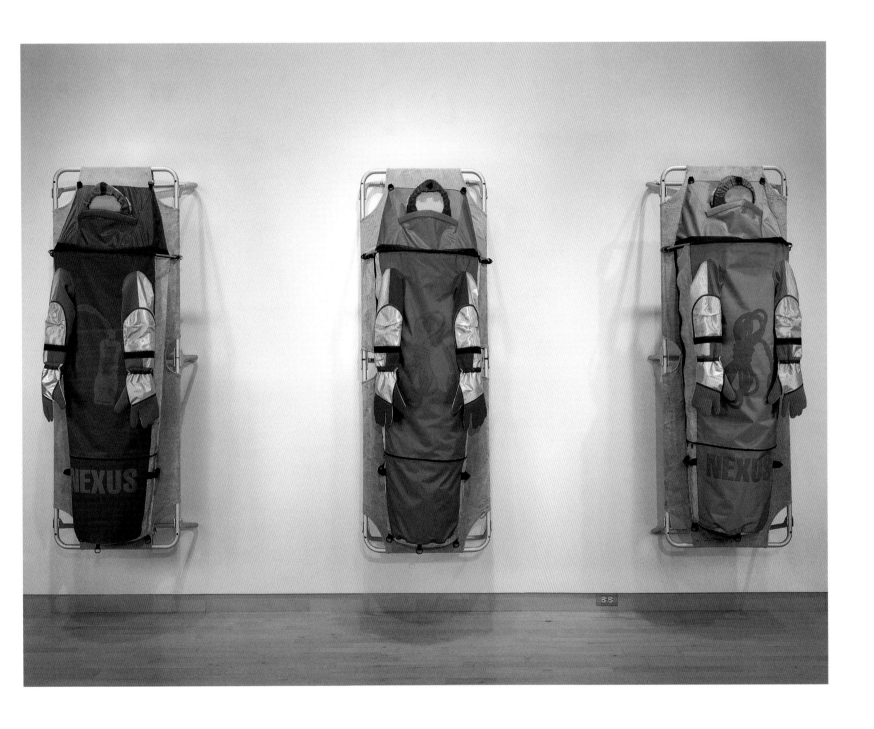

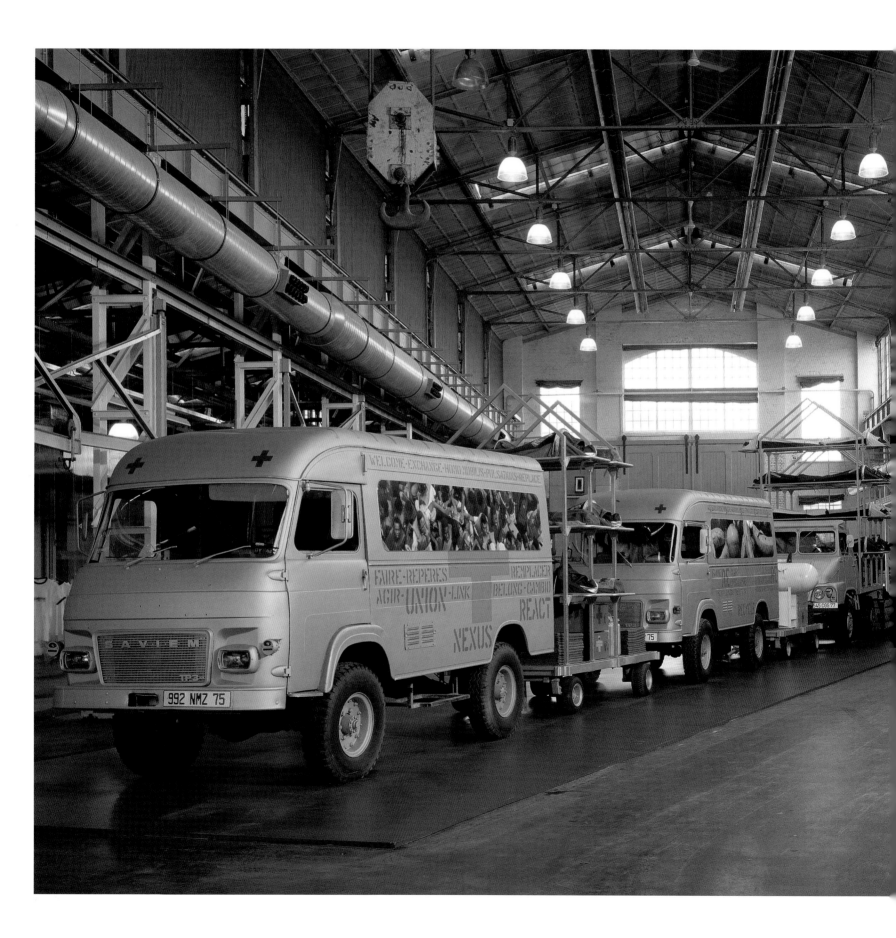

Mobile Intervention Convoy,
Units I−IX (with Jorge Orta)
2003
Various reconfigured military
vehicles, steel structure, camp
beds, various surplus military and
navy objects, vinyl adhesives,
sleeping linens, diverse technical
textiles, woollen blankets, ladder
500 x 2800 x 500 cm
Installation, 'Kaap Helder', Den
Helder, The Netherlands

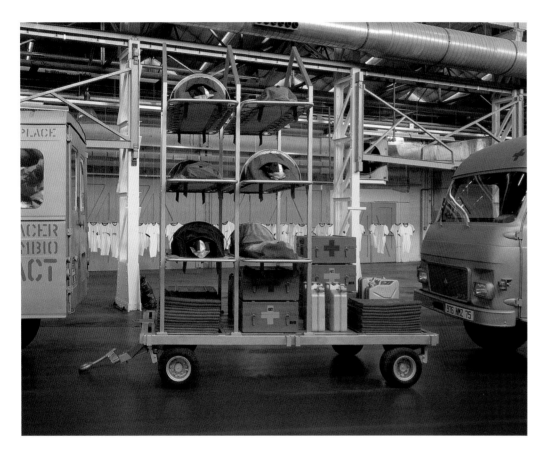

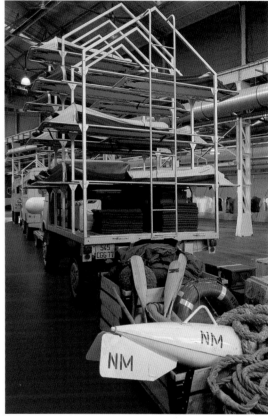

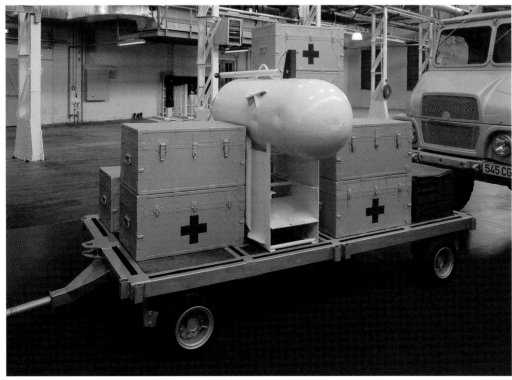

1 Translated from Orta's original French: *Les séjours prolongés sans abris dégradent rapidement la santé physique et morale. Le temps de sommeil insuffisant majore le stress, affaiblit les défenses immunitaires et accélère la perte d'identité et la désocialisation.*

2 But also the idea of habit: 'The first piece I made was named *Habitent*: a portable habitat that provides minimum personal confort and mobility for nomadic populations. The habit, a monk's gown, implies a kind of uniform for meditation and spiritual refuge; "inhabitant" implies a human presence as an occupant for dwelling.' Transcription of Lucy Orta's lecture published in *La Generazione delle immagini 7,* curated by Roberto Pinto *Tales of Identity*, Edizioni Comune di Milano, Milan, 2002, pp.136–67.

3 Lucy Orta, interviewed by Valérie Guillaume, *Art Press*, special issue, Paris, October 1997

4 See Andrew Bolton, interview with Lucy Orta, *The Supermodern Wardrobe*, V&A Publications, London, 2002, p.133: 'In the early 1990s, I was completely disillusioned with fashion and its blatant consumerism. As a result, I installed *Refuge Wear* under the Louvre Pyramid during Paris Fashion Week. I chose the Vivienne Westwood show, not only because she is a true innovator, but also because she was connected to the experimental art scene of the 1970s. Since then, a new generation of designers has emerged and I now enjoy working within the fashion system. I try to question fashion, to go beyond fashion – not its functional aspects but its social and poetic aspects.'

5 It would be worthwhile to conduct a specific study on the effect that Orta's work has had on the fashion world – always hungry for stylistic and innovative ideas – especially in the field of sportswear.

6 Andrew Bolton, op. cit., p. 133

7 Ibid., p. 133

8 Numerous sociological texts on this subject that have been published over the last few years, an example being Zygmunt Bauman's *The Individualized Society*, Politi Press, Cambridge, 2001, where he writes: 'The new global power structure is governed by the contrast between the notion of mobility and the notion of stasis, contingency and routine, rarity and density of conditionings. It is as if the long historic period begun with the triumph of the notion of resting in one place over the nomadic is reaching a conclusion. Globalization can be defined in many ways, but the concept of the "vendetta of the nomads" is rather good if not better than others.' (p. 49).

9 A concept explained by Paul Virilio in 'Urban Armour', *Lucy Orta Refuge Wear*, Editions Jean Michel Place, Paris, 1996, Chapter F, p. 2–6: 'The survival of most animals depends on running with the pack. The concept of the pack is linked to animal nature. Lucy's collective wear represents a denunciation of man's return to the pack. At a time when we are told that men are free, emancipated, totally autonomous, she tells us that, on the contrary, there is a threat and that man is regrouping. We refer to this new phenomenon in terms of gangs, new tribes, commandos.'

10 'There is a prophetic dimension in her work. The realistic aspect is less important than the prophetic aspect', Paul Virilio, op. cit., Chapter F, p. 4–6

11 Studio Orta has recently created a website – www.fluidarchitecture.net – not only as an information source but also as a further conceptual development of the intervention process. Besides videos and images of work under construction, it presents texts and transcripts of conferences as well as testimonials and forums on the problematics raised by Orta's work and workshops.

12 Since there was no Argentinian Pavilion, they made interventions in the city itself. Jorge Orta's work, *Luminographic light Projections*, could be viewed at night, while Lucy Orta's *Nexus Architecture x 16* was conducted by day in the squares and bridges of Venice.

13 In *Lucy Orta, Process of Transformation*, Editions Jean Michel Place Paris, 1998, p. 37, Jen Budney writes, 'In a city as devastated by poverty and crime as Johannesburg, this giant, indoor art exhibition based on ideas of multi-culturalism and post-colonialism, but marketed mainly to a (white) suburban middle-class, failed to draw the interest of any local community. Orta's

project brought questions of class into the Biennale as no other work did, asking: for whom is art, who does it represent, to whom does it speak and which audience does it benefit? Are there any more relevant projects for the communities of Johannesburg right now?'

14 Created for the first time for the public art show 'In the Midst of Things', Bournville Village Green, Birmingham, UK, 1999.

15 Lucy Orta, 'Life Nexus Village Fête', artist's statement, 1999.

16 Curated by Jérôme Sans for Forum Saint-Eustache, Paris, 1997.

17 Concerning the differences between Orta's work and other activist art, the critic Jen Budney writes: 'Orta's approach is entirely different, in that within each project she undertakes she makes direct contact with others and does her best to leave behind new, permanent infrastructures such as recycling programmes, creative, paid work, projects for the unemployed or a curriculum for schools. While governmental and charitable institutions continue to devote themselves to cost-efficiency and 'turn-around', her projects emphasize patience and close attention to detail whilst working with people from all sectors of society.' In *Lucy Orta – Secession*, Vienna, 1999.

18 Orta interviewed by Hou Hanru, in *Lucy Orta,* Secession, Vienna, 1999.

19 Lucy Orta, *Tales of Identity*, op. cit., pp. 136–67.

20 *Transform*, exhibition catalogue, Emanuela De Cecco and Roberto Pinto (eds), CONAI, Milan, 2001.

21 They were the only vehicles in the city centre. Due to tight security, cars and any other removable objects were prohibited.

22 Created thanks to the FRAC de Lorraine, Metz, France and to the Casino Luxembourg, which planned a series of 'Public Art Interventions'.

23 Numerous books deal with the environmental problem tied to both direct and indirect economic costs, an example being Lester R. Brown's *Eco-economy: Building an Economy for the Earth*, Earth Policy Institute, Washington, DC, 2001.

24 To honour this condition of marginalization and lack of society, Orta shifted the initial objective of making one's own clothing to a more generic construction of clothing for the homeless who partcipated in the workshop due to the discomfort they experienced when thinking on a personal level about the clothes they wore. It is interesting that the participants in the workshop were exclusively male, which underlines the fact that there are different levels of homeless and marginalized experience, and groups of people with whom it is more difficult to make contact.

25 See Pierre Lévy, *L'intelligenza Collettiva. Antologia del Cyberspazio*, La Découverte, Paris, 1994.

26 Gilles Deleuze, 'Gli intercessori', *L'Autre Journal*, No. 8, October 1985, conversation with Antoine Dulaure and Claire Parnet: 'That which is essential are the intercedents. Creation is intercedents. Without them there is no work. It can refer to people – for a philosopher, artists or scientists, for a scientist, philosophers or artists – but even to plants, animals, as in Castaneda. Fictitious or real, animate or inanimate, their own intercedents need to be fabricated. It is a series. If a series is not formed, even completely imaginary, it is lost. I need my intercedents in order to express myself, and they cannot be expressed without me: you always work in many even when it doesn't seem to be so. It is even greater when it is visible: Felix Guattari and I are intercedents for one another.'

27 In *Relational Aesthetics*, edited and translated into English by Les Presses du Reél, Dijon, 2002.

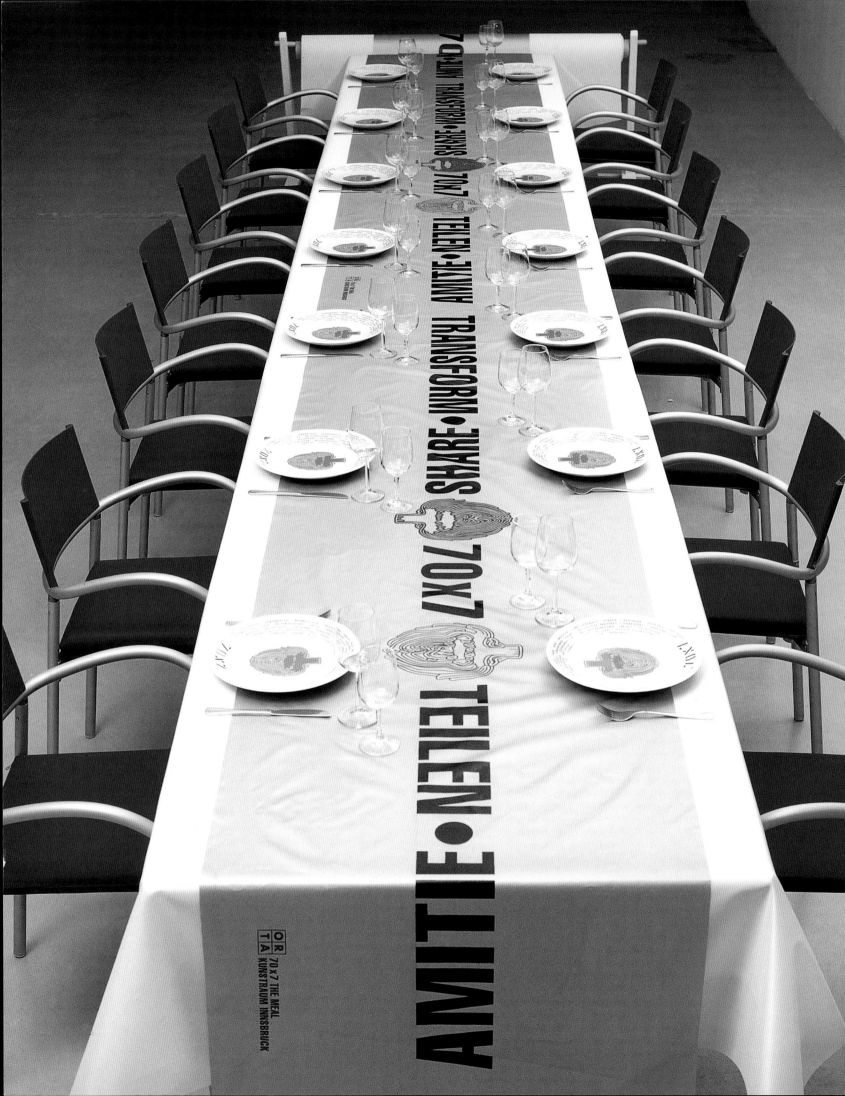

Contents

Lucy Orta's *70 x 7 The Meal* takes as its starting point a multiplication game designed to stimulate conviviality and communication, with the Christian signification of 'infinity'[1] as its impetus. The work sets up encounters between multiples of seven guests at a potentially endless series of meals. The series *70 x 7 The Meal,* which begins at Act III, evolved out of two earlier projects. Act I is *Dans le même panier (All in One Basket)* (1997), in which waste produce from local markets was collected and transformed into syrups, jams and preserves, and Act II is *Hortirecycling Enterprise* (1999), a similar project in which Orta proposed a system for recycling food using mobile kitchens created specifically for the project. For each meal in the *70 x 7 The Meal* series the artist designs a limited edition of Royal Limoges porcelain plates, and a so-called endless silkscreen-printed tablecloth. Each set of plates is quite different and evokes the subject of conversation to be raised for discussion at the meal. A recurring theme in the design, however, is that of the heart, a symbol that exists 'in all the editions in various forms: anatomical, edible, ancestral, scientific, poetic, biological.'[2]

At these communal events, a combination of the ordinary and the everyday intermingles with the provocative and debatable, as individuals, deliberately drawn from different social, political and economic backgrounds, are invited to share a meal, often leading to demanding, unusual and unexpected conversations. Here all certainties of identity are dissolved into myriad ambiguities that potentially involve change, transformation, loss and gain, love and hate – all the dramatic but actual elements of human experience.

The *70 x 7 The Meal* series is an excellent example of a new form of populist interactive work in which the artist develops a proactive practice in order to encourage direct experiential engagement and communication between the artwork and different audiences. Exhibiting art in this way is at once critical, joyful and engaging for a broad public, and not merely for the 'initiated'. In this way, the work is allowed to exist as a viable part of social reality, not just as a static object or effect set up for public edification. Key to these concerns is the need to transform the modernist safety zone of art presentation and display, and the desire to work against the bounds of the archival, informational, ideologically limited and exclusively visual in order to stimulate a more open-ended, non-didactic interaction between art and its multiform audiences. *70 x 7 The Meal* promotes the subjective view over the mediated representation, emphasizing the notion of individuated identity.

70 x 7 The Meal, Act III Innsbruck
2000
Royal Limoges plates
⌀ 27 cm
Edition of 490

70 x 7 The Meal, Act XIV Cologne
2001
Royal Limoges plates
⌀ 27 cm
Edition of 490

70 x 7 The Meal, Act X Napa
2002
Royal Limoges plates
⌀ 27 cm
Edition of 490

70 x 7 The Meal, Act XI Antwerp
2001
Royal Limoges plates
⌀ 27 cm
Edition of 210

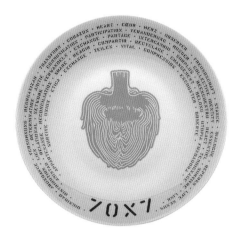

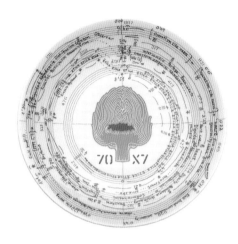

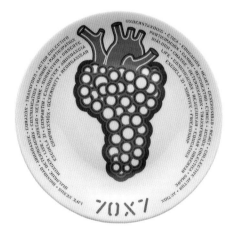

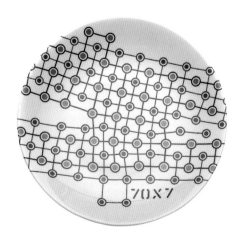

Recently, a number of exhibitions have explored the renewed interest in issues of the 'real'. In more than a few of these the possibilities of sense-based communication has been foregrounded. The senses of touch, smell, taste and hearing play a major role in fostering an awareness of the artwork as a 'felt' reality, rather than just a retinally based communiqué. Perhaps one reason for this growing interest is the increasing textualization of everyday life. With practically every facet of reality increasingly subject to manipulation and spin it becomes increasingly difficult to convey meaning – whether aesthetic, poetic, spiritual or otherwise – based on assumptions of shared transcendence. Inevitably the *70 x 7* meals are complex situations, but they directly confront Baudrillard's view of reality as an implosion of alterity and difference into a digitalized accumulation of repetitive effects. Rather, the dinners are communal spectacles that emphasize individuality and singularity, their participants a selection of winners and losers, lonely hearts and social butterflies, radicals and conservatives. An extraordinary concoction of transactional possibilities can often result from the initial indicators for conversation inscribed on the plates and the tablecloth. Unexpected shifts in conversation trace the individual voice in all its originality, without didactic effort, and a play of communication, a more fluid intersubjectivity, announces itself, initiating an ongoing chain of personalized dialogues, often with a local flavour to its topics, politics and gossip.

In some cases (as in Dieuze, Mexico City, Essex and Eindhoven) co-creation workshops precede the meal. Members of the local community or participants in the dinner are invited to take a part in the production and organization of the meal. This process, which includes discussions, performances, and contributions to the recipes, manifestos and graphics, extends the personalized and subjective vision that contributes to the underlying context and design of the event.

Lucy and Jorge Orta set up *70 x7 The Meal* in 2000 as a model of

communal communication and potential regeneration to commemorate the commitment and life-long work of Padre Rafael García Herreros, whose vision demonstrated the transformative role that culture and education can play in the development of communities. Herreros initiated a series of benefit banquets to raise money for a major social development project in Bogotá. The project was designed to radically transform the most abandoned zones of the city into thriving communities, and consisted of a regeneration programme involving the construction of community schools, family housing with gardens, a theatre, a contemporary art museum, small factories and a university. The meals were so successful that they raised enough funds to construct 'El Minuto de Dios', a whole district of the city.

Since 2000 Lucy and Jorge Orta have initiated twenty meals in the *70 x 7 The Meal* series, each meal inciting new discussion and debate. The series intends to jumble both the identities of the participants and our notions of identity through an open-ended conversation that can lead in any direction. It is significant that their non-linear method

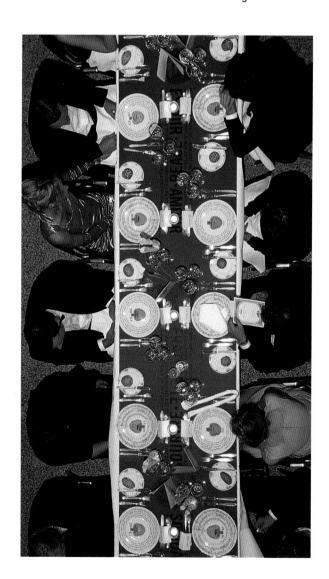

starts a process of transporting and transforming ideas and identities using complex layering rather than a supposed clarity of knowledge. On a social level, we are now experiencing a new 'techno life' since in many contemporary situations, we don't really have to create things or physically make them, we need only programme them. In a sense, the whole world has become a kind of fiction – an incessant, ongoing work in progress, proposing reality, art and culture as a service industry of virtual narratives that we can choose to buy at will.

70 x 7 The Meal articulates a 'multiple' text, expanded from the usual formality and homogeneity of art. Through the very structure of the meals, the ambiguities of life become part of the scenario, complicating and

left, **70 x 7 The Meal, Act XIV**
Cologne
2001
Installation for 350 guests,
Museum für Angewandte Kunst
Köln, Cologne

opposite, **70 x 7 The Meal, Act III**
Innsbruck
2000
Installation for 63 guests,
Kunstraum Innsbruck, Austria

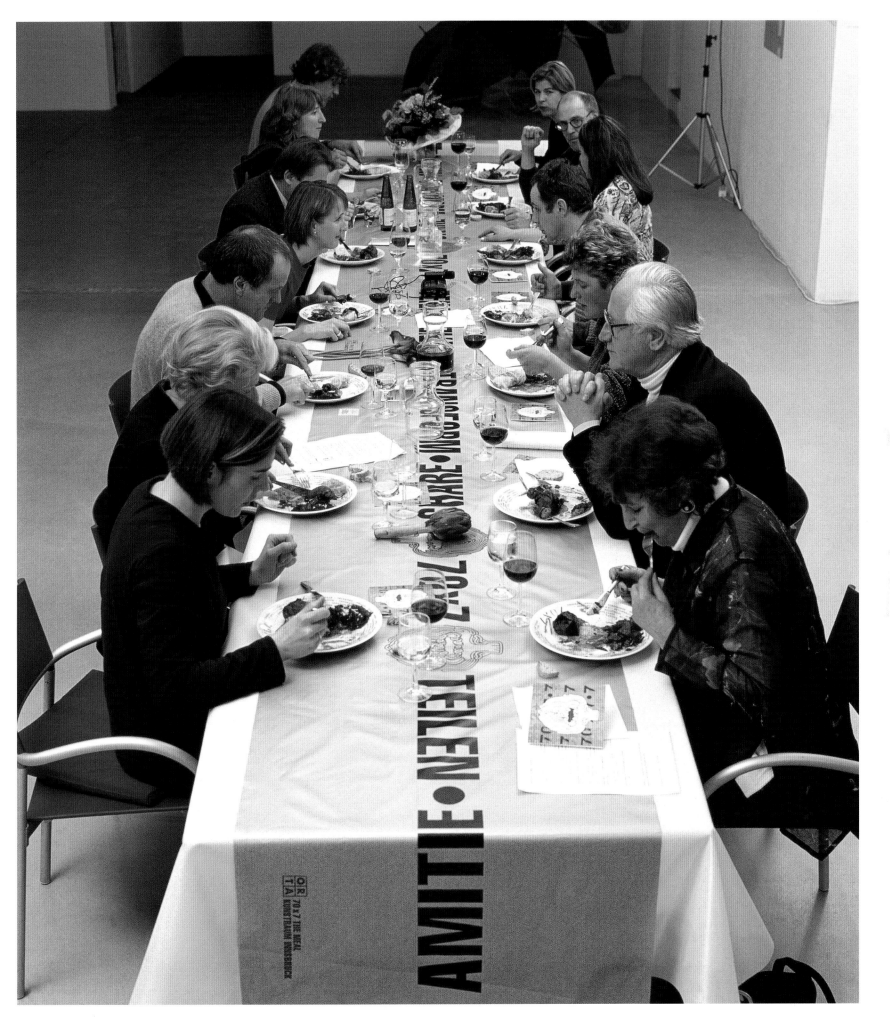

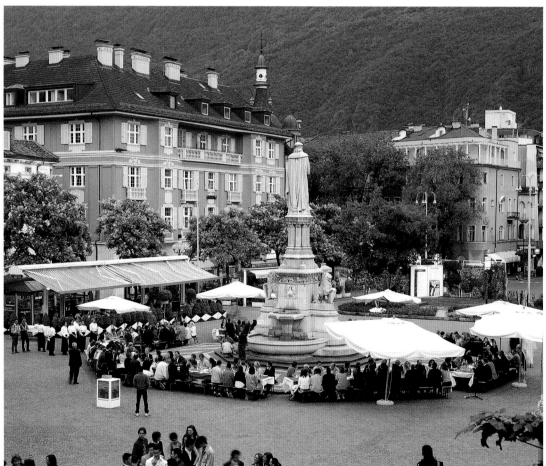

questioning realities. The events introduce flexible or fractured identities, imperfections, arguments and disagreements. The meals also allow the possibility for new connections and dialogues between diverse segments of society that would not ordinarily meet. The discussions between individuals with independent opinions can bring out transgression and change, affection and perhaps even love.

The real situation of sharing a meal turns into a virtuality of possibility. Orta's dinners actualize virtualities from the personal, social, cultural and political realities that surround us all. Each encounter also brings about a collective pseudo-fictional experience as an alternative reality to daily life. This is especially significant in today's society where so much has become information-based and standardized, a virtual text of illusionary ready-made 'spin' realities substituting for the hopes and dreams, losses and gains of life.

The exhibition 'The Invisible Touch' (Kunstraum Innsbruck, 2000) initiated the project with *70 x 7 The Meal, Act III Innsbruck* and instigated the commission of the first dining set and tablecloth for the meal. This took the form of an edition of 490 Royal Limoges porcelain plates; seven plates encased in seventy beech wood boxes; and an aluminium hand-screenprinted tablecloth measuring 49 metres. An image of an artichoke was the central motif on the plates, representing a heart enveloped with endless leaves waiting to be peeled back, in a kind of exposure.

For *70 x 7 The Meal, Act III, Innsbruck*, Orta invited people from very diverse backgrounds – musicians, actors, politicians, organic farmers, bureaucrats, business people, doctors, etc. – to two meals held in the gallery. Of the fourteen guests invited to attend the first meal, seven were instructed to invite an additional six guests of their choice to a second meal, lending a performative continuity to the event. The food was surplus produce collected from vendors at the local markets, and prepared in a simple and modest manner by a local chef. The provider and the preparer of the food were less important than what was extracted from them – a willingness to participate in something new and unknown to them. In this and other ways, the project explores a model of communal democracy. With minor alterations to take account of each particular situation, this process continues at each site where the event takes place, and the blurring of formal homogenous or standardized co-ordinates occurs differently in every location.

For *70 x 7 The Meal, Act XVI*, which took place on Friday 7 June 2002 in Bolzano, Italy,

70 x 7 The Meal, Act XVI Bolzano
2002
Installation for 168 guests,
Waltherplatz piazza Bolzano, Italy

twenty-one guests – once again specifically drawn from different socio-cultural groups and nationalities, and with varying political inclinations – were each asked to invite seven other people to participate in a communal meal on Waltherplatz, Bolzano's central piazza, making for an astonishing total of 168 attendants. Walthers', a prominent local restaurant catered for the whole event. A limited-edition set of 490 Royal Limoges plates and a tablecloth designed by the artist provided the props for this celebratory open-air event.

Orta's ceremonies reveal a connection to the exigencies of ritual behaviour. *70 x 7 The Meal* has oblique similarities in terms of communication and entertainment with the traditional Japanese geisha. As part of her training, the geisha is presented around Gion – in the past Kyoto's main geisha district. She is introduced in ritual manner to the mistresses of all the teahouses, to the man who makes wigs for stage performances, to the chefs at the important restaurants, and so on. At night she entertains her customers and patrons under strict codes of behaviour. For example, she eats only when specifically invited or requested

left, opposite, left and middle,
70 x 7 The Meal, Act IV Dieuze
2001
Installation for 1,995 guests in the rural town Dieuze, France, from the salt mine to the Town Hall

opposite, far right,
70 x 7 The Meal, Act VII Aspen
2001
Installation for 448 guests
International Design Conference
Aspen, Colorado

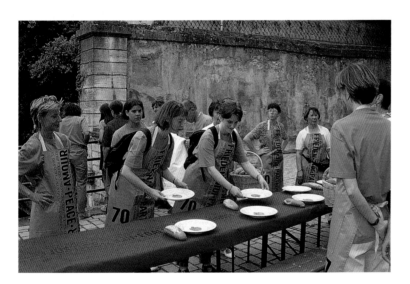

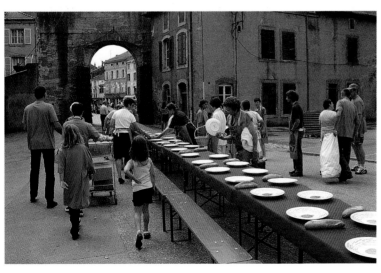

to do so by a customer. Geisha entertainment is prescribed by an intensive schooling that covers not only dance and the tea ceremony but also the playing of music, singing and other arts. And since the 'gei' of geisha means 'arts', 'geisha' really means 'artisan' or 'artist'. Her work is an artwork. A geisha, above all, is a performative entertainer: she initiates communication. Lucy and Jorge Orta, in an elliptical relation to the formal geisha manner, transform the ancient ritual of the meal into a poetic event that brings people together, to meet, to talk and to share a

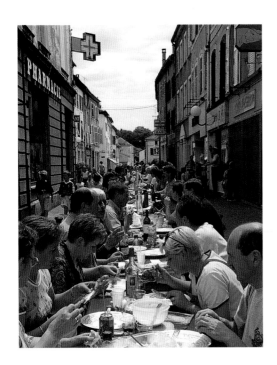 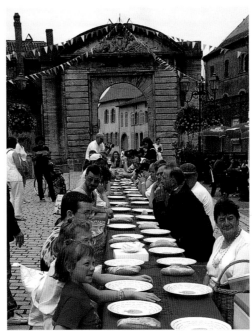 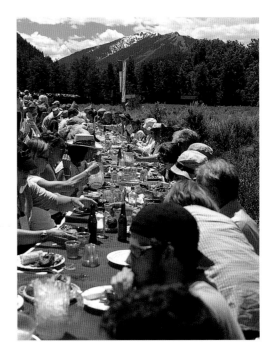

moment of communal reflection.

70 x 7 The Meal, Act XVIII Graz was arranged for the Steirischer Herbst festival in Graz (2002). An initial dinner for forty-nine people was followed by a buffet for 252 people. The edition of thirty-five sets of seven plates produced for the event was surprisingly bare of decoration except for a bright red ambulance convoy that accentuated the rim. For the first time however the underside of the plates was covered with vibrant and breathtaking colour images. Giving in to the impulse to turn the plate over and discover the origin of the porcelain, guests were confronted by a series of 'target windows' representing visions of human conflict: boat people, refugees, displaced people, famine victims, and the homeless. A hopeful future figured too in the depiction of children who are involved in the artists' *Escuela 21* project, a non-profit organization that co-ordinates an education programme in Latin America.

Using the *haute bourgeois* Limoges china in combination with such images of human suffering, as well as the ambulances as symbols of aid, Orta sets up, deliberately or unwittingly, an ironic disjunction. In the case of the meal in Graz, lending the plates to a local restaurant for public use for two years took the growing interactive element of the *70 x 7 The Meal* a step further. The symbol of the artichoke/heart on the final plate completes the circle back to the first meal held in Innsbruck.

Unlike more conventional artworks, interactive projects such as Orta's require unique

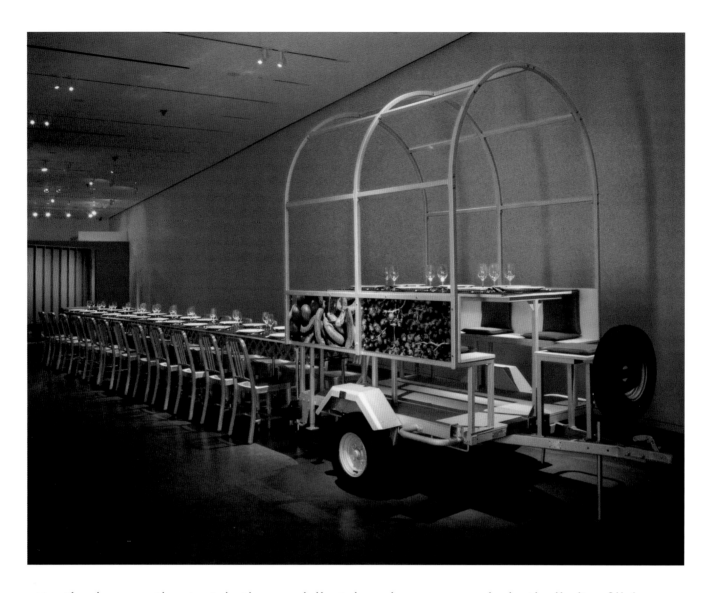

attention because they test, both more delicately and more aggressively, the limits of living with and responding to art. Orta's practice initiates a movement of subjective negotiation from within the self towards a view of others, bringing up in singular terms the profound ethical aesthetic paradigm shift in the relationship between the Self and the Other. The meals resemble living organisms, displaying all the peculiarities of individual existences and thus entail practices outside of traditional curatorial roles. They are not based on the ego of the artist but on the staging, enacting and re-enacting of the reality of the individual participants. Since it is less didactic, less rhetorical, less egocentric, and more socially politicized, Orta's work could be described more as a 'performative interaction' than a performance.

Orta is careful to avoid the trappings of formal extravagance and equally careful to project simplicity in the selection of food offerings. Although local 'celebrity' chefs are often invited to participate with great panache, they are asked to use regional and seasonal food, and in some cases left-overs, so marking the difference between this approach and precious or formally

70 x 7 The Meal, Act X Napa (M.I.U. V)
2002
Trailor, iron structure, wood, cusions, telescopic table, 70 x 7 table cloth, 70 x 7 Royal Limoges plates
290 × 200 × 1200 cm
COPIA The American Center for Wine, Food and the Arts, Napa, California

staged 'food art' performances and dinners such as those of Daniel Spoerri and Rirkrit Tiravanija. *70 x 7 The Meal* is not a question of offering great food or entertainment; Orta's performative action is based on sharing, on a movement from the singular egocentric moment to generous exchanges and subjective multiplicities.

There is a lad here, which hath five barley loaves, and two small fishes: but what are they among so many? And Jesus said, Make the people sit down. Now there was much grass in the place. So the people sat down, in number about five thousand. And Jesus took the loaves; and when he had given thanks, he distributed to the disciples, and the disciples to them that were set down; and likewise of the fishes as much as they would. (John 6.9–11)

1 And if he trespass against thee seven times in a day, and seven times in a day turn again to thee, saying, I repent; thou shalt

 forgive him. (Luke 17.4)

2 Conversation with the artist, 27 March 2003.

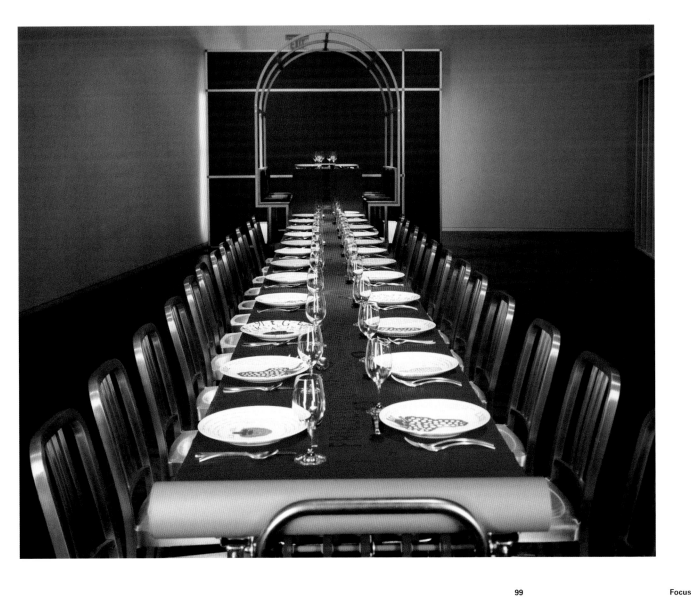

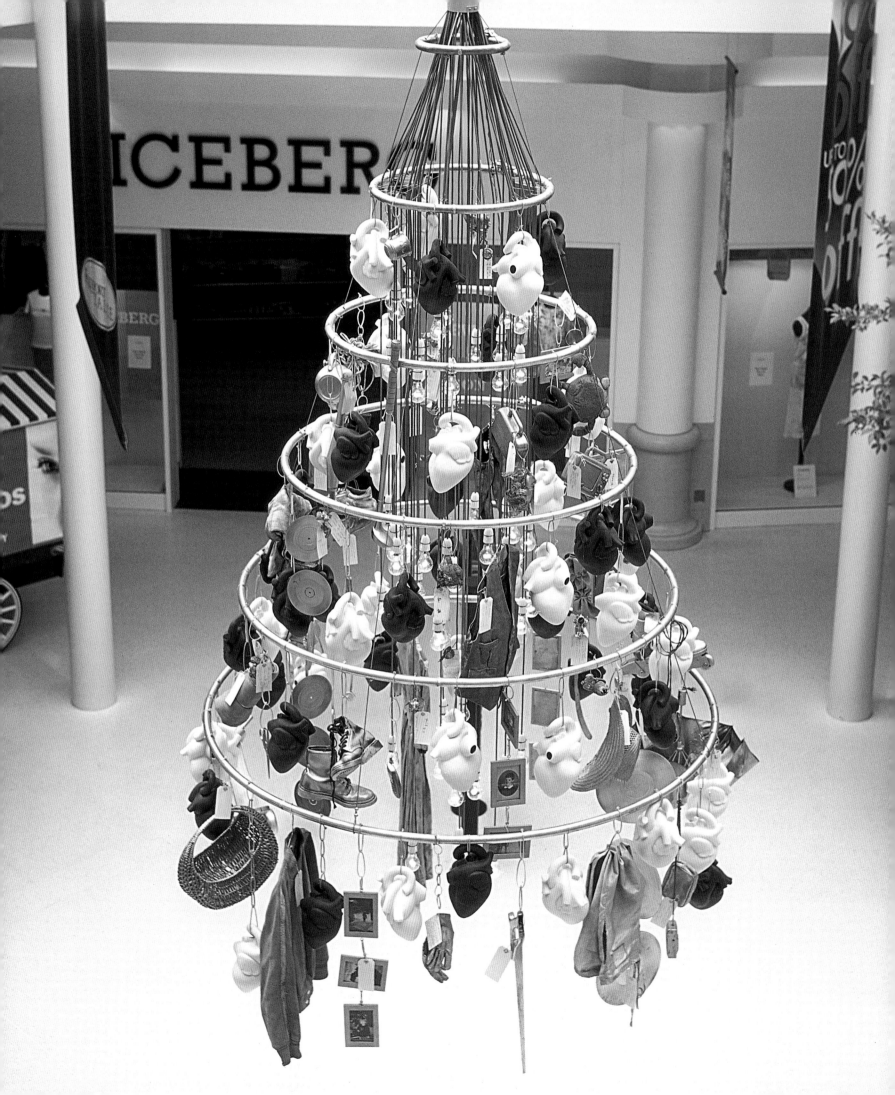

Contents

'Desperate, I will never be, but today in the face of this wave of humanity crushed by misery, I am telling myself that I have pottered around with my meagre means my whole life and that the time has come to stop trying to patch things up. Don't stand there doing nothing. I implore everybody on my knees to do whatever they can. That, in front of children dying of exhaustion and massacred, each person may ask himself what he can and must do.'
– Sœur Emmanuelle

Are the ideals of youth ephemeral; the force of will that desires to change everything; that innate nonconformism which usually characterizes the individual who is beginning to discover the world, society and rules?

Does the clash with a system established by adults, often in dis-accord with the pure and naive view of the adolescent who believes he has the strength with which to change society's blind course, belong only to the young?

Do the ideals of youth inevitably form part of an individual's initial awakening, slowly dissolving over the course of time as he adjusts and adapts to the pre-established system?

Is the mind's initial vitality relative to the progressive loss of physical strength? Is the conformist adaptation directly proportional to age?

It did not appear to be like that, at least for certain people who silently or forcefully shaped my youth. Those like Martin Luther King, Helder Camera, Mahatma Ghandi, Mother Teresa and many others whom, by total sacrifice of their lives, have opened the way to hope.

The time for Utopias appears to be over. With the explosion of Communism, our era appears to cling more than ever to an intense materialism, in which rampant super-capitalism has imposed an inhumane model for the end of the century.

More than ever extreme poverty spreads, conditioned by the wealth of a very few. The survival of the fittest is offered as the ideal for our youth; a kind of Noah's Ark for those who are fortunate enough to come aboard.

In this leap into the dark, what is left for the other two-thirds of humanity (hereinafter known as 'dust'), other than the cataclysm of a flood that will bury them in the ground before their time is out?

Varying degrees of despair appear to invade mankind. For some, our disorientated youth seem to look for understanding and future; for others, their complaints seem to become useless to the point of passive acceptance, or for the most fragile on the route to endless exile, an extreme resignation to the point of abandonment (as broadcasted via satellite networks).

Individuals and the masses appear to accept a social system that generates misery and marginalization.

There are no longer any important projects, and the international humanitarian organizations vacillate between being discredited or powerless in the realm of action.

The despair, conformity, helplessness, abandonment of the fight, self-underestimation, the lack of risk, the acceptance of a system that has lost its sense of direction, all nourish the kingdom of 'Anti-Utopias'.

But beware; it is not in the least my intention to present a view of an apocalyptic end of a century, invaded by nihilism, dominated by pessimism and without hope for betterment. On the contrary, to outline the diagnosis is to understand the present in order to imagine the future.

To prompt the return of the Utopias is to search for the keys that will open the doors to the third millennium for all of us, allowing us to see farther and to facilitate a reconciliation. A society cannot renew itself, much less exist, without Utopia. Utopia is the movement. It is the will to go farther, to invent another world, so that ours may be revitalised.

To build Utopias is to search for the evolution of change, to imagine the change and undertake the change.

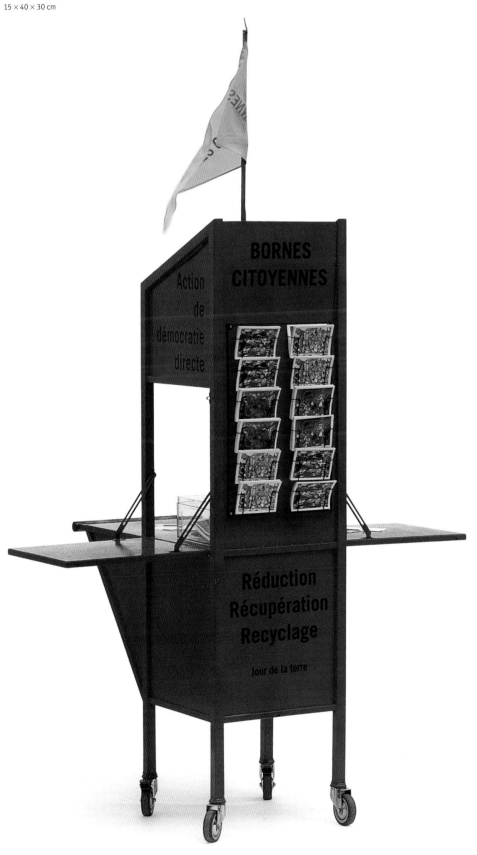

Utopia is radical, it is a return to basic principles, it is to re-form, to re-make, to re-activate, to replace, and to re-integrate ... Utopias are like clouds that allow new ideas to fall like rain, followed by the nitrate needed to make them flourish.

The Third Millennium is a challenge for men of imagination, who invent and who take risks with a sense of immensity and the perfection of humanity.

Thus, we are presented with a model of 'Republican Justice', like Plato's ideal city. The imaginary new world should lead us to the transformation of the present world, and forge the way from the 'Perfect City' to the notion of a perfected world for all mankind.

Utopia leads us to reform permanently the laws of a system incapable of, or not interested in, a precise understanding of what is the best and the most just for each individual, and so to adapt these laws progressively to the diversity of behaviour and to the spirituality of mind.

To make this step materialize, the Artist-Utopias is needed in order to merge productive Utopias. The 'Spiritus Phantasticus' is required more than ever. Only the creative imagination can give the mind the necessary insight with which to design a model and put it into practice.

Art is not an imitation of reality, it surpasses reality in its perfectionable aspects. Feelings of harmony, of well-being (*bien-être*) refer to a state of the soul in accordance with the forces of nature. Modern man tends to move away from that design. The daily pace of work, the stress, the struggle and the competitiveness characteristic of urban centres, the saturation of information, of publicity, of consumption, of noise, of interference and the overall number of obligations, plunge us more deeply into an artificial world. The loss of the natural environment often entails the loss of certain spiritual values: the reference to our primary essence, to the origin of creation, to our own origin and destiny.

Art in the natural environment is an experience that embraces nature, the cosmos, and a journey into the interior of the spiritual being, a tapping into the soul's energy sources.

In order to gain harmony it is essential to rely on Utopia. It enables us to imagine the ideal world out of the one of rebelliousness and criticism. Utopias push us towards transcendence, towards the search for truth, destroying all those clichés that block our phantasticus. Utopia is the untiring search for perfection, as inspired by an ideal world and an absolutely perfect Being, in order to return to the conversion of our earthly Being.

Utopia, which implicitly carries the notion of the infinite and perfection, leads to victory over dust, and over death.

The revelation that Lucio Fontana passed his earlier years in the house of my grandparents' progressively allowed me to understand the 'space' that he had left open in art.

Going beyond the limits of the pictorial surface, he penetrates the canvas by ripping it, perforating it, torturing it to the point of laceration. It is an irreversible and radical gesture.

And it is precisely into that laceration, that open sore, that deep wound with no visible end, that I wish to intrude.

Network of Dust[1] is a trip into Fontana's gaping wound, which takes us to that other space inhabited by the dust, which goes beyond the 'Aesthetic Space' and leads us to a moral space, raising questions about the role of art in the modern context. A wound for our world, which goes beyond aesthetics and situates itself before ethics.

Today's art finds itself in a moment of transition that demands a break from the aestheticism of recent 'DOLL-ART' decades.

A profound change is necessary in essence and in form, in media and in objectives. Art needs to be re-united after the accelerated transformations that are hastening at the end of this century. Art that in principle is active from the forefront, has been forced to yield to events from the rear guard. Luckily the current market crisis exposes the 'doll-art aesthetics' and accelerates the possibility of a new art form.

An extraordinary challenge: everything is to be re-done, re-invented at the dawning of the third millennium.

'Aesthetics becomes a product resulting from any human activity.' Thus suggests the intermittent signal from the 'Beuys lighthouse'. His doctrine on spiritual evolution is a doctrine that includes the ethics of social sculpture. Alchemist by nature, he believed all transformation is possible and all transformation is desirable. His disappearance takes away one of the last energetic Utopias, but leaves us an open road.

The aesthetics of action knows no miraculous solution. It is a type of aesthetics that confronts the mythicizing of new technologies, often interpreted as an end in itself. There is a great temptation to believe that they are redeeming by means of an imaginary disconnection from the human element. Is it still possible to believe that the electronic revolution may, on its own, heal Fontana's cut and reconstruct social splitting and global dismemberment?

The techno-world confronts the artisan-world without realizing that this interaction will enable us to recover the organic human condition. It is thanks to the interaction of these apparent extremes that the social individual will be reunited with his era. As suggested by Torres García, it is essential to move the South, thus inversing the North of certain populations.

Network of Dust evokes the cycles of misery in the modern world, of Rwanda and the former-Yugoslavia, of Somalia and Chechnya of nationalist or religious conflicts, of genocide owing to a lack of assistance ... to summarize, the two-thirds of humanity that will begin the third millennium totally excluded.

One great enemy, a subtle and a very dangerous one, is gaining ground: indifference, a weapon of terrible devastation that silently annihilates and sends out shock waves of global proportions. 'That's not my problem' we repeat incessantly, while we cling to the trappings of privileges, dictating or supporting the laws of an inadequate world; a world that we reduce to our near surroundings, in conscious ignorance of the global reality. A world locked within the individual confronted with an unprecedented communications network.

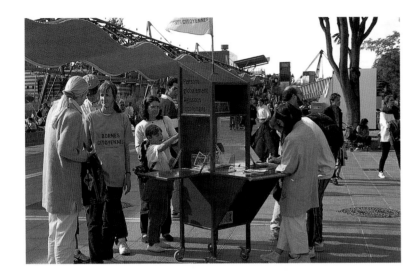

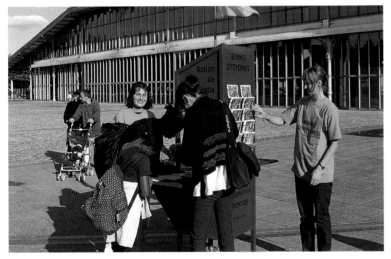

Network of Dust is concerned with the underlying forces that counteract the chaos and confront all pessimism. In particular, tolerance and love, two weapons of seemingly 'archaic technology' that are amazingly efficient, capable of reconstructing a third millennium from interior peace. These are the only suitable forces for confronting the worst of the enemies that dwell within.

Tolerance and love: two ancestral Utopias that human selfishness strives to keep from blossoming.

Where the alchemist artist is concerned, the challenge consists of transforming dust into gold and ashes into life. Utopia is energy that defends the most fragile. The real Utopia is actually ethics. The aesthetics of ethics is actually nothing more than giving moral meaning to an artist's work, when the circumstances summon us to defend a route that could lead us towards a new poetic life.

For a renewed Utopian art form.

1 *Network of Dust*, Jorge Orta, XLVI Venice Biennale. Proposal for the installation of
 ephemeral light paintings on palaces along the Grand Canal

'Return of the Utopias: The Aesthetics of Ethics, A Draft Manifesto for the Third Millennium'
(1994), *Light Messenger – XLVI Venice Biennale*, Editions Jean Michel Place, Paris, 1995

'The inert man gets in his own way.'
– Seneca

Alongside the pollution of the substances that make up our environment, which ecologists are always harping about, surely we should also be able to detect the sudden pollution of distances and lengths of time that is degrading the expanse of our habitat.

Being eternally preoccupied by the pollution of nature, are we not deliberately overlooking this pollution of life-size that reduces to nothing earth's scale and size?

While citizenship and civility depend not only on 'blood' and 'soil', as we keep being told, but also, and perhaps especially, on the nature and proximity of human groups, would it not be more appropriate to come up with a different kind of ecology? A discipline less concerned with nature than with the effects of the artificial environment of the town on the degradation of the physical proximity of beings, of different communities. Proximity of the immediate neighbourhood of different parts of town; 'mechanical' proximity of the lift, the train or the car and lastly, more recently, electromagnetic proximity of instantaneous telecommunications.

So many connections broken: from the soil, the neighbourhood unit, one's fellow human beings, be they relatives, friends, or next-door neighbours. The media-staged gap is no longer just a matter of the too great distance between the urban centre and its suburbs or periphery; it also involves televisual intercommunication, fax, home shopping and sex hotlines.

As 'citizens of the world' and inhabitants of nature, we too often forget that we also inhabit physical dimensions, the scale of space and the lengths of time of the *life-size*. The obvious degradation of the elements, chemical or other, that make up the substances comprising our natural surroundings has joined forces with the unperceived pollution of the distances that organize our relationships with others, and also with the world of sense experience. Whence the urgency of backing up the ecology of nature with an ecology of the contrivances of transport and transmission technologies that literally *exploit*

the size of the geophysical environment and damage its scope.

'Speed destroys colour: when a gyroscope is spinning fast everything goes grey,' wrote Paul Morand in 1937, in the middle of the new paid holidays. Today, when the extreme proximity of telecommunications is putting paid to the extreme speed limit of supersonic communication tools, would it not be appropriate to set up a grey ecology alongside the green? An ecology of those 'archipelagos of cities', intelligent and interconnected, that will soon reshape Europe and the world.

It is in this context of a space-time turned on its head by the teletechnologies of action at a distance that we can effectively speak of an urban ecology. An ecology that would be concerned not only with the air and noise pollution of the big cities but, first and foremost, the sudden eruption of the 'world-city', totally dependent on telecommunications, that is being put in place at the end of the millennium.

Long-haul tourism, celebrated by Paul Morand in his day, is now rounded off by a sort of 'on-the-spot tourism' based on cocooning and interactivity.

'You have turned a world into a town', the Gallo-Roman Namatianus chided Caesar. This imperial project has recently become an everyday reality, a fact we can no longer ignore, either economically or, more especially, culturally. Hence the end of the town-country opposition which we are seeing in Europe, following the Third World's lead, with the depopulation of a rural space now delivered up to idleness, full of land left lying fallow – the intellectual 'shrinking' that such an urban supremacy supposes requiring, it would seem, another 'intelligence' of the artificial and not merely another policy on nature.

At the precise moment when the necessary direct transparency of the 'optical' layer of the terrestrial atmosphere is being overlaid with the indirect transparency of the 'optoelectronic' (and electroacoustic) layer of the empire of *real-time* telecommunications, we cannot long go on ignoring the damage done by progress in an area ecologists have completely overlooked: the area of *relativity*, that is, of a new relationship

Survival Skin - On Board
1995
Neoprene, silkscreen print,
diverse objects, PVC
120 × 85 cm

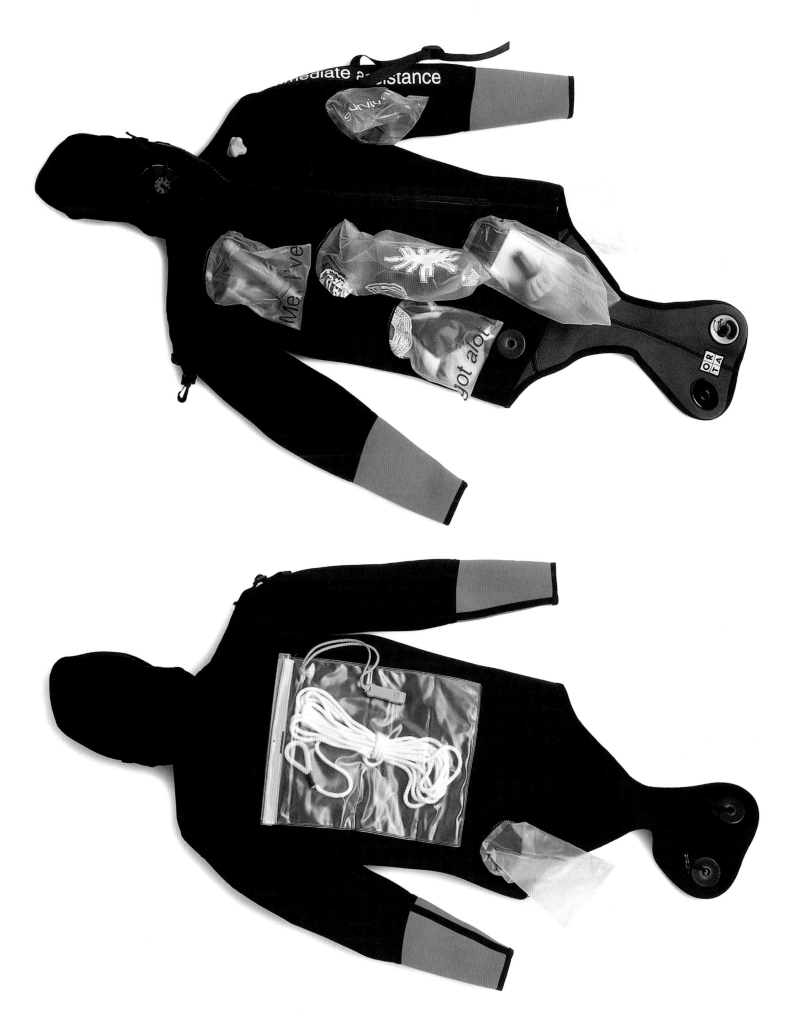

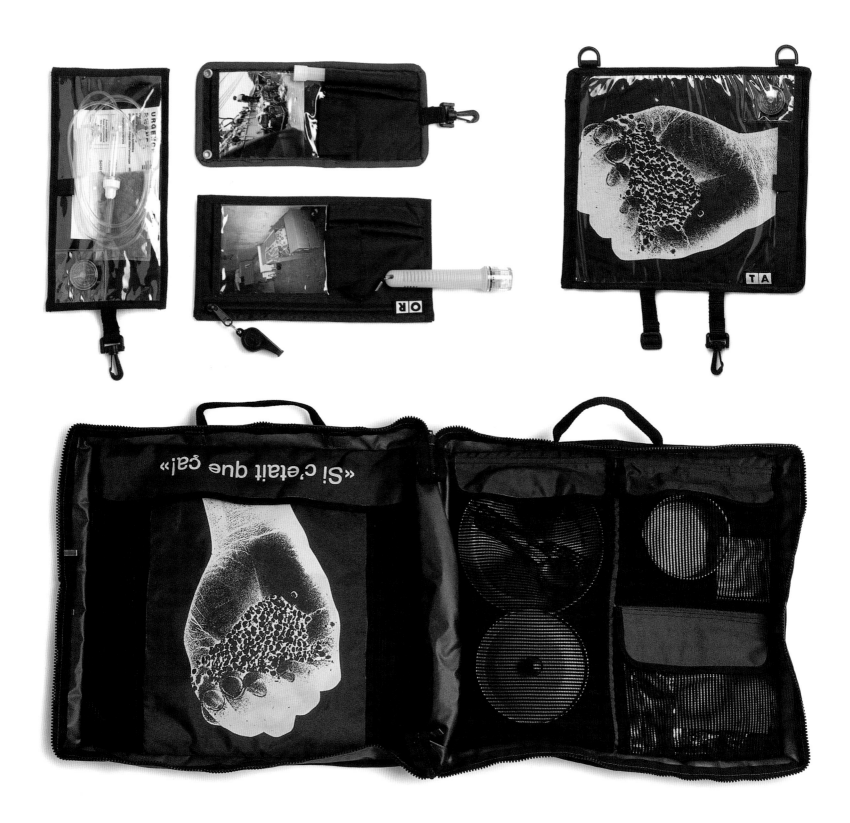

top left, **Survival Kit - Argentina Kit**
1993–94
Diverse textiles and fastenings,
colour photograph, meditative
objects, PVC
30 × 12 cm

top right, **Survival Kit**
1993–94
Diverse textiles and fastenings,
silkscreen print, meditative
objects
25 × 15 cm

bottom, **Survival Kit - Si c'etait que ça**
1993–94
Diverse textiles and fastenings,
silkscreen print, meditative
objects
85 × 42 × 5 cm

to the places and time distances created by the broadcasting revolution, with the recent implementation of the absolute speed of electromagnetic radiation. Even if the transport revolution, which only implemented the relative speeds of the train, the plane or the automobile, seems to hold no interest for disciples of the 'environmental sciences', except for the disastrous effects its associated infrastructures (highways, high-speed railways and airports) may have on the landscape.

Oriental wisdom has it that *time is useful when it is not used*. Surely we can say the same of space, the unused life-size of the expanse of a world unknown and often ignored.

Today, faced with the decline in geography, now converted into an abstract *science of space*, and the disappearance of exoticism with the boom in tourism and mass communication equipment, surely we should be asking ourselves in all urgency about the meaning and cultural importance of geophysical dimensions.

In the sixteenth century, Jérôme Cardan noted in his autobiography: 'I was born into a century in which the whole earth had been discovered, whereas the Ancients scarcely knew a third of it.'[1]

What can we say at the end of this twentieth century that saw the first moon landing, except that we have exhausted the time of the finite world, standardized the earth's expanse?

Whether we like it or not, races are always *eliminative*, not only for the competitors engaged in the competition, but also for the environment underlying their efforts. Whence the invention of an artificial arena, of a 'stage' on which to practise the exploit of extreme speed: stadium, hippodrome or autodrome. Such an instrumentalization of space signalling a tailoring, not only of the body of the athlete, trained to exceed his own limits, or the bodies of the racehorses in our stables, but also of the geometry of the environment supporting such motor performances: *the closed-circuit connection* of all those vast sporting amenities heralding the closed-loop connection, the final looping and locking up of a world that has become *orbital*, not only in terms of circumterrestrial satellites on the beat, but of the entire array of telecommunications tools as well.

And so, after the expropriated land of railways and of a system of highways that has now become continental, one last form of pollution is becoming a concrete reality: the pollution of the geographical expanse by supersonic transport and the new telecommunications tools. With the damage that this now presupposes to the sense of reality we each possess, as the world becomes meaningless now it is no longer so much whole as reduced by technologies that have acquired, in the course of the twentieth century, the absolute speed of electromagnetic waves – on top of the speed required to 'get off the rock': 'orbital velocity' at 28,000 kilometres per hour.

Whence the urgent political necessity of scrapping the *law of least effort* that has always been behind our technology boom, a law utterly vital to us and one based, like the law of the astronomical movement of the planets, on *gravity*, that force of universal attraction that at once lends weight, meaning and direction to the objects that make up the human environment.

If the 'accident' helps in understanding the 'substance', the accident of falling bodies reveals to all and sundry the quality of our environment, its specific weightiness.

Since it is *use* that defines terrestrial space, the environment, we cannot cover any expanse or therefore any (geophysical) 'quantity' except through the effort of more or less lasting (physical) motion, through the fatigue of a journey where the only void that exists exists by nature of the action undertaken in order to cross it.

So, the 'ecological' question of the nature of our habitat cannot be resolved unless we also try to find the connection linking 'space' and 'effort', the duration and extent of a physical fatigue that gives the world of tangible experience its measure, its 'life-size' quality. The lack of effort involved in teletechnologies for hearing, seeing or acting at a distance obliterates all direction, the vastness of the earth's horizon. It remains to us now to discover the 'new world': not the world of the far-flung antipodes that we discovered five centuries ago, but a world where proximity has no future, where the technologies of *real time* will soon prevail over those that once shaped the *real space* of the planet.

If being *present* really does mean being *close*, physically speaking, the *microphysical* proximity of interactive telecommunication will surely soon see us staying away in droves, not being there any more for anyone, locked up, as we shall be, in a *geophysical* environment reduced to less than nothing.

'The world has shrunk, shrunk unbelievably; we no longer travel, we get around.'[2]

This lone sailor's lament once again sets the question of limits, the limits of a world in the grip of doubt, but also of disorientation, in which the markers of position and location are disappearing one by one in the face of progress. Not progress in the acceleration of historical knowledge any more but, this time, in the acceleration of geographical knowledge, the very notions of scale and physical dimension gradually losing their meaning in the face of the infinite fragmentation of point of view.

At the turn of the century, Karl Kraus quipped: '*An adjustable horizon cannot be tight.*'[3]

Now let's hear it from an expert on the horizon of television: '*Since the space of the screen is pretty small, the programme can't be too long.*'

That about sums it up. Where the display space is reduced, the pace has to pick up so that what is lacking in extension can be put back in duration! The perspective of the (real) life-size space of a world still full, still whole, is now of necessity saddled with a relativistic perspective of time: that real time of an instantaneity that makes up for the definitive loss of geophysical distances.

It is interesting to note as well that, in these times of virtual navigation and periscopic immersion in the cybernetic world, it should once again be mariners who are the first to express the sense of lost reality. In the journal he kept of crossing the Pacific by raft, Gérard d'Aboville writes: 'To reach my goal, I had to create a mental universe *in which the distance travelled reigned supreme*. A fragile universe, since now I'm no longer making headway, the temptation to give up looms.'[4]

To give up locomotive force, in other words, to die.

A parable of the history of universal navigation, of the headway made in knowledge of the world's limits, whereby *distance* has followed navigators around in the same way as the *substance* of the seas, and this up to the untimely elimination of all maritime or continental expanses, with the acquisition of the supreme speed of waves – electromagnetic ones this time.

So, entrapment within the circumterrestrial space of a geophysical reality made up of the sound and the fury of the oceans will shortly be succeeded by imprisonment in the 'real time' of a microphysical (virtual) reality, the result of a transhorizon perspective, the veritable 'time barrier' of this no-delay time of the speed of light that has suddenly put the finishing touches to the effects of breaking the barriers of sound and heat: a feat that has enabled man to free himself from earth's gravitation and to land on the shores of the night star.

Once, each generation of human beings had to try and find out how *deep* the wide world was for themselves, to free themselves from their familiar neighbourhood and discover distant horizons. Travel is the best education, they used to say.

In the near future, each generation will inherit an *optical layer* of reality thinned out by the effect of a perspective both fundamentally 'temporal' and 'atemporal' *at the same time*. And this will enable them – at birth, or as good as – to perceive the end of the world, the narrowness of a habitat instantaneously accessible no matter what the geographical distance.

This is a pollution no longer atmospheric or hydrospheric but dromospheric that will soon see the semblance bowing out, the geophysical reality of this 'territorial body' without which neither the 'social body' nor the 'animal body' could exist, since being means *being situated* – in situ – here and now, *hic et nunc*.

'What doth it profit a man if he gain the whole world, but lose his only soul', his *anima*, that which moves him and allows him to be both animated and loving, allows him to draw towards himself not only the other, *otherness*, but the environment, *proximity*, by moving from place to place?

Survival Valise - On Board
1995
PVC, heavy-duty netting, silkscreen print, life jacket, meditative objects
85 × 42 × 5 cm

Survival Kit - Madrid Kit
1995
Diverse textiles and fastenings, colour photograph, meditative objects, PVC
26 × 43 cm

Survival Kit - Peru Kit
1993–94
Diverse textiles and fastenings, colour photograph, meditative objects, PVC
25 × 43 cm

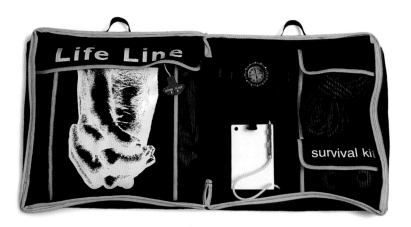

An Armenian proverb puts it well: 'If my heart is narrow, what is the good of the world being so wide?'

True distances, the true measure of the earth, lie in my heart. For animals, distance is only ever a time distance. Man, along with seagulls and spiders, carries the expanse of the environment around with him, in motion, in animation. Forty thousand kilometres around the Earth is nothing. The measurements of geography exist only for geographers and cartographers who want to determine the distance from one point to another. For the living being, this metric gauge will never equal the size of the world.

For whoever exists distance is nothing more than knowledge, memory and analogy. With the different technologies of (supersonic) transport and (hypersonic) transmission, we find ourselves in the position of someone who has been warned by the weather report that it will rain the next day: that person's today, their lovely day is ruined, *already ruined*, and they have quickly to make hay. As in the example of the small screen necessitating the acceleration of televised sequences, here it is the urgency of the present that makes itself felt.

But the tragic thing in this temporal perspective is that what is thereby polluted, fundamentally damaged, is no longer just the immediate future, the sense of what the weather will be like, but the space that is *already there*, the sense that the environment is missing: in a word, *the death of geography* […]

1 Jérôme Cardan, *Ma Vie*, Paris, 1992.

2 Jacques-Yves Le Tournelin.

3 Karl Kraus, *Beim Wort Genonunen*, Munich, 1965. Originally published by Herbst in 1918.

4 G. d'Aboville, *Seul*, Paris, 1992.

Translated by Julie Rose

'Grey Ecology', *Open Sky*, Verso, London, 1997

Collective
Wear

ZIP —— —— ZIP

TUBE
HOLE

SEAM

×2

cut 1 more wing
cut 3 tubes/social link

6·5cm

RED

Contents

GENERIC TERM	REFUGE WEAR	
TYPE	HABITENT	
MATERIALS	100% POLYAMIDE ALU	
ORTA LUCY ORTA	DATE	1992

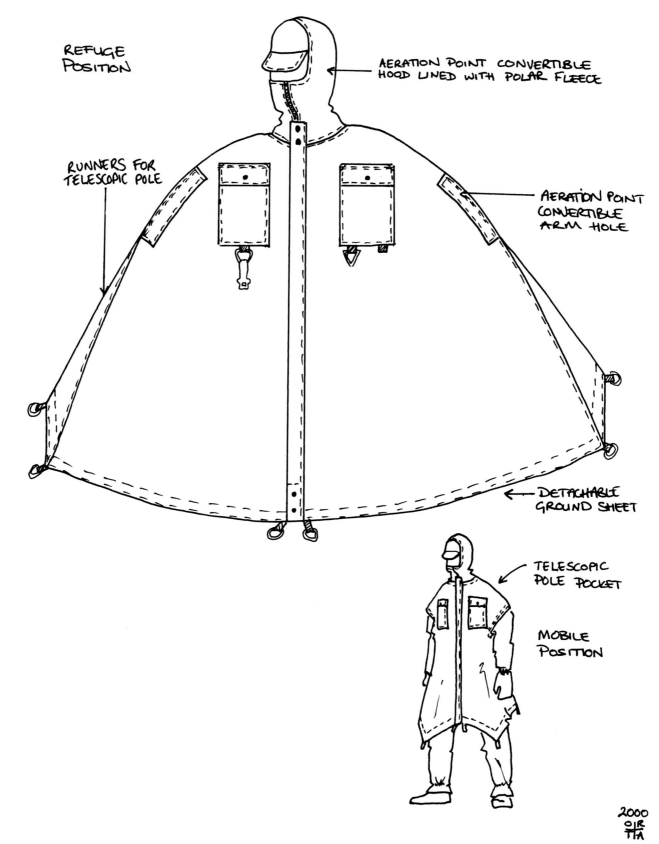

REFUGE
POSITION

AERATION POINT CONVERTIBLE
HOOD LINED WITH POLAR FLEECE

RUNNERS FOR
TELESCOPIC POLE

AERATION POINT
CONVERTIBLE
ARM HOLE

DETACHABLE
GROUND SHEET

TELESCOPIC
POLE POCKET

MOBILE
POSITION

2000
ORTA

GENERIC TERM	BODY ARCHITECTURE	
TYPE	COLLECTIVE	WEAR X 4
MATERIALS	ALUMINIUM COATED POLYAMIDE	
ORTA	LUCY ORTA	DATE 1994

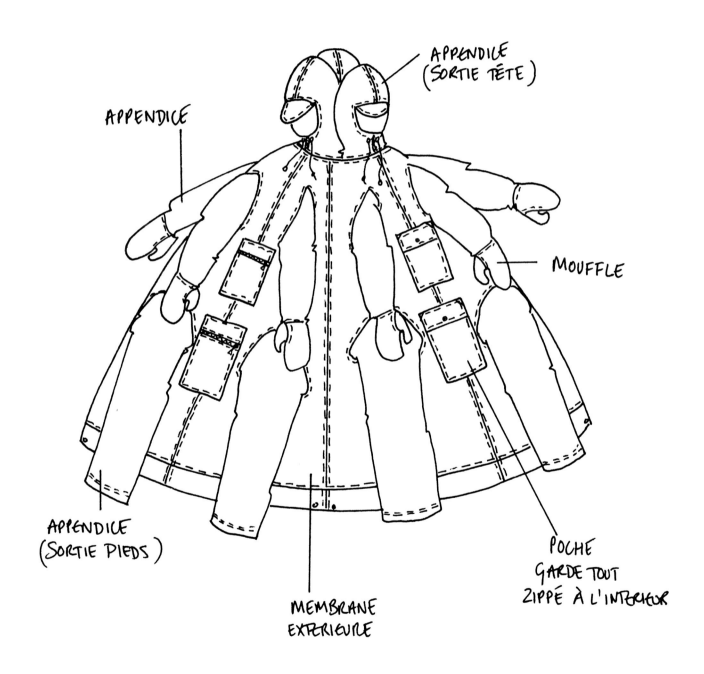

APPENDICE (SORTIE TÊTE)

APPENDICE

MOUFFLE

APPENDICE (SORTIE PIEDS)

POCHE GARDE TOUT ZIPPÉ À L'INTÉRIEUR

MEMBRANE EXTERIEURE

FONDATION CARTIER PARIS		
SEQUENCE	4	ELEMENT NEXUS ARCHITECTURE
MODULAR ARCHITECTURE		
ORTA LUCY ORTA	DATE 1996/1997	

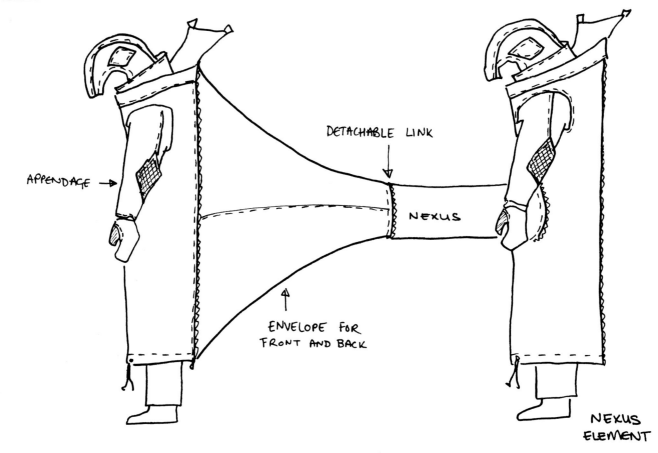

APPENDAGE

DETACHABLE LINK

NEXUS

ENVELOPE FOR FRONT AND BACK

NEXUS ELEMENT

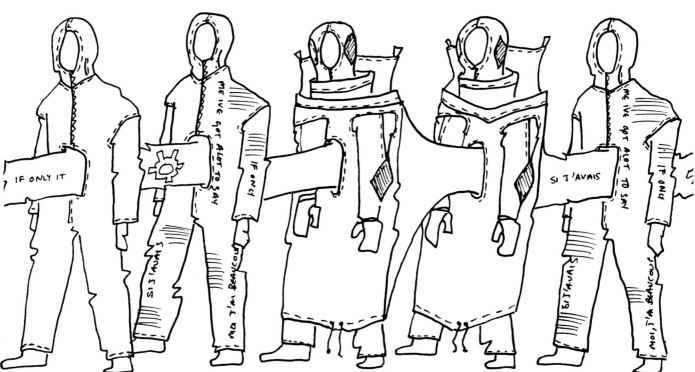

IF ONLY IT

ME IVE GOT ALOT TO SAY

IF ONLY

SI J'AVAIS

MOI J'AI BEAUCOUP

SI J'AVAIS

SI J'AVAIS

MOI, J'AI BEAUCOUP

ME IVE GOT ALOT TO SAY

IF ONLY

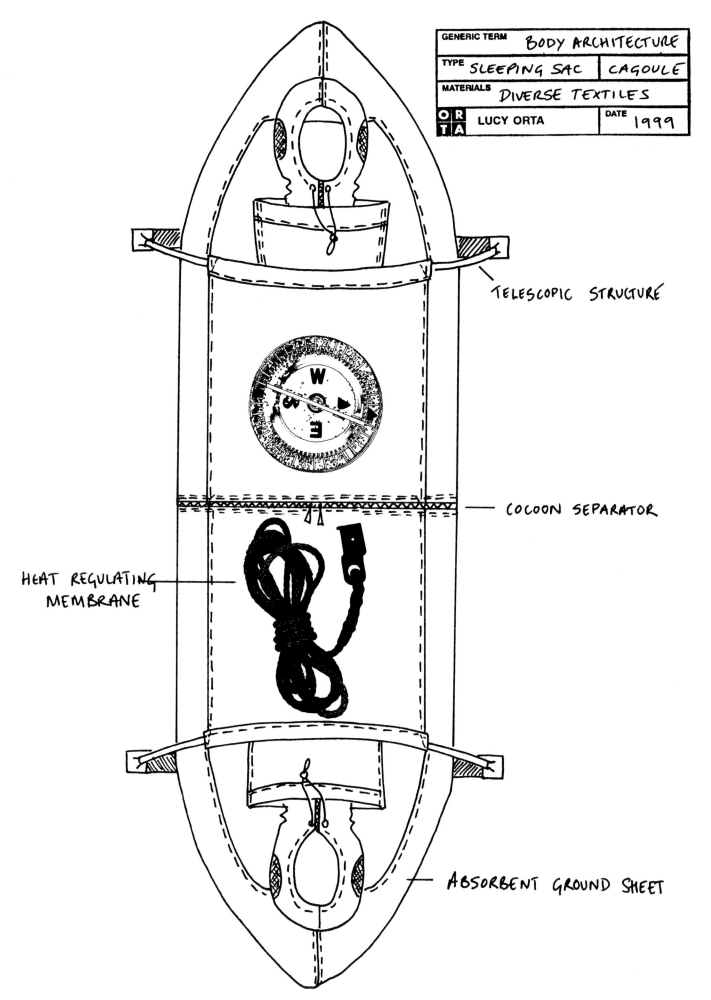

GENERIC TERM	BODY ARCHITECTURE	
TYPE	SLEEPING SAC	CAGOULE
MATERIALS	DIVERSE TEXTILES	
ORTA LUCY ORTA		DATE 1999

TELESCOPIC STRUCTURE

COCOON SEPARATOR

HEAT REGULATING MEMBRANE

ABSORBENT GROUND SHEET

Paul Virilio What attracted me to your work was its situational nature. The problem in art today is that of its delocalization. There's a lot of talk about deconstruction, but what seems to me more important is its delocalization. In a sense art is no longer found in galleries or in museums, but where mutating social situations condense – situations that renew our relationship with the world. Art is one of the elements of the *welterscheinung*, of our vision of the world, and this vision is constantly changing. I first encountered your work in the street, where things change. My discipline takes its name from the street. The street is rush, hurry, what the Greeks call *dromos*. Dromology is the science of speed, of rush. The root of *rue* (road) is *ruée* (rush); hurry comes from the same root.

At the time when I first encountered your work I was working on *Balises Urbaines* (Urban Beacons), which were designed for homeless people, though they were not dwellings but rather kiosks in the traditional sense of the word. Your urban equipment appeared in the street too, and they interested me because they were pertinent, primarily because it was outrageous. Just as my Urban Beacons had created an outcry among architects, who had perceived them as a sign of alarm, I saw your work as an alarm signal alerting us to a new human fragility and precariousness.

I really don't know whether we should call it 'art' or not. It was art in as much as it was taking stock of a situation and was a plea to take into account a relationship with the body. Art originated in the body, came out of the body of dance, out of the theatrical, war paint and tattoos. Art, before emancipating itself on the walls of galleries, did so on the body itself, through the transformation of the body into form. Your works seemed to me like cave paintings that had drawn themselves round the body. The body, clothed as it were by your *Refuge Wear*, becomes a kind of witness to what threatens it. Not only of the threats posed by unemployment, social insecurity and so on, but also the danger of the body vanishing into virtuality, into cyberbody, into 'hyperbody' and other so-called 'post-human' techniques. This interested me a great deal because as an architect, I am also concerned with the body's disappearance, through virtualization, the creation of clones and spectres, and telepresence. There is, therefore, in my view, a topicality to your work. That's what I wanted to say to start with.

Lucy Orta **Did you see the collective events, the garments for eight people, the *Nexus Architectures*, which are site-specific performances?**

Virilio Yes, I saw those too. They made me think of how we resort to collective body practices to survive. To survive one is obliged to form a pack. Primeval animals lived in packs. No animal emancipated itself from the group. Rats are sometimes even found with their tails knotted together, forming a collective entity. The survival of most animals is linked to living in packs. Your collective garments were announcing man's return to the pack. At a time when we're are told that man is free, emancipated, hyper-autonomous, a Walkman, you're saying no, wait a minute, we're banding together again into packs, gangs and new tribes. The collective clothing also made me think of commando tactics. I come from a military background; I'm familiar with the question of war, and commando techniques are group practices. Everyone protects each other, watches each other's back. A commando's life depends on his comrade. In your work, one person's warmth is another's. There are signs, pathological symptoms that run counter to the myth of comfort, of a man alone in an apartment, alone with his computers, and there is also the will to preserve bodies, to save them from their solitude, and therefore from dying of solitude.

Orta **There is the social bond, 'Nexus', which is a bond that facilitates communication, shared experience.**

Virilio I think that the work you're doing can never be dissociated from the threat of regression it evokes, which was the same threat one felt with the *Balises Urbaines*. Behind the innovation, the novelty of a collective garment, a suit for surviving in reality, lies the fear of a regression. If someone says your work is entirely positive, optimist, benevolent, then they've understood nothing. There's a tragedy, a 'dramatic art', one could say, in your work. Your work is akin to Antonin Artaud's and William Shakespeare's. There is no art without drama. This is very important.

Orta **A question that preoccupies me is whether or not I should commercialize the *Habitent* (1992–93), the tent which transforms into a poncho. There are situations in which it could come in useful, such as natural catastrophes, refugee situations, cases of really extreme urgency. But, is this really what one should be pursuing as an artist?**

Virilio I think the fact that you were miraculously welcomed – and I use the word 'miraculously' intentionally – by the Salvation Army and the Protestant Church, is because your work goes beyond art, and the art market's commercialization. Vincent Van Gogh sold

following pages, **Nexus
Architecture City Interventions
1993–1996**
2001
Original colour photograph
60 × 90 cm

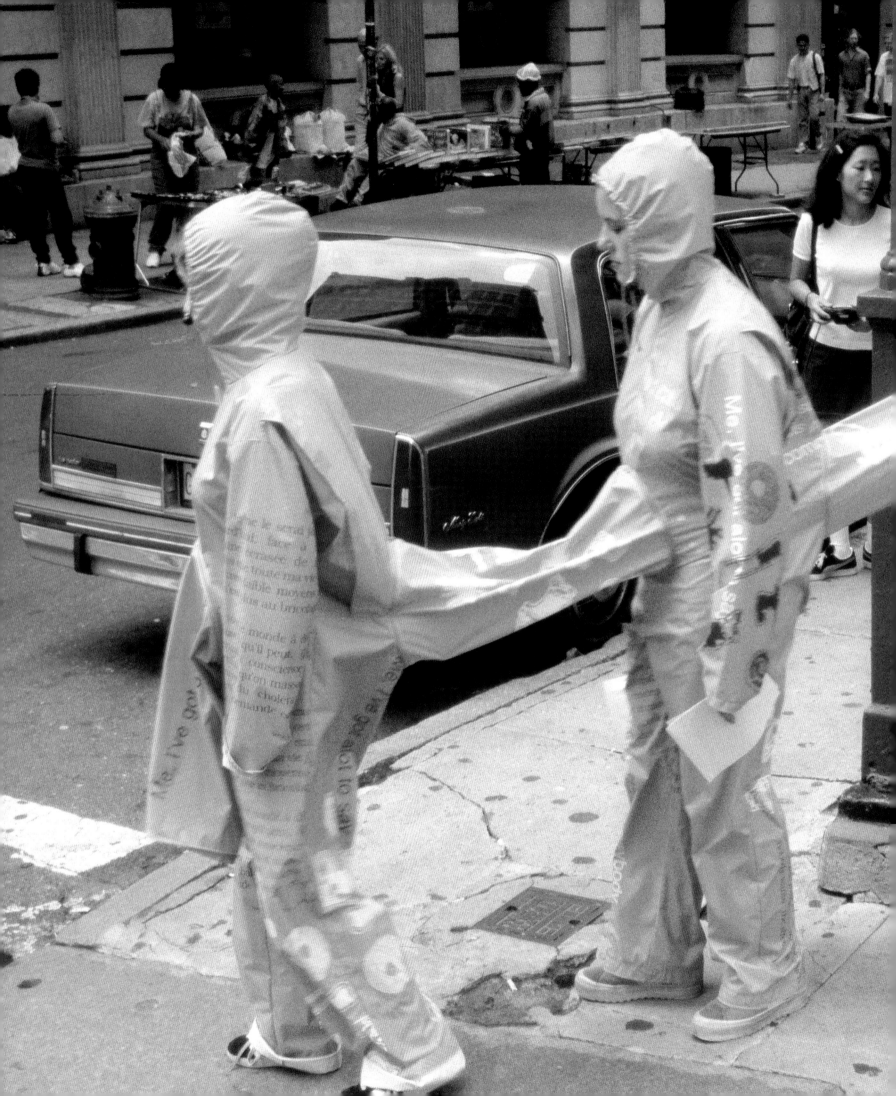

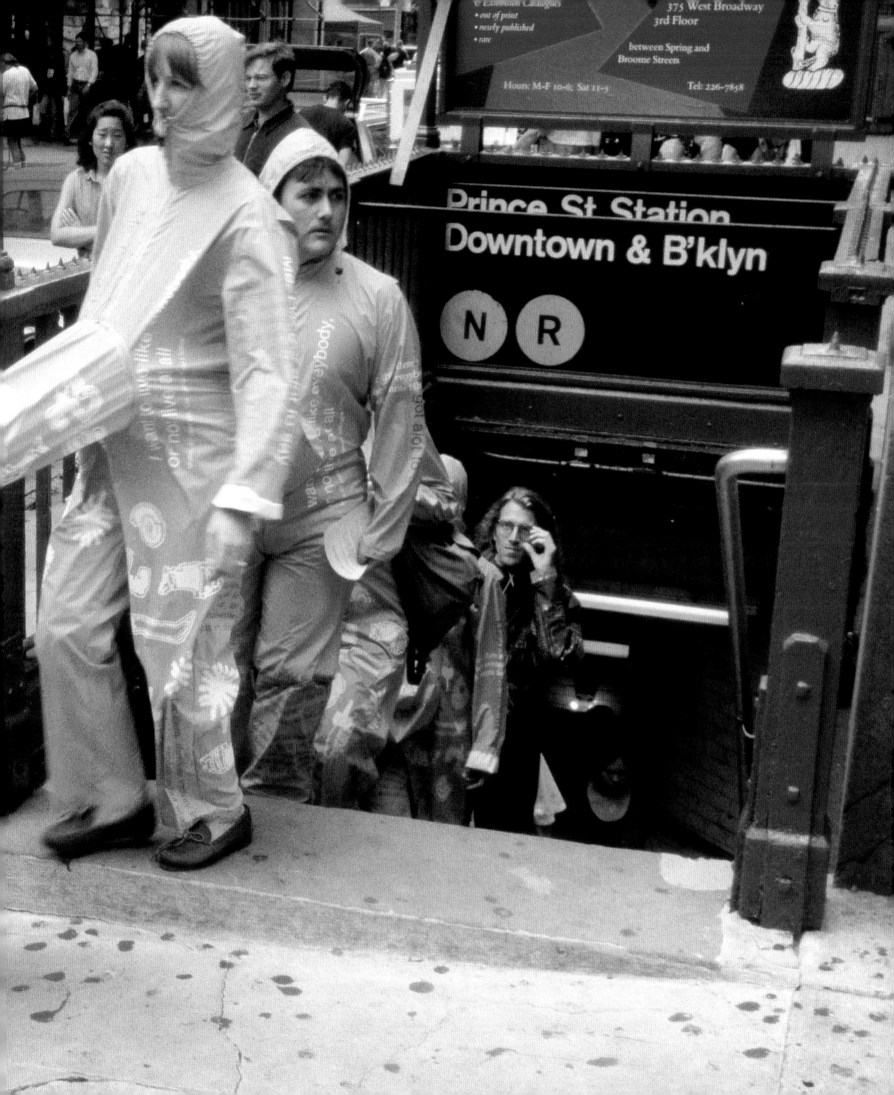

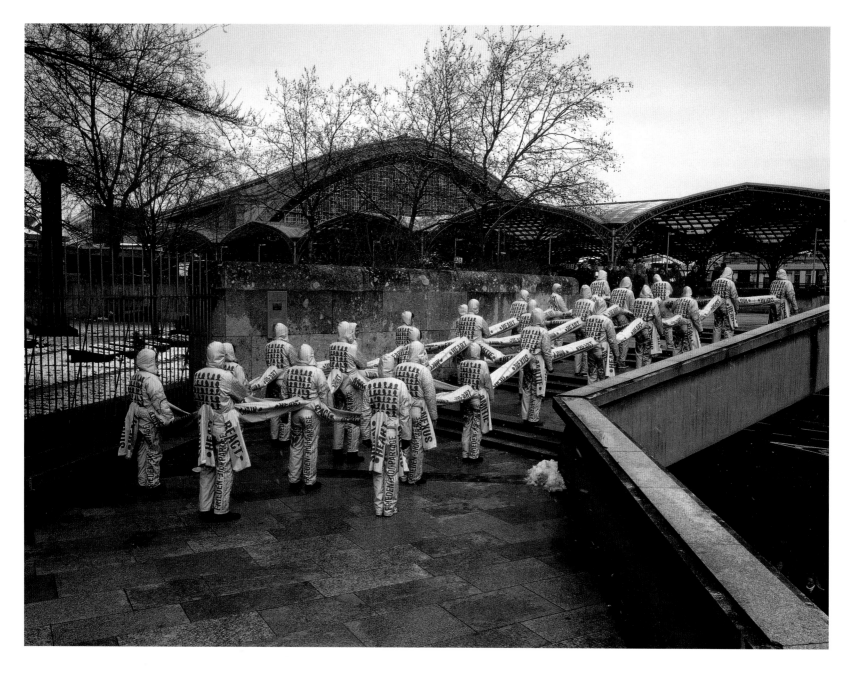

only one painting during his lifetime. And for someone like Artaud the notion of sale or commercialization doesn't exist. Commercialization comes after death. It's your heirs' meal ticket not yours. In my opinion, all avant-garde art, and I include your work here, is outside commercialization. Take Franz Kafka: he published only one or two books in his lifetime, then left instructions for Max Brod to burn all his works. I sense that you're similar.

Orta **We're talking about humanitarian art. Isn't that precisely what one should do: go out and address humanitarian needs, work towards a new artistic questioning?**

Virilio I think the humanitarian question is inseparable from the social dimension. You're working in a period of social disintegration. You're making collective clothing at a time when divorce is on the increase, and are proposing a kind of marriage by garment to prevent people from drifting apart. It's extraordinary. At a time when there are more and more single parent families, there you are making collective clothing in which parents and children share the same garment – a garment that is a symptomatic metaphor for the state of a society. So I'd say your work is more social than humanitarian. Even if these garments can help or save people, their primary purpose is to warn us about social decomposition, social divorce.

The latest United Nations survey puts the number of homeless people in the world at 500 million. It's mind boggling. So on the one hand you have 500 million homeless and the question of their precarious habitat, and on the other the disintegration of society with families breaking down. As well as divorce and remarriage, we now have the problem of 'NCCs', 'non-cohabiting couples' – I have some among my students – who marry not to live together but to remain separate. Their children are born into an alternating existence, exactly as if their parents were divorced. One can see this as a symptom of a new insecurity that is different from that of the unemployed. It's the social insecurity of solitary individuals. I'm wondering whether we can consider these non-cohabiting couples or single-parent families to be humanitarian aid cases. I think not, and yet it's a real problem.

So I think that the work you're doing is more social than humanitarian. It denounces a situation of social disintegration that you reveal in your projects and which your projects do not alleviate. But it functions on another level too. When I see your figures – because for me your garments are figures – I think of Hieronymus Bosch. The work you do is the same as his. When he paints hell, he doesn't show hell in all its horror – people massacring

Nexus Architecture x 50 Nexus Intervention Köln
2001
original colour photograph
120 × 150 cm

Nexus Architecture x 50 - Nexus
Type Opera.tion
2001
50 individual Nexus overalls;
microporous polyamide,
silkscreen print, zips
200 × 800 × 800 cm
Installation, 'Untragbar', Museum
für Angewandte Kunst Köln,
Cologne

each other – but people in strange situations: living inside fruit, dressed in a lemon. This isn't humanitarian.

Orta **_Refuge Wear_ has been installed in all kinds of places: inside railway stations with crowds constantly milling by, and outside where it was isolated, vulnerable and exposed to the world.**

Virilio In this sense, there is a prophetic dimension in your work. This is its essential vocation. I think that the realist aspect is less important than the prophetic dimension.

There is another element, which is the development of what one could term 'packaging'. It goes without saying that there is a packaging ideology in our society, which goes hand in hand with communication and mobility; firstly to facilitate transport and secondly to facilitate the message. Packaging is the wrapping of the message that sells the product that is packaged. It seems to me that in your work there's a reflection on packaging, on the garment no longer considered as body covering, as a second skin, but as packaging, somewhere midway between architecture and clothing. We have multiple skins: underwear, clothes, overcoat – onion layers that one can further add to – sleeping bag, tent, cargo container, house and so on. Your work is part of this. The garment emancipates itself, expands, attempts to become a house or a vehicle. For example, there is clothing that can be inflated to help survival in the sea.

Orta **The objects I showed at the Venice Biennale in 1995?**

Virilio Yes, the garments became inflatable life rafts. The idea is that the garment is more than just a garment, it becomes a vehicle for survival and against anonymity. I'll give an example: in London, many homeless people paint themselves white to look like ghosts. In my view, this is very important because these people have understood that it isn't enough to beg; one has to dramatise one's person. They no longer need to hold out their hand – they're already excluded by their costume. There's an information dimension, which the writing on _Refuge Wear_ explains further. Sandwich-board men also 'wear' signs, but advertising is an entirely different kind of message. Again, your work makes me think of Hieronymus Bosch because it puts the body into situations involving volumes, into niches. This perhaps has to do with solitude. In my view, there's a parallel here, between his hell and your street, because the street today is hell for the people you're talking about.

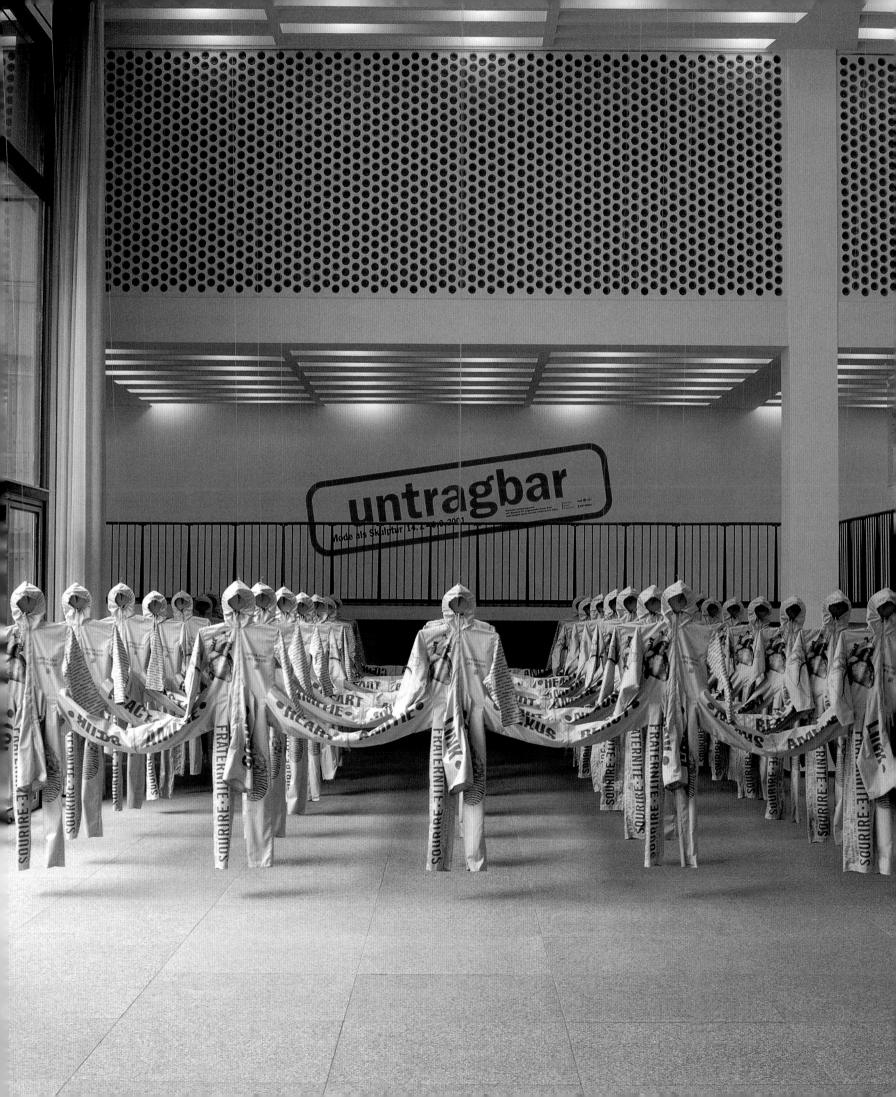

Nexus Architecture x 50 - Nexus
Type Opera.tion VII
2001
Performance for 50 dancers.
Collaboration Markus & Simon
Stockhausen, Annamirl van der
Pluijm, Jorge Orta

Orta **After *Refuge Wear*, I began more in-depth work with people in difficulty: first with Salvation Army residents, then with inmates, children in care homes and unemployed people. These workshops are closely linked to the artistic process. For example in the *Identity + Refuge* (1995) workshop, we transformed abandoned clothes, giving a new lease of life not just the objects but the workshop's participants as well.**

Virilio Well, that's extremely interesting because I know women who run writing workshops and in a sense I can see the same approach in your work, one that I would call feminine. I'm neither a feminist nor a macho, merely a man of my generation. In these workshops, people who have lost out, who no longer know how to write, who have forgotten how to, can put themselves back into their story. They don't come to write French; this is not part of an illiteracy programme. They're given a pencil and told, 'Describe your life, the situation you're in. Try. Don't worry about spelling mistakes, just put it down in writing.' I happen to know quite a few social workers who work this way and it's extraordinary the 'customer loyalty' they manage to create. These people, whether they're immigrant workers or French, get back in touch with themselves again by literally writing their story, sometimes pages and pages. No longer blocked by literary form, they manage to say things and reconstruct their minds through the therapy of writing. This is what I think you do by sewing, by 'writing' your garments, which tell a kind of story.

Take, for instance, Van Gogh's painting of the boots, which Martin Heidegger analyzes.[1] What are these boots? Are they Van Gogh's boots? Did he find them in the street? We know perfectly well that a garment or a pair of shoes says much about the person who wears them, and it seems to me that the work you just described has the same purpose. The therapy goes into the garment, which becomes a story. It's no longer simply a piece of clothing in which to keep warm or cool. It's the antithesis of the uniform, which deprives the wearer of his story. The work you're doing is antithetical in this respect. A uniform is a collective garment that everyone wears – everyone wears the same suit so everyone is in the same regiment – which is the opposite of your clothing. How does the uniform differ from the collective garment? And how does the collective garment illustrate a different collectiveness from that of the regiment?

Orta **Did you see my exhibition at the 'Ateliers de l'ARC' at the Musée d'Art Moderne de la Ville de Paris (1994)?**

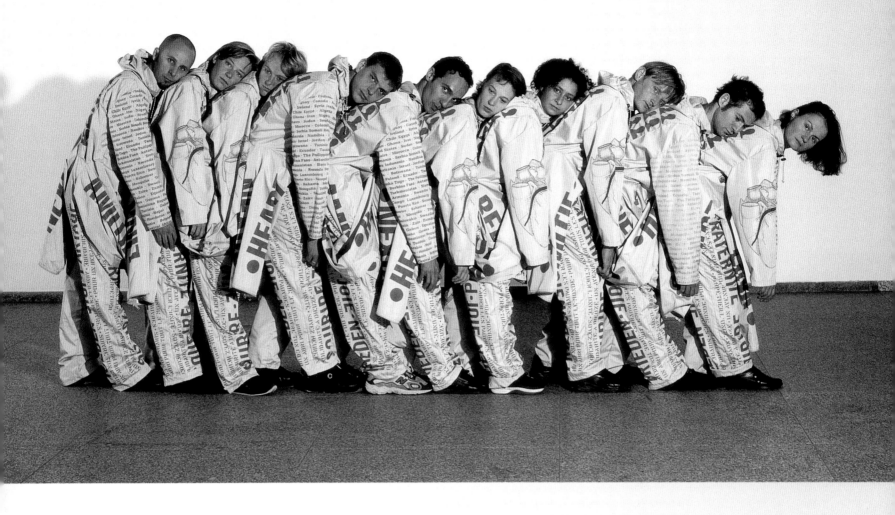
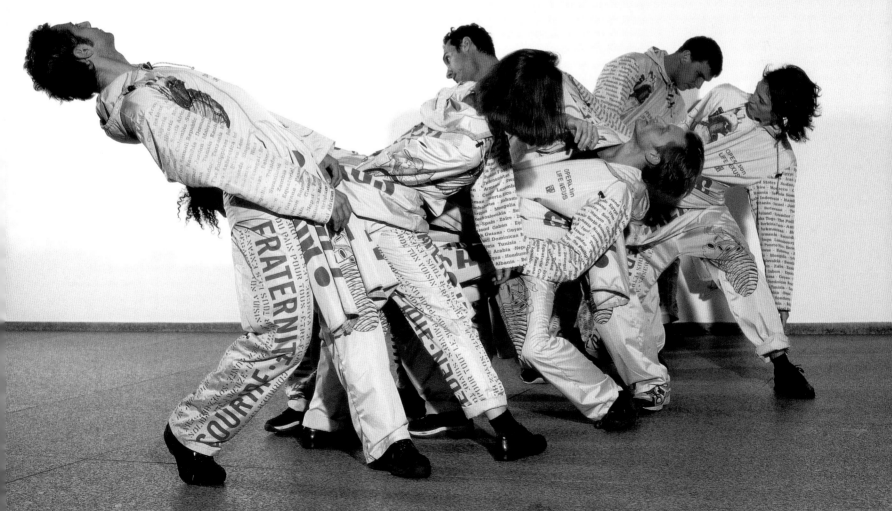

Modular Architecture - The Unit
x 10
1996
Microporous polyester, diverse
textiles, zips, telescropic
aluminium structure
Installation, Art Gallery of
Western Australia, Perth

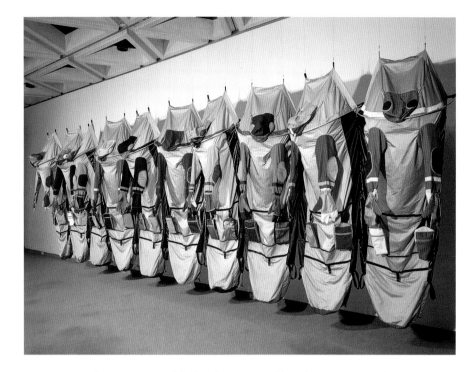

Virilio Yes, and I was very struck by it. I forgot everything else I saw except the room you were in and the work by my students, a project on reading, with books that were also a kind of manifesto but which didn't have the power of your work. The other work in the show was all just gimmicks to me and so it wasn't art. It was nothing. It didn't touch on any kind of reality. I'm perhaps being cruel, but I don't mean to be; I'm just saying what I think. I really have the impression that there were only two things there, but above all one, that were something solid, which had a truth, an authenticity and a frankness to them. We've all had enough of the comedians *dell'arte*. There are too many actors in art. So your work seemed to me to turn the exhibition on its head. In your space, one was no longer in the exhibition, one was in something else that had far more value than the rest. The rest didn't stand up; it was just galleries presenting gimmicks.

In a certain sense, the critical function of your work is superior to the exhibition function. You liquidate the context and I'm sure you don't make many friends doing so. I have great admiration for your work, because it's completely innovative. You're still pursuing the same route, irrespective of what people think. There is in your work something that evokes primitive art. When we talk about primitive art, we're talking about an art whose originators 'made do' with whatever came to hand, and about the violence that characterized their period. I find the same simplicity in your work, and it plays an absolutely specific role. As I said before, art came first from the body, and your work seems to me to be like cave paintings drawn on the body. The body, clothed not simply by a type of garment – overgarment or undergarment – but also by a social way of doing this.

It's therefore very difficult for someone to exhibit next to you – impossible even – but that's OK. I have to say I hardly go to galleries at all anymore. I'm fed up with art, with what people still call 'art'. I think were are on the verge of a catastrophe.

Orta **It's hard today not to take into account cultural networks and exhibition places.**

Virilio Perhaps insecurity is art too. Perhaps the artists who exhibit in museums are already art's homeless. Maybe they are already people in situations of social insecurity and exponents of an art struggling for survival – survival not from dying of hunger but from lack of meaning. Art is losing its meaning. Though traditional art lives on, of course.

1 Martin Heidegger, 'The Origin of the Work of Art' (1935–36), *Poetry, Language, Thought*, Harper and Row, New York, 1971.

Translated by David Wharry.

Previously unpublished.

Modular Architecture - The Unit

x 10

1996

Dance performance, La Fondation
Cartier pour l'art contemporain,
Soirées Nomades, Paris

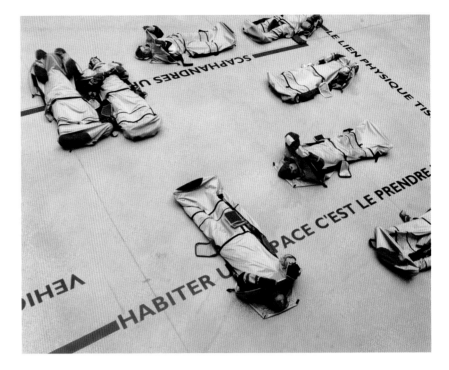

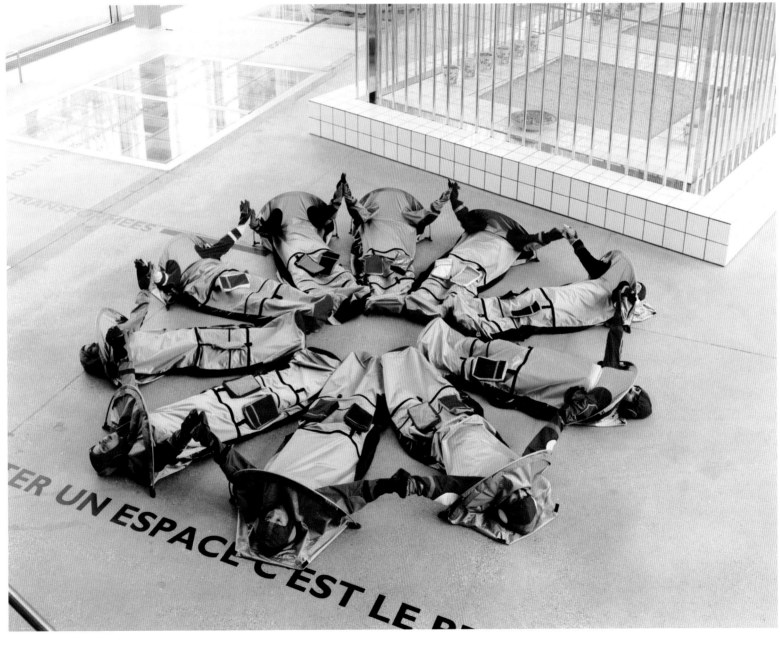

00152 The image that goes with the reason why you're here and what you think you are aren't always the same … 00205 All of us have an image corresponding to our crime and we don't necessarily feel we correspond to this image…00225 Me, I'm here for murder … 00244 It's an experience that serves no purpose, nobody's taught anything in here…00254 Anyway, you're being punished just by being here, aren't you. Punished by your children … 00305 Everyone here is punished and those close to them as well … 00333 People always think that in prison it's only the person who's in prison that's punished, it's not true … 00338 Prison isn't meant to re-educate people … 00356 I'm on remand. I haven't been tried yet … 00408 Five months and two days … 00414 A hundred and fifty days inside … 00417 I count the days … 00439 We're deprived of everything, but never all at once … 00449 I'd like to hug my children but I can't … 00530 I don't know what to say, I really don't … 00542 I'm accused of something, of course, otherwise I wouldn't be in here … 00628 In a few days it'll be nine months, I got four years … 00635 I hope they shorten it because it's disproportionate to the crime … 00640 All because of junk. I'm a user, still would be if I could – prison doesn't mean no drugs … 00750 Time goes by … 0800 Out of affection, tenderness … 00809 I'd like to go home, not have any more withdrawal symptoms … 00815 There's nothing but constraints here … 00825 What does it matter, though, what I'm going through here or anywhere as long as I'm alive … 00948 No it isn't the first time … 00950 The first time I was a minor, seventeen years ago … 00955 Prison is where I learnt everything … 01000 Prison doesn't do a thing for you … 01059 I'm an addict: heroin, pot, LSD, I'll do anything as long as it's illegal, anything legal I don't do … 01145 It's down to me to prove I'm not guilty, and how am I going to prove that in here … 01150 They say I'm a dealer, but I'm not having that … 01254 I was with this young bloke. Hadn't smoked ten joints in his life, took some ecstasy and got banged up for six months. Outrageous … 01319 In ten, twenty years time they'll still be putting youths in prison for smoking pot … 01410 It's no longer a solution shoving them in prison for a while. I'd be the first to point the finger at the dealers … 01420 You let them out and they're back on it again the same day. Nobody's interested in finding out why they dope themselves up … 01452 I've been doing drugs since I was seventeen … 01458 My friends, everyone knew about it, not even the gendarmes said anything … 01517 I was put inside with him, sentenced for use and ended up in here … 01525 Twenty years I'd been doing drugs and never once did they bother me … 01538 The only thing I did wrong was do my family wrong …

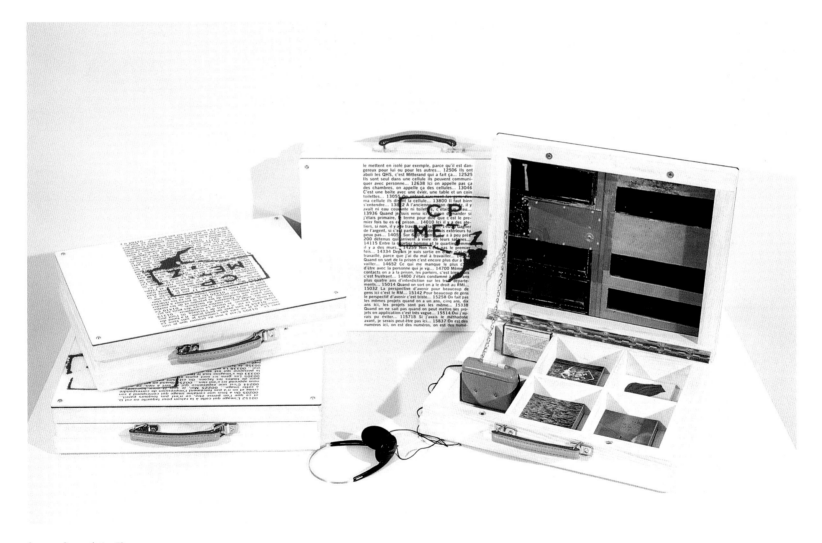

Commune Communicate - 19
Doors Dialogue
1996
Wood, laminated Cibachrome,
Walkman, postcards, bromure,
silkscreen print, handle
10 × 50 × 40 cm

Commune Communicate -
Perimeter Communication Unit
1996
Folding table, laminated
Cibachrome, bromure, silkscreen
print, handle
90 × 200 × 60 cm

00152 L'image qui colle à la raison pour laquelle on est là, et ce que l'on pense être, ce n'est pas toujours pareil... 00205 On a tous une certaine image qui correspond à son crime et on n'a pas forcément l'impression de correspondre à cette image... 00225 Moi, je suis là pour homicide... 00244 C'est une expérience qui ne sert à rien, ce qu'on nous apprend ici c'est rien... 00254 Quand on est ici on est puni de toutes les façons. On est puni par ces enfants... 00305 Les gens ici sont punis et leur entourage aussi... 00333 On s'imagine tout le temps qu'en prison il n'y a que la personne qui est en prison qui est puni, ce n'est pas vrai... 00338 La prison ne sert pas à rééduquer les gens... 00356 Je fais parti des prévenus. Je ne suis pas encore jugé... 00408 Cinq mois et deux jours... 00414 Oui, ça fait cent cinquante jours, oui... 00417 Moi je compte... 00439 On est privé de tout, mais jamais en même temps... 00449 J'aimerais serrer mes enfants dans mes bras, je ne peux pas... 00530 Qu'est ce que je pourrais raconter, moi, je n'en sais trop rien... 00542 On me reproche bien sur quelque chose sinon je ne serais pas là... 00628 Ca fait neuf mois dans quelques jours, ils m'ont condamné à quatre ans... 00635 J'espère qu'ils vont la baisser, parce que je trouve ça disproportionné au fait... 00640 C'est une histoire de came. J'en consomme, j'en consommerais toujours. C'est vrai que la prison n'empêchera pas d'en prendre... 00750 Le temps passe... 00800 D'affection, de tendresse... 00809 J'aimerais rentrer chez moi, je n'aurais pas de manque... 00815 C'est que des contraintes ici... 00825 Ce que je vis ici et ailleurs du moment que je vis, l'important c'est de vivre... 00948 Non c'est pas la première fois... 00950 La première fois j'étais en prison j'étais mineur, ça fait dix sept ans... 00955 J'ai tout appris en prison... 01000 La pénitentiaire fait rien pour nous... 01059 Je suis toxicomane, je prends de l'héroïne, du hachisch, du LSD, tout ce qui est illégal je le prends, tout ce qui est légale je ne le prends pas... 01145 C'est à moi de prouver que je ne suis pas coupable, j'ai du mal ici à le prouver... 01150 Eux ils disent que je suis dealer, mais je ne suis pas d'accord

le mettent en isolé par exemple, parce qu'il est dangereux pour lui ou pour les autres... 12506 Ils ont aboli les QHS, c'est Mitterand qui a fait ça... 12525 Ils sont seul dans une cellule ils peuvent communiquer avec personne... 12638 Ici on appelle pas ça des chambres, on appelle ça des cellules... 13046 C'est une boîte avec une évier, une table et une toilettes... 13055 On entend rarement les gens ma cellule ils disent la cellule... 13800 Il s'entende... 13812 À l'ancienne prison de Metz il y avait ni eau courante ni toilettes, c'était un seau... 13936 Quand je suis venu ici il m'on demandé si j'étais primaire, le terme pour dire que c'est le premier fois tu es en prison... 14010 Ici il y a des ateliers, si non, il y a le travail auxiliaire... 14050 Gagner de l'argent, si c'est participer à des frais extérieurs tu peux pas... 14055 Sur 600 détenus il y a à peu près 200 détenus qui arrivent à vivre de leurs salaires... 14115 Entre la quartier homme et le quartier femme il y a des murs... 14259 Non c'est pas le premier fois... 14334 Depuis je suis sortie en 87 je n'ai pas travaillé, parce que j'ai du mal à travailler... 14554 Quand on sort de la prison c'est encore plus dur à travailler... 14652 Ce qui me manque le plus c'est d'être avec la personne qui je vis... 14700 Même les contacts on a à la prison, les parloirs, c'est bien mais c'est frustrant... 14800 J'étais condamné à trois ans plus quatre ans d'interdiction sur les trois départements... 15014 Quand on sort on a le droit au RMI... 15032 La perspective d'avenir pour beaucoup de gens ici c'est le RM... 15142 Pour beaucoup de gens le perspectif d'avenir c'est triste... 15258 On fait pas les mêmes projets quand on a un ans, cinq ans, dix ans ici, les projets sont pas les même... 15338 Quand on ne sait pas quand on peut mettre ses projets en application c'est très vague... 15514 Oui j'aurais pu éviter... 115718 Si j'avais le méthadone avant, je serais peut-être pas ici... 15837 On est des numéros ici, on est des numéros, on est des numé-

avec ça... 01205 C'est à moi de prouver que je suis innocent et je ne sais pas comment je vais faire ça ici... 01254 Je suis avec un petit jeune. Il a fumé dix joints dans sa vie, il a pris de l'ecstasy, ils l'ont mis six mois de prison. Je trouve ça scandaleux... 01319 Dans dix, vingt ans, on mettra encore des gens en prison parce qu'ils fumeront du hachisch... 01410 Ce n'est pas une solution de les prendre et de les mettre quelque temps en prison. Je suis le premier à gueuler après les dealers... 01420 Un jour on va les relâcher puis ils vont faire la même chose. On ne va pas chercher à comprendre pourquoi ils prennent la came... 01452 Moi, depuis l'âge de 17 ans je touche à la drogue... 01458 Mon entourage, tout le monde était au courant, même les gendarmes m'ont laissé tranquille... 01517 Ils m'ont mis dedans avec, et j'étais condamné pour usage et je me suis retrouvé ici... 01525 Ca fait vingt ans que je touche à la drogue, ils m'ont jamais embêté... 01538 Le seul tort que j'ai fais, c'est de faire du tort à ma famille... 01550 Ca fait huit mois que je suis là... 01954 On est privé de liberté, on n'est pas privé de dignité, on n'est pas privé de santé, on n'est pas privé d'hygiène, on est privé de liberté point final... 02008 On est privé de liberté, de rien d'autre, rien d'autre... 02350 On peut tout avoir, il me manque rien... 02355 Ce qu'il me manque serais un petit week-end par mois pour les gens condamnés... 02550 Si j'étais dans mon pays natal, parce que je ne suis pas français, jamais je n'aurais eu ce gendre de problème, jamais je n'aurais été condamné... 02628 Je suis rentré dans un engrenage, j'ai fait du business, dealer ça s'appelle... 02711 Un jour on tombe dans les mailles et voilà quoi... 02711 Cercle vicieux non, par ce que j'aurais pu m'arrêter... 03031 Je ne suis pas condamné mais je m'attend à un an, un an ferme... 03042 Condamné à deux ans mais je suis primaire, primaire ça veut dire que c'est la première fois que l'on va en prison... 03054 La prison ce n'est pas pour moi... 03104 Il y

a des gens qui vont, qui viennent, qui se sentent ici chez eux... 03125 Il y a des gens ici qui sortent et qui quinze jours après reviennent... 03208 On ne vieillit pas en prison... 03518 Je vais me prendre entre cinq ans et dix ans... 03759 Je regrette d'être venu, de m'être laissé attraper plutôt... 03837 Le seul tort que j'ai fait c'est de faire tort à ma famille... 03920 J'ai commencé à l'âge de 17 ans avec du hachisch et d'acide... 03957 Je suis menuisier de métier... 04128 Moi j'adorais mon métier, j'avais une petite entreprise... 04227 Ici on a tous été différent, on a tous une parcours différent avant d'arriver, par contre ici on est tous le même chose, on est tous exactement pareil... 04236 La seule chose positive à la prison est que ça permet de rencontrer des gens que je n'aurais certainement jamais rencontrer autrement... 04310 Est-ce que j'aurais la force, est-ce que j'arriverais déterminé pour essayer de remonter tout ça... 04319 Est-ce que c'est l'espoir ou de l'utopie... 04427 Deux douches par semaine, la bouffe chaude deux fois par jour... 04436 Si tu compares ta vie avec la vie d'un SDF, tu es content d'être ici... 04443 Si tu compares ce que tu as eu avec ce que tu as maintenant, moi je suis triste... 04610 Il y a que des horaires, c'est une petite façon de nous brimer... 04854 On dépend tous de nos familles... 04903 Je suis le seul dans la famille à faire des conneries... 10120 On a les cellules qui prennent beaucoup de poussière... 10243 Il n'y a pas de petit déjeuner ils donnent juste du café ou du thé, c'est 7h30... 10255 Tout se fait dans la cellule, c'est dur, à part la douche... 10321 Nous avons un peu l'avantage, les autres sont enfermés ils peuvent sortir que pour la promenade le matin deux heures et l'après midi deux heures... 10352 Ils sont enfermés ils tournent en rond, c'est deux mètres par trois... 11927 De ne pas avoir de courrier, de ne pas avoir de correspondance, pas avoir de parloir, d'être isolé, d'être complètement isolé très souvent ça peut casser le moral des gens... 12045 Un détenu dangereux ils

01550 Eight months I've been in here now … 01954 You're deprived of your freedom, not deprived of your dignity, not deprived of your health, not deprived of hygiene, just deprived of freedom full stop … 02008 You're deprived of your freedom, that's all, that's all … 02350 You can't have everything, I want for nothing … 02355 What I miss is a weekend a month, like those doing time … 02550 If I'd been back in my home country, because I'm not French, I'd never have had this kind of problem, I'd never have done time … 02628 I got caught up in the system, in the business, dealing … 02704 One day you get caught in the net and that's it … 02711 What's known as a vicious circle, because I could have got out of it … 03031 I've not been sentenced but I'm expecting a year, one year with no remission … 03042 I got two years but I'm a first, first means first time you've done time … 03054 Prison isn't my thing … 03104 There are blokes who are in and out all the time, who feel at home here … 03125 There are blokes who get out and who are back two weeks later … 03208 You don't age in prison … 03518 I'll get between five and ten years … 03759 I regret coming here, or getting caught rather … 03837 The thing I did wrong was wrong my family … 03920 I began when I was eighteen with shit and LSD … 03957 I'm a carpenter by trade … 04128 I loved my job, I had my own little company … 04227 Everyone was different before here, we all had different lives before here, but here we're all the same, we're all exactly the same … 04236 The only positive thing about prison is that you get to meet people you'd definitely never have met otherwise … 04310 Will I be strong enough, tough enough to overcome all this … 04319 Is it hope or Utopia … 04427 Two showers a week, two hot meals a day … 04436 If you compare your life to the life of a homeless person, you're glad you're in here … 04443 If you compare what you had with what you've got now, then you're sad … 04610 It's nothing but timetables here, one of their little ways of breaking you … 04854 We're all dependent on our families … 04903 I'm the only one in my family who did stupid things … 10120 The cells generate a lot of dust … 10243 There's no breakfast, all you get is coffee or tea at 7:30 … 10255 You do everything in the cell, except shower … 10321 The only advantage we have over the others is that they're shut in their cells, they're only let out for two hours exercise in the morning and two hours in the afternoon … 10352 They're cooped up in their cells, two metres by three … 11927 Not letters, no mail, no visits, isolated, being all on your own like that can break people … 12045 Take a dangerous inmate, they'll put him in solitary because he's a danger to himself and to others … 12506 They abolished the High Security Wings,

Commune Communicate
1996
Action at the Metz Detention
Centre and the city of Metz

Mitterand did that ... 12525 They're alone in a cell, can't communicate with anyone ... 12638 We don't call them rooms here, we call them cells ... 13046 It's a box with a sink, a table and a toilet corner ... 13055 You rarely hear someone say 'my cell' they say 'the cell' ... 13800 You have to get on together ... 13812 In the old prison in Metz there was no running water or toilets, just a bucket ... 13936 When I arrived here they asked me if I was a first, which means first time inside ... 14010 Here there are the workshops, otherwise there's the auxiliary work ... 14050 Earning money, if you mean help paying for outside expenses, then you can't ... 14055 Out of 600 inmates only around 200 manage to live off their wages ... 14115 The men's and the women's wings are separated by walls ... 14259 No it isn't the first time ... 14334 I haven't worked since I got out in '87, because I find it hard, work ... 14554 When you come out of prison it's even harder to work ... 14652 What I miss most is being with the person I'm living with ... 14700 I was sent down for three years plus four years denial of access to three departments ... 15014 When you get out you're entitled to income support ... 15032 Income support is about all a lot of people in here can hope for ... 15142 For a lot of them the future is a pretty gloomy prospect ... 15258 You don't have the same projects if you're doing a one, five, or ten stretch, your projects aren't the same ... 15338 When you don't know when you'll be able to put your projects into practice they become very vague ... 15514 Yes, I could have avoided this ... 11571 If I'd have had methadone before, I might not have been in here now ... 15837 You're just a number here, a number, a number ...

Recordings with the inmates of the Metz Detention Centre, 1996. Previously unpublished.

Translated by David Wharry.

Interview with Andrew Bolton (extract) 2001

Andrew Bolton [...] Some of your public interventions might be seen as a critique of fashion. How do your clothes relate to the fashion system?

Lucy Orta **In the early 1990s, I was completely disillusioned with fashion and its blatant consumerism. As a result, I installed** *Refuge Wear* **(1992–96) under the Louvre Pyramid during Paris Fashion Week. I chose the Vivienne Westwood show, not only because she is a true innovator, but also because she was connected to the experimental art scene of the 1970s. Since then a new generation of designers has emerged and I now enjoy working within the fashion system. I try to question fashion, to go beyond fashion – not its functional aspects but its social and poetical aspects. For example, I worked with the magazine** *Dazed and Confused*, **which, to quote editor Mark Sanders aimed 'to turn the notion of style culture upon its head, releasing a set of suppressed social links within an arena of blatant visual consumerism.' Similarly, in the 'G'ym' collection, I created a series of portable message boards comprised of interchangeable outfits inscribed with graphic texts and quotes from philosophers. I imagined that each wearer could construct an ensemble to convey his/her opinions. Armin Linke photographed the clothes on people he met in cities around the world to further the idea of a global communications network.**

Bolton Could you talk about your interest in textile developments and your use of technologically advanced fabrics?

Orta **After graduating from Nottingham Trent University in 1989, I chose to work in fashion forecasting, as I was particularly sensitive to economic and social change. The transition from designer to artist occurred over a period of time and was linked to my interest in textile technology, innovative fibre development and the social, political and economic climate of the late 1980s and early 1990s. I became a founding member of Casa Moda in Paris, a group of designers and artists who were interested in creating links with textile research and experimental design. This formed the foundations for the first textile-based** *Refuge Wear* **prototypes that followed.**

I'm particularly interested in fabrics with 'multi-technical' properties and I look for a correlation between the technical specificity of the fabric and the poetics of the final object. I prefer using aluminium fabrics, not only because they reflect heat but also

Refuge Wear
1993
Installation view, Salvation Army
Cité de Refuge, Paris, 1993

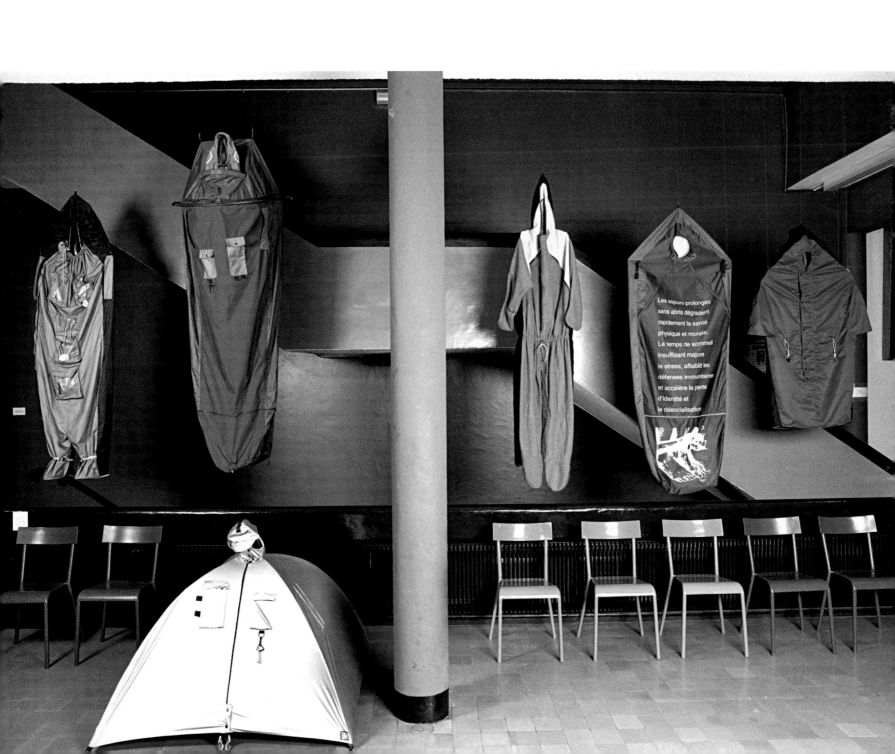

below, **Refuge Wear - City
Interventions**
1993–96

opposite, **Refuge Wear - City
Interventions 1993–1996**
2001
Original colour photograph
60 × 90 cm

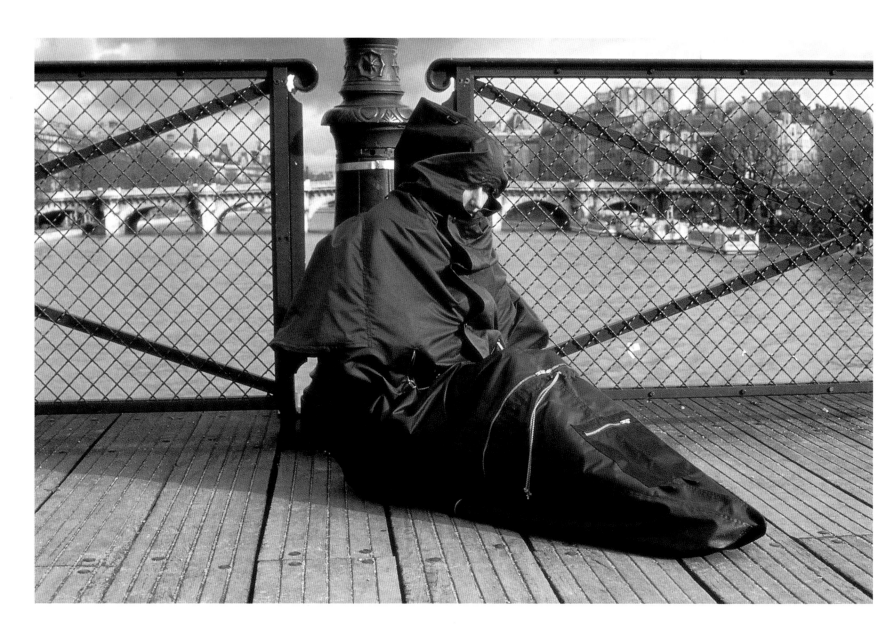

because they create a mirror that reflects the environment, enabling us to merge more
intimately with our surroundings. Exploring the unique properties of technological
textiles is extremely important in my work.

Bolton Can you explain this relationship in more detail?

Orta I take into account the 'subject' of the piece and the various transformation
possibilities of the fabrics. Materials that have a microporous-membrane coating are
particularly interesting as they attempt to mimic certain characteristics of the skin, such
as the transfer of body humidity from the interior to the exterior. This micro-process is

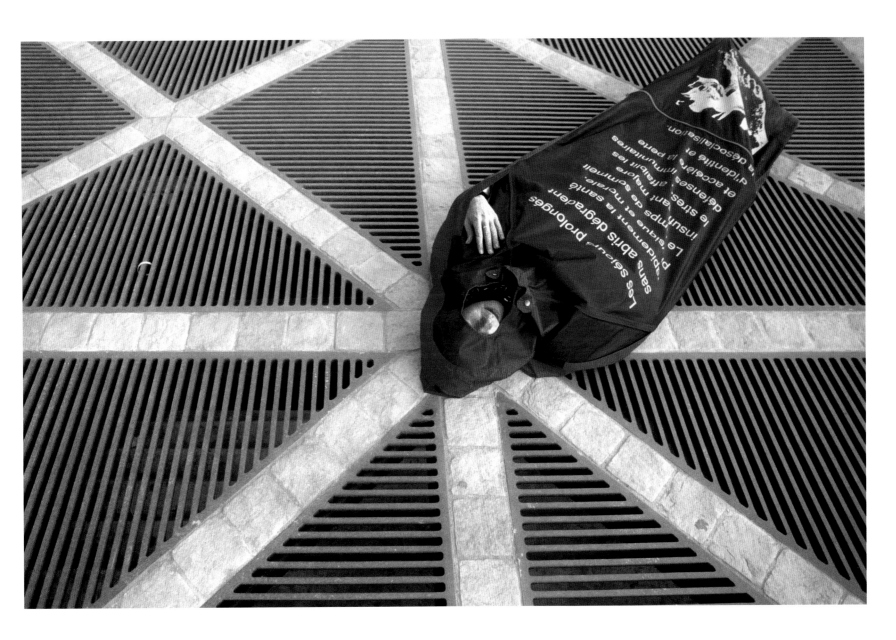

fundamental to our wellbeing and, even though the viewer may be unaware, it's part of the poetry of the object. A 'Mobile Survival Sack' may have a combination of microporous ripstop with a PU-coated polyamide, which takes into account abrasions during movement as well as the need for body comfort. Photo-luminescent weaves and Kevlar provide a barrier membrane that act as warning signals. Aluminium surfaces can be placed on the outside to reflect the sun's rays and/or on the inside to reflect the body's heat. It is the idea that our body is in complete interaction with the surrounding environment, that we determine the harmony within our habitat that I find particularly interesting. Thermochromic-coated fabrics used for the *Mobile Cocoon with Detachable Baby Carrier* (1994) change colour with temperature fluctuations enabling the mother

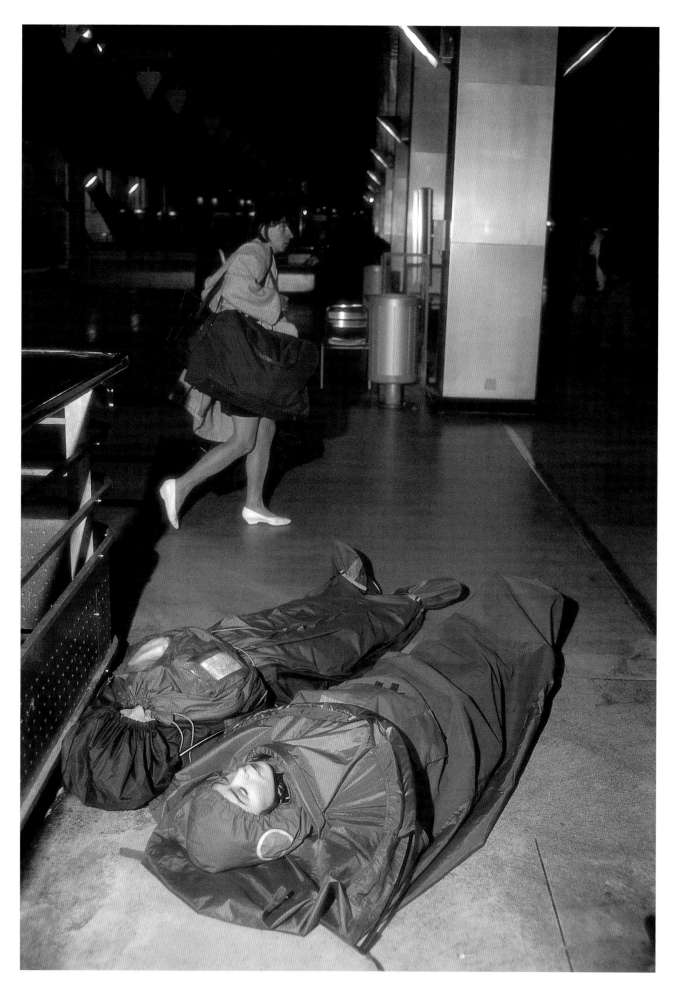

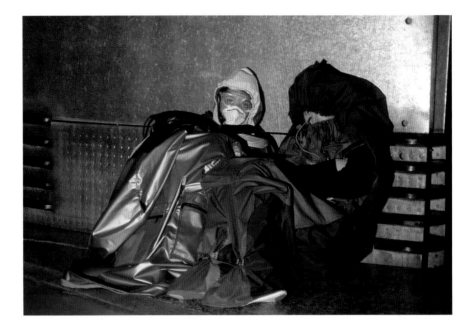

'unit' to react to and control climatic variations. For the *Mobile Cocoon* I was fascinated by developments in fleece undertaken by Rhone Poulenc, which retain five times more heat than wool.

Bolton How closely do you work with fabric manufacturers?

Orta **I work at the concept and experimental stages with fabric manufacturers in Switzerland and Italy. I participate in think-tank groups with philosophers, scientists, environmentalists and fibre technologists to co-ordinate new theory with practical applications […]**

Bolton Your pieces are unique; have you thought about producing your designs commercially?

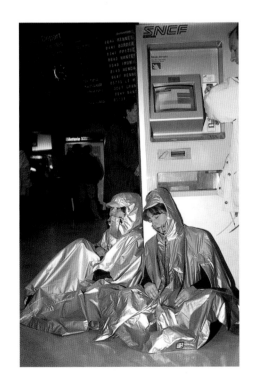

Orta *Refuge Wear* **pieces are original, but they are also prototypes. After I exhibited the *Habitent* in 1993, I was approached by two manufacturers to commercialize the design. I pursued the industrial prototyping for several years, hoping that we could develop a fully functional 'aid kit' in keeping with the original concept. The final industrial prototype bore a physical resemblance to the original, but no longer manifested its poetical side. The integrated front and back armature pockets and the objects were eliminated, which meant that the wearer would need surplus accessories, rendering him less mobile and more vulnerable. I took the decision at this point to dedicate my energies to 'initiatives' and 'pilot projects'. However, the industrial *Habitent* prototype will be donated to an aid organization when necessay.**

** *Street Range* was a prototype for a multipurpose shopping bag that I presented to TATI, the Parisian discount department store. They already sold the typical cellophane plaid bags that have become the symbol of street vendors and shoppers in the 19th Arrondissement in Paris and the transport bag for North African immigrants at CDG airport. I imagined that it could be replaced by a transformable 'trolley-come-shopping bag-come briefcase' – a pluri-functional bag that would be even more readily available – 'art for all'.**

** In 1996 I was invited by Première Vision, the international fabric trade fair, to create an exhibit for their new 'trend forum', designed to highlight developments in textile**

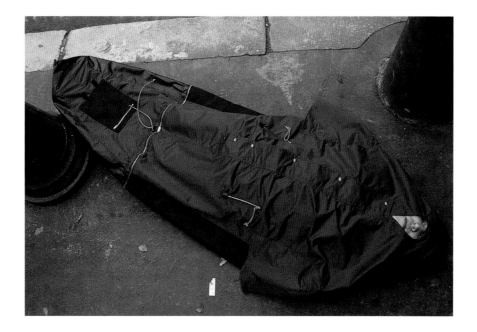

technology. I was responsible for the selection of innovative textiles and made a 15-metre arrow-shaped catwalk for a series of *Refuge Wear* pieces. This exhibition was instrumental in inspiring the high-tech fabric trends and 'transformable' clothing that emerged in the following seasons.

I have not commercialized any pieces, but the fact that designers are showing coats that convert into sleeping bags, or wearable back packs, and that C.P. Company produced a *Habitent*, is evidence that my art is filtering into the fashion system. However, I was shocked that the Design section of the Centre Georges Pompidou in Paris exhibited the piece as 'innovation' in 1999, particularly since my *Habitent* dates back to 1992. I find it surprising that more brands like C.P. Company don't approach me, especially since I'm extremely open to collaboration. In fact, it's part of the driving force behind my work. It's important that manufacturers working with designers on an experimental basis encourage innovation and push forward product design. However, the practice of not crediting sources of inspiration, commonplace in fashion, merits debate […]

1 Mark Sanders, 'Lucy Orta', *Blueprint*, No. 150, London, May 1998, p. 34.

2 *OPÉRA.tion Life Nexus* publicity material.

Andrew Bolton, 'Interview with Lucy Orta, September 2000–May 2001', *The Super Modern Wardrobe*, Victoria & Albert Museum Publications, London, 2001

above,
Refuge Wear - City Interventions
1993–1996
2001
Original colour photograph
60 × 90 cm

opposite, **Refuge Wear - City Interventions**
1993–96

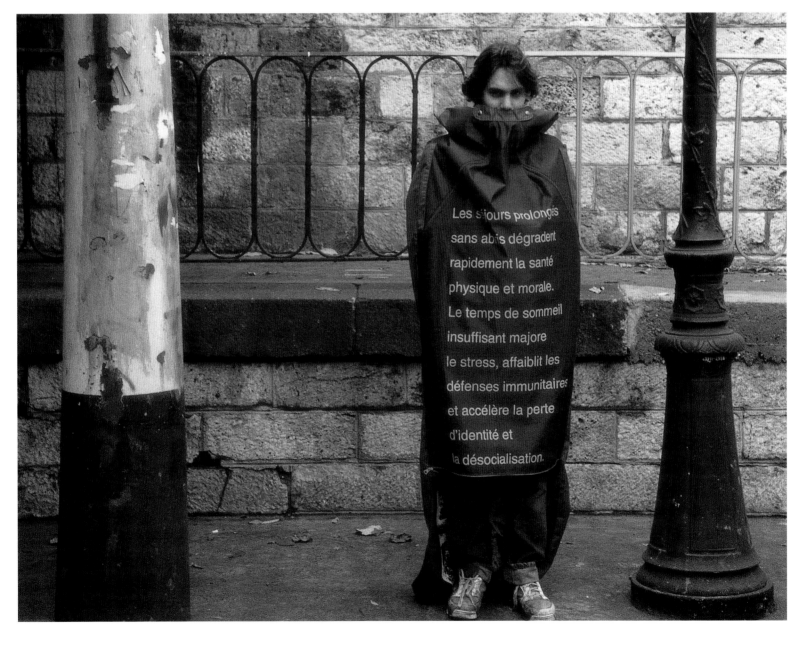

On the garment, the following text appears:

Les séjours prolongés
sans abis dégradent
rapidement la santé
physique et morale.
Le temps de sommeil
insuffisant majore
le stress, affaiblit les
défenses immunitaires
et accélère la perte
d'identité et
la désocialisation.

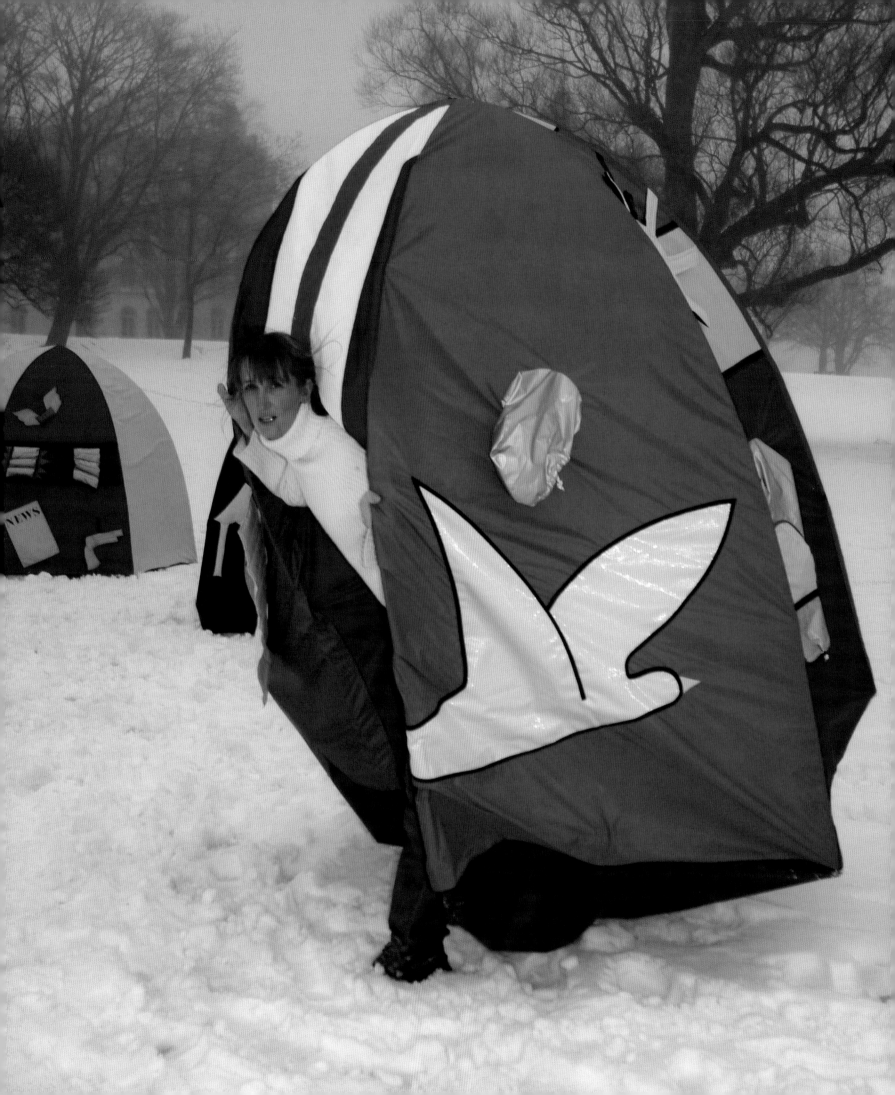

Contents

Selected exhibitions and projects
1992–95

1992
Establishes Studio Orta, Paris

Luminographic collaboration, *Imprints on the Andes*
(with Jorge Orta),
Machu Picchu / Andes Mountain range, Peru

'Poussière',
Galerie Paris Bastille (solo, with Jorge Orta)

1993
Receives, Sissel d'Or Prize for Innovation

'Art Fonction Sociale!',
Salvation Army Cité de Refuge, Paris (group)
Cat. *Cité de Refuge*, Paris, texts Paul Ardenne, Denis
Lebaillif

'Body Ware, Habitus',
Galerie Anne de Villepoix, Paris (group)

1994
Refuge Wear,
Montparnasse Station, Paris (intervention)

Nexus Architecture x 8,
Cité La Noue, Montreuil (intervention)

Refuge Wear,
Louvre/Le Pont des Arts, Paris (intervention)

'Ateliers 94',
ARC Musée d'art moderne de la ville de Paris (group)
Cat. *Ateliers 94*, ARC Musée d'art modern de la ville de
Paris, texts Suzanne Pagé, Béatrice Parent

Refuge Wear,
Salvation Army Cité de Refuge, Paris (workshop with
residents)

1995
Identity + Refuge Act I,
Cité de Refuge, Salvation Army, Paris (pilot workshop
and catwalk performance)

'Shopping',
capc Musée d'art contemporain de Bordeaux (group)

Nexus Architecture - Collective Wear x 16,
XLVI Venice Biennale (intervention, with Jorge Orta)

XLVI Venice Biennale (group)
Cat. *On Board*, log book, texts Jérôme Sans, Karin
Schorm

Kulturhuset, Stockholm (group)

Magazine project, *Zing Magazine*, New York, Fall

Selected articles and interviews
1992–95

1993

Piguet, Philippe, 'Cité de Refuge', *La Croix*, Paris, 7
November
Tredre, Roger, 'A Home for Survival', *Observer*, London,
31 October

Ergino, Natalie, 'Living Room', *Documents*, No. 2, New
York, February
Giroud, Michel, 'Vêtements de Lucy Orta', *Kanal*, No. 4,
Paris, October

1994
Fayolle, Claire, *Archicrée*, No. 260, Paris, Autumn

Gauville, Hervé, 'Tremplin pour debutants', *Libération*,
No. 42, Paris, 9 November

1995
De Vandière, Anne, 'Éthique dans l'esthétique',
Avenue, No. 1, Paris

Cabasset, Patrick, *Vogue France*, No. 754, Paris, March
Sans, Jérôme, 'Un Sac Pour La Rue', *CAPC Magazine*,
Bordeaux

Exposer, *Art Press*, Paris, No. 204, July–August

Mohal, Anna, 'Der Kunstler als Dandy', *Atelier 1*,
Germany

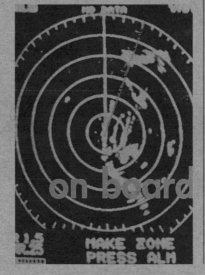

Invitation card, Shopping', capc Musée d'art contemporain de Bordeaux

Selected exhibitions and projects
1996–97

1996
'Modular Architecture',
**La Fondation Cartier pour l'art contemporain,
Soirées Nomades**, Paris (solo and dance
performance)

Refuge Wear,
Soho Festival, New York (intervention)

'Lucy Orta: Identité + Refuge',
Espace d'Art Yvonamor Palix, Paris (solo)

'Visual Reports',
ICC Cultural Centre, Antwerp (group)
Cat. *Visual Reports*, ICC, Antwerp, text Greta van
Broeckhoven

'On Route to Mex',
Art & Idea, Mexico City (group)

'Actions Urbaines',
Cāsino Luxembourg (group)

Commune Communicate Act I,
Metz detention centre/Metz city centre (workshop
with inmates from the detention centre and public
action)

'Shopping',
Deitch Projects/Salvation Army, New York (group and
catwalk intervention: *Identity + Refuge Act II*)

'L'art du plastique',
École Nationale Supérieure des Beaux Arts, Paris
(group)

'Refuge Wear',
Première Vision, Paris (installation)

Magazine project, *Time Out*, New York, 4 September

Book, *Lucy Orta Refuge Wear*, Editions Jean-Michel
Place, Paris, texts Philippe Piguet, Jean-Michel
Ribettes, Jérôme Sans, Paul Virilio

1997
'Collective Dwelling Act II',
Le Creux de l'Enfer, Thiers (solo and community
workshops)

'All in One Basket Act I',
Gallerie du Forum St Eustache, Paris (solo and public
action)

Refuge Wear,
East End, London (interventions)

Commune Communicate Act III,
Metz Detention Centre, Metz (interventions)

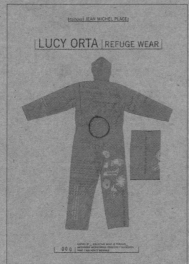

Invitation card, 'All in One Basket Act I', Gallerie du Forum St
Eustache, Paris

Selected articles and interviews
1996–97

1996
'L'Architectura del Corpo', *Mondo Arte*, No. 4, anno 2
Piguet, Philippe, 'Architectures Corporelles', *L'Oeil*, No.
478, Paris, January

Coleman, David, 'In Soho, Art and Fashion Are on the
Outs', *New York Times*, 15 September

'"Identity & Refuge", Works by Lucy Orta', *Paris Free
Voice*, No. 4, May

Polegato, Lino, interview, *Flux News*, No. 10, Liège,
August

Bamberger, Nicole, 'Des vêtements déclarés d'utilité
politique', *Jardin des Modes*, No. 19, Paris

1997

Virilio, Paul, 'Urban Armour', *Dazed & Confused*,
London, No. 29, March,

'Interactivité à Metz: l'Art au Parloir', *Le Républicain
Lorrain*, Metz, 6 February
'Lucy Orta crée l'art passe-muraille', *Le Républicain
Lorrain*, Metz, 31 January

Selected exhibitions and projects
1997–98

'Trade Routes: History and Geography',
2nd Johannesburg Biennale (group, installation and
community workshop)
Cat. *Trade Routes History and Geography*, 2nd
Johannesburg Biennale, South Africa, texts Francesco
Bonami, Okwui Enwezor, Paul Gilroy, Pedrag Vinci,
et al.

'Produire Créer Collectionner',
Musée du Luxembourg, Paris (group)
Cat. *Produiré, Créer Collectionner*, Caisse des dépôts
et consignations, Musée de Luxembourg, Paris, texts
Deepak Anarth, Ariella Azoulay, Christophe Bident,
et al.

'PS1 Open',
PS1, New York (group)

'Ici et Maintenant',
La Villette, Paris (group and action: *Citizen Platform*)
Cat. *Ici et Maintenant*, ASPV, La Villette, Paris, texts
Yves Jammet, Marie-Dominique Moreau, Michel Onfray

'Touche pour Voir',
Le Creux de l'Enfer, Thiers (group)

'Ici et Ailleurs',
Le Parvis, France (solo)

Magazine project, *Vogues Hommes International*, No. 2,
Italy (with Harriet Quick)

Magazine project, *Dazed & Confused*, No. 29, London,
March

1998
'Personal Effects: The Collective Conscious',
Museum of Contemporary Art, Sydney (group)
Cat. *Personal Effects: The Collective Conscious*, Museum
of Contemporary Art, Sydney, text Ewen McDonald

Collective Dwelling Act V,
Museum of Contemporary Art, Sydney (community
workshop)

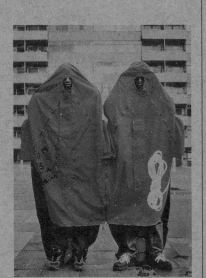

Cover, *Personal Effects: The Collective Conscious*, Museum of
Contemporary Art, Sydney

Selected articles and interviews
1997–98

'Arte conceptual en San Francisco', *La Razon*, La Paz,
Bolivia, 21 August
Budney, Jen, 'Who's It For?, The 2nd Johannesburg
Biennale', *Third Text*, London, February 1998
Cristina Morozzi, 'Wearing vs. Inhabiting', *Intramuros*,
No. 73, Paris
Diawara, Manthia, 'Moving Company: The 2nd
Johannesburg Biennale', *Artforum*, New York, March
1998
Guillaume, Valérie, interview, *Art Press*, Special
edition, Paris, October
Heartney, Eleanor, 'Mapping the Postcolonial', *Art in
America*, No. 6, New York, June 1998
Martin, Laurence, 'Le Refuge Wear de Lucy Orta',
Journal du Textile, No. 1481, Paris, 13 January
Restany, Pierre, *Domus*, No. 793, Milan, May

'En quête de partenaires pour New York', *La Montagne
Thiers*, 12 October 1998
'Huit lycéennes thiernoises invitées à New York', *La
Montagne Thiers*, 12 May 1998
'Le Creux de l'Enfer s'habille de rêves d'enfants', *La
Montagne Thiers*, 20 October 1998
'Le Creux de l'Enfer s'ouvre aux jeunes', *La Gazzette
Thiers*, 22 October 1998
'Les élèves du lycée Sonia Delaunay apprivoisent les
matériaux de l'avenir', *Huit A*, Thiers, 5 January 1998
'Prolongement d'une expo', *La Gazzette Thiers*, 1
January 1998

Paul Ardenne, *L'Age Contemporain*, Editions du Regard,
Paris

1998

Selected exhibitions and projects
1998–99

'Urban Armour',
Art Gallery of Western Australia, Perth (solo)

Nexus Architecture,
Appel d'Air, Paris; March Against Child Labour, Lyon
(protest interventions)

Collective Dwelling Act III,
Grand Street Rink, New York (community workshop
and event)

'Addressing the Century',
Hayward Gallery, London (group)
Cat. *Addressing the Century*, Hayward Gallery, London,
texts Peter Wollen, Judith Clarke, Ulrich Lehmann,
Caroline Evans, et al.

'The Campaign Against Living Miserably',
The Royal College of Art Galleries, London (group)
Cat. *The Campaign Against Living Miserably*, Royal
College of Art, London, texts Bridget Ashley-Miller,
Ciara Ennis, Patricia Kohl, et al.

Passage de Retz, Paris (group)

Magazine project, *Atlantica*, No. 19, Las Palmas,
Canary Islands

Text, 'From the Nest to the Web', *View Points*, Vol. 1,
Amsterdam

1999–2002
Head tutor, Fashion and Costume
École National Supérieure des Arts Décoratifs, Paris

1999
'Hortirecycling Entreprise Act II',
Secession, Vienna (solo)
Cat. *Lucy Orta*, Secession, Vienna, text Hou Hanru,
Lucy Orta

Nexus Architecture,
Haus der Kulturen, Berlin (intervention)

'Passages',
Centre d'art Contemporain, Troyes, France (solo)

Selected articles and interviews
1998–99

De Santis, Sophie, 'Les formes de Lucy Orta',
Figaroscope, Paris, 13–19 May
Yann, C., 'La Street Life de Lucy Orta', *Jalouse*, Paris,
No. 8, March

Anne & Julien, 'cc costumes', *Nova Magazine*, No. 39,
Paris, March

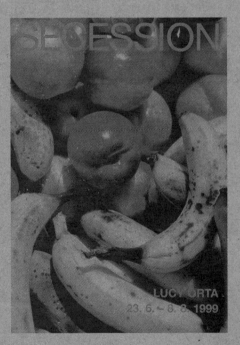

Crosling, John, 'Body Architecture', *Architectural
Review*, No. 65, London, Spring
Eshun, Kodwo, 'Refuge Wear', *i-D Magazine*, No. 179,
London, September
Goldberg, Roselee, *Performance: Live Art Since the
60's*, Thames and Hudson, London
Quick, Harriet, 'Refuge Wear', *Frank*, London, October
Sanders, Mark, 'Lucy Orta', *Blueprint*, No. 150, London,
May
Sumpter, Helen, 'Art Couture', *Big Issue*, London, 27
April

1999
Borchhardt-Birbaumer, Brigitte, 'Soziale und
strukturale Strategien', *Wiener Zeitung*, Vienna, 16
July
Hofleitner, Johanna, 'Die Landwirtschaft & das
Kleinstadtische', *Schaufenster Die Presse*, Vienna, 25
June

Aberle, Marion, 'Wohnkleider und Hosenzelte für die
Nomaden des 21. Jahrhunderts', *Frantfurter
Allgemeine*, Frankfurt, 15 January 2000
Hufschlag, Inge, 'Im Overall das Wohnen wagen',
Handelsblatt, Dusseldorf, 18 January 2000

Fitoussi, Brigitte, 'Robe'n'Nobel', *Numéro*, No. 8,
France, November
Morozzi, Cristina, 'L'Art à Porter', *Intramuros*, France,
No. 73, October–November

Selected exhibitions and projects
1999–2000

'Collective Dwelling Act VII',
Fabrica Gallery, Brighton (solo)

Institut Français d'Architecture, Paris (group)

Urban Life Guards,
Expofil, Paris (research project)

'Visions of the Body',
Museum of Modern Art Kyoto, toured to **Museum of
Contemporary Art**, Tokyo (group)
Cat. *Visions of the Body*, Museum of Contemporary Art,
Tokyo, texts Toru Endo, Akiko Fukai, Mori Watanabe

'In the Midst of Things',
Bournville Village Green, Birmingham (group and
action: *Life Nexus Village Fête*)

'Design Machine',
Kelvingrove Museum, Glasgow (group)

Collective Dwelling Act VI,
Gorbals Estate, Glasgow (community workshop)

'Model Homes',
The Edmonton Art Gallery, Canada (group)

Ronald Feldman Gallery, New York (group)

Magazine project, *The Tampa Tribune*, Tampa, Florida,
28 February

Magazine project, 'Vestito da Abitare', *Amica*, No. 39,
Milan, September (with Cristina Morozzi)

Round table discussion, 'Architecture Mobile et
Nouvelles Cultures Urbaines', (with Claire Pétetin et
Philippe Grégoire, Debis Gaudel, Marie-Claude Vachez,
Paul Virilio and Odile Decq)
École Superieure de l'Architecture, Paris

Book, *Lucy Orta Process of Transformation*, Editions
Jean-Michel Place, texts Pierre Restany, Mark Sanders,
Christina Morozzi, Jen Budney

2000–01
Virtual Fellow,
Edinburgh College of Art, Edinburgh

2000
OPERA.tion Life Nexus Act III, (with Jorge Orta, C.O.
Caspar, Kasper Toeplitz, Marina Rosenfeld, Christof
Kurzmann, Paco Dècina, François Chat)
Chapiteau LarueForaine, Paris

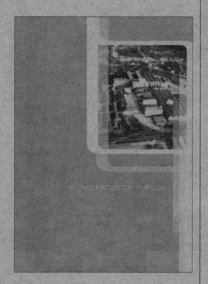

Selected articles and interviews
1999–2000

Szabo, Julia, 'Wear House', *i-D Magazine*, Vol. 46, No.
3, London, May

Braunstein, Chloe, 'G-Y'm', *L'Architecture
d'Aujourd'hui*, No. 328, Paris, September

Art & Mode, Editions Assouline/Thames and Hudson,
Florence Müller, Paris
Harmel, Francoise, 'Process of Transformation', book
review, *L'Architecture d'Aujourd'hui*, No. 225, Paris,
March
Castro, Anna Maria, 'L'architettura del corpo nomade',
Vol. 40, No. 57, Italy, April
Hirvensalo, Virve, 'Wrap around shelter', *Frame*, Vol. 2,
No. 8, Amsterdam, May–June

2000
Hazout-Dreyfus, Laurence, 'Recette de Lucy Orta',
Beaux Arts Magazine, No. 191, Paris, April
M., O., 'Une artiste textile crée des vêtements abris',
Journal du Textile, No. 1606, Paris, 17 January

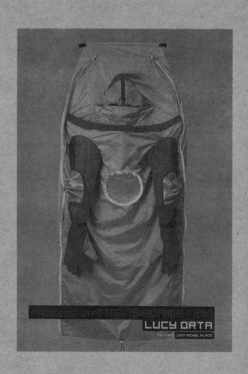

Selected exhibitions and projects
2000–01

'Connector Mobile Village sector VII',
Talbot Rice Gallery, Edinburgh (solo)

'Connector MacroWear sector VI',
Kapelica Gallery, Ljubljana, Slovenia (solo)

Connector Mobile Village Sector V,
Musashino Art University Tokyo, Japan (workshop)

'Connector Mobile Village I',
Pitti Imagine, Florence (solo)

'Connector Mobile Village I',
Australian Centre for Contemporary Art, Melbourne
(solo)
Cat. *Red*, Australian Centre for Contemporary Art,
Melbourne, 2001, texts Philip Brophy, Edward Colles,
Jenepher Duncan, Stuart Koop

70 x 7 The Meal, Act IV Dieuze
Dieuze, France (public event)

Invitation card, **70 x 7 The Meal, Act IV Dieuze**, Dieuze,
France

'Dynamic City',
La Fondation pour l' architecture, Brussels (group)
Cat. *Dynamic City*, La Fondation pour l'Architecture,
Brussels, ed. Skira/ Seuil, texts Maurice Culot, Lionel
Blaisse, France de Griessen, Danièle Pauly, et al.

Connector Mobile Village II,
E.N.S.A.V. La Cambre, Brussels (community
workshop)

'Air en Forme',
Musée des Arts Décoratifs, Lausanne, toured to **Vitra
Design Museum**, Weil am Rhein (group)
Cat. *Air en Forme*, Musée des Arts Decoratifs Lausanne,
texts Magali Moulinier, Sandra Sounier

'The Invisible Touch',
Kunstraum Innsbruck, Austria (group, project: *70 x 7
The Meal, Act III Innsbruck*)

'Ici On Peut Toucher',
Galerie TBN, Rennes (group)

'Home',
Art Gallery of Western Australia, Perth (group)
Cat. *Home*, Art Gallery of Western Australia, Perth,
texts Jen Budney, Alan R. Dodge, Gary Dufour, Trevor
Smith

Djibril Diop Mambety Dakar
Kendell Geers Johannesburg
Rodney Glick Perth
David Goldblatt Johannesburg
Igloolik Isuma Productions Igloolik
Joseph Kpobly Cotonou
Sarah Morris New York / London
Zwelethu Mthethwa Cape Town
Matthew Ngui Singapore / Perth
Lucy Orta Paris
Marko Peljhan–Projekt Atol Ljubljana
Abderrahmane Sissako Paris / Nouakchott
Annalies Štrba Richterswil
Jeff Wall Vancouver

Art Gallery of
Western Australia

Selected articles and interviews
2000–01

Jeffrey, Moira, *Sunday Herald*, Glasgow, 3 December

Ishiguro, Tomoko, 'Creating a future from voluntary
social action', *Axis*, Vol. 90, Tokyo, January 2001

'Abiti-abitazione', *Il Giornale della Toscana*, Florence,
13 January
Paola Bortolotti, 'Le umane tribu rivestite da Lucy',
Corriere di Firenze, Florence, 12 January
Piccinini, Laura, 'Trovare Casa in un Vestito', *Amica*,
No. 8, Milan, February
Taroni, Francesca, 'La nuova estetica delle relazioni tra
open-air buffets e banchetti senza fine', *Casa Vogue*,
Milan, October
Tommasini, Maria C., 'Corporal Architecture', *Domus*,
No. 824, Milan, March

Bralic, John, 'Corporeal Limits', *Monuments*, No. 42,
Darlinghurst, June–July 2001
Hill, Peter, 'Deconstructing Deconstruction', *Art
Monthly Australia*, No. 130, Canberra, June

Creux, Philippe, 'Dieuze se prépare aux agapes du
siècle', *Le Républicain Lorrain*, Metz, 2 May
'Dieuze la conviviale festoie sans retenue', *Le
Républicain Lorrain*, Metz, 3 July
'Dieuze: pique-nique du siècle', *Le Républicain Lorrain*,
Metz, 1 July
'Tous invités au pique-nique du siècle ce dimanche à
Dieuze', *Le Républicain Lorrain*, Metz, 28 June

Invitation card, 'The Invisible Touch', Kunstraum Innsbruck, Austria

Selected exhibitions and projects

2000–01

'Mutations/Modes 1960–2000',
Musée Galliera, Paris (group)

Purchase of an industrial site, The Dairy.
Plans drawn up for a centre for research and cross
disciplinary collaborations

2001

'Connector Mobile Village sector IV',
grant for exhibition awaded by The Andy Warhol
Foundation for the Visual Arts, New York
organised by the University of South Florida
Contemporary Art Museum, Tampa
**University of South Florida Contemporary Art
Museum**, Tampa, toured to **Florida Atlantic University
Galleries**, Boca Raton; **Southeastern Centre for
Contemporary Art**, Winston-Salem; **Bellevue Art
Museum**, Bellevue, Washington (solo)

'Connector Guardian Angel sector VIII',
Casa de Francia, Mexico City (solo)

'OPERA.tion Life Nexus act VII', (with Jorge Orta,
Simon and Markus Stockhausen, and Annamirl van der
Pluijm)
Museum für Angewandte Kunst Köln, Cologne (solo)

'Active Ingredients',
**COPIA The American Center for Food, Wine and the
Arts,** Napa, California (group, project: *70 x 7 The Meal,
Act X Napa*)
Cat. *Active Ingredients*, COPIA, The American Centre for
Wine, Food and the Arts, Napa, California, texts Amy
Cappellazaro, Margaret Miller

'Plug In',
**Westfälisches Landesmuseum für Kunst und
Kulturgeschichte**, Münster (group)
Cat. *Plug In*, Westfälisches Landesmuseum für Kunst
und Kulturgeschichte, Münster, texts Klaus
Baussmann, Michael Rossnagl, Ostrud Westheider,
et al.

'Untragbar',
Museum für Angewandte Kunst Köln, Cologne
(group)
cat. *Untragbar*, Museum für Angewandte Kunst Köln,
Cologne; Hatje Cantz, Ostfildern, texts Marie
Hüllenkremer, Michael Rossnagl, Susanne Anna, et al.

'They Say this Is the Place',
Provinciebesturr van Antwerpen, Antwerp (group,
project: *70 x 7 The Meal, Act XI Antwerp*)

'To the Trade',
Diverse Works, Houston (group)

'Wegziehen',
Frauen Museum, Bonn (group)
Cat. *Wegziehen, Der weibliche Blick auf Migration in
Kunst und Wissenschaft*, Frauen Museum, Bonn, texts
Gudrun Angelis, Marianne Pitzen, Monika Mattes, et al.

Invitation card, 'Connector Mobile Village sector IV',
University of South Florida Contemporary Art Museum,
Tampa

Selected articles and interviews

2000–01

Corrigan, Susan, 'Orta go to the g-y'm', *i-D Magazine*,
No. 197, London
Warr, Tracey ; Jones, Amelia, *The Artist's Body*, Phaidon
Press, London

2001

Milani, Joanne, 'Lucy Orta: Global Gear', *The Tampa
Tribune*, 25 November

Florez, Maricruz Jiménez, 'Connector Gardien', *Cronica*,
Mexico City, 31 March

Muchnic, Suzanne, 'Eat, Drink and Be Cultural', *Los
Angeles Times*, 25 November

Posca, Claudia, 'Plug-in: Einheit und Mobiliat',
Kunstforum International, No. 156, Cologne,
August–October

'Utragbar = Unwearable', *Mood*, Teramo, June

Aageenbrug, 'Marusja Door, Mensen moeten
participeren in kunst', *Eindhoven Dagblad*, 16 October

Einheit und Mobilität 02.06.–29.07.2001
Eine Kooperation des Westfälischen Landesmuseums Münster mit
dem Siemens Kulturprogramm. www.Plug-In-Muenster.de

Selected exhibitions and projects
2001–02

'Global Tools',
Künstlerhaus Vienna, Austria (group)

'Transforms',
Trieste (group)
Cat. *Transforms*, Trieste, texts Mario Cristiani,
Emmanuela de Cecco, Roberto Pinto

Commission, *Arbor Vitae*,
Freeport Talke , Staffordshire
'Making History', Staffordshire University,
Staffordshire County, Borough and District Councils

Key Speaker, 'The More Things Change', International
Design Conference Aspen, 51st anniversary, Colorado

Speaker, 'Generazione delle Immagini, VII Racconti
d'Identita', Commune of Milan, Italy

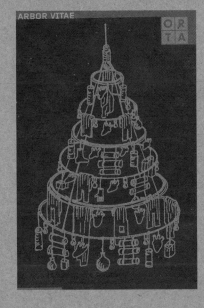

2002
Appointed Head of MA program, 'Man and Humanity',
Design Academy Eindhoven, The Netherlands

Appointed Rootstein Hopkins Chair of Fashion
(nominated as the first Chair),
London College of Fashion, The London Institute

Appointed Visiting Fellow,
École National Supérieure des Arts Décoratifs, Paris

'70 x 7 The Meal, Act XIX',
Design Academy Eindhoven (solo)

Nexus Architecture x 110, (community workshops and
public intervention)
organised by Florida Atlantic University Galleries
Miami Design District for Art Miami Basel

'Enactments of the Self',
Sterischer Herbst, Graz (group, project: *70 x 7 The
Meal, Act XVIII Graz*)

Borderline, (with Blanca Li and Jorge Orta)
Compagnie Blanca Li/Maison des Arts de Créteil
European tour premier, contemporary dance

Selected articles and interviews
2001–02

Noé, Paola, 'Transforms', *Teme Celeste*, Milan, March

Berwick, Carly, 'Clothes Encounters', *ARTnews*, Vol.
100, No. 10, New York, November
Marger, Mary Ann, 'Lucy Orta: Fashioning Change
Through Art', *St. Petersburg Times*, 18 November
Neradil, Barbara, 'The Art of Connection', *The Oracle*,
Tampa, 21 November
Poncet, Emmanuel, 'L'art à l'école', *Beaux Art
Magazine*, Paris, October
Schulze, Karin, 'Zwischen Qual und Lust', *Financial
Times Deutschland*, Hamburg, 17 July
Socha, Miles, 'The Great Unworn', *Women's Wear Daily*,
Vol. 182, No. 26, New York, 7 August
White, Lisa, *View On Colour 18*, Paris
William Jeffett, *NY Arts*, Vol. 6, No. 12, December
Wright, Bruce N., 'Fabric Interventions', *Public Arts
Review 12*, Minneapolis, Summer

2002

Adamson, Zita, 'From Street to Chair', *The London
Institute Review*, 25 February

Arie, Altena, 'Over de gastvrijheid van kunst',
Metropolis, No. 5, Utrecht, October–November
Haagsma, Lotte, 'Beschermende kleding als symbool',
Tubelight, No. 22, Rotterdam, September

Fluid Architecture II,
The Dairy, St. Siméon, France
Online interactive workshop to inaugurate the Design
Academy Eindhoven MA program 'Man and Humanity'

'Fluid Architecture II',
Stroom Centre for Visual Arts, The Hague (solo,
installation and online workshop)

'Connector Mobile Architecture IX',
Musée d'Art et d'Histoire, Cholet, France (solo)

Borderline,
Berlin Ballet/Komisch Oper
Contemporary dance collaboration (with Blanca Li,
Jorge Orta, Matthew Herbert and Tao Gutierrez)

Fluid Architecture I,
City of Melbourne, Australia (residency and community
workshop)

Invitation card, 'Jorge + Lucy Orta: OPÉRA.tion Life Nexus',
Two Ten Gallery, The Wellcome Trust, London

'Jorge + Lucy Orta: OPÉRA.tion Life Nexus',
Two Ten Gallery, The Wellcome Trust, London (solo
with Jorge Orta)

'All You Need to Know',
The Laing Gallery, Newcastle upon Tyne (group)

Virilio, Paul, 'Un habitat exorbitant', *L'Architecture
d'Aujourd'hui*, No. 328, Paris, June

Bokern, Anneke, 'Lucy Orta, Fluid Architecture',
Bauwelt, No. 35, Berlin, September
Quint, Erik, 'Kunst met een humanitaire boodschap',
UIT, The Netherlands, 21 August
Van Driel, Anne, 'Solidair regenjack', *de Volkskrant*,
Amsterdam, 25 July

'Bienvenue au village textile de Lucy', *Le Hic*, Cholet,
20 March
Boucault, Vincent, 'Lucy Orta habille le monde de ses
vêtements refuges', *Le Monde*, Paris, 17 June
'Connector IX - Village Mobile', *Cholet magazine*,
Cholet, No. 157, March
'Le lycée de la mode tisse des liens avec Lucy Orta', *Le
Pays Choletais*, Cholet, 22 March
'Le vêtement, lien social de Lucy Orta', *Courrier de
l'Ouest*, Angers, 18 March
'Lucy Orta campe au musée jusqu'au 2 septembre', *Le
Pays Choletais*, Cholet, 2 August
'Lucy Orta est connectée au musée d'art', *Ouest France*,
Rennes, 18 March
'Lucy Orta imagine l'art en mouvement et en reseau',
Le Pays Choletais, Cholet, 22 March
'Lucy Orta met le monde en connection au musée d'art
et d'histoire de Cholet', *Courrier de l'Ouest*, Angers, 22
March
'Lucy Orta se connecte à Cholet', *Ouest France*, Rennes,
5 May
'Mes vêtements sont ma maison', *Le Hic*, Cholet, 13
March
'Nexus Architecture x 110: l'art contemporain est aussi
un jeu d'enfants', *Courrier de l'Ouest*, Angers, 25 May
'Une exposition vivante, place Travot', *Ouest France*,
Rennes, 25 May
'Une sculpture vivante place Travot', *Le Pays Choletais*,
Cholet, 31 May
'110 enfants en reseau', *Le Hic*, Cholet, 15 May

Jan Ben, Angelika, 'Die bewegte frau – Multitalent in
motion', *Luftansa Magazine*, Frankfurt, August

Bone, Ili, 'Map of the Human Art', *The City Weekly*, No.
13, Melbourne, 18 April
Douglas, Michael, 'Like a thump on the head', *Real
Time*, No. 49, Melbourne, June–July
Halliday, Claire, 'The Art of Social Activism', *The Age 1st
edition*, Melbourne, 23 April
Hay, Ashley, 'Fluid Architecture', *The Bulletin*,
Melbourne, April
Meehan, Karen, 'An Agent for Exchange',
www.dramaticonline.com, Australia, 17 April
O'Doherty, Fiona, 'Funding Knockback', *Melbourne
Yarra Leader*, 15 April

A. A., 'Urban Armor', *Dwell*, San Fransisco, December

Selected exhibitions and projects
2002

'Strike',
Wolverhampton Art Gallery (group)
Cat. *Strike*, Wolverhampton Art Gallery, text Gavin
Wade

'Somewhere: Places of Refuge in Art and Life',
Angel Row Gallery, Nottingham (group)
Cat. *Somewhere*, Angel Row Gallery, Nottingham, texts
Guy Brett, Deborah Dean, Angela Kingston

'Shine',
The Lowry, Salford Quays, Salford (group)
Cat. *Shine*, The Lowry, Salford, texts Emma Anderson,
Alistair Robinson

'Comfort Zone, Portable Living Spaces',
The Fabric Workshop, Philadelphia (group)

'To Actuality',
Ar/ge Kunst Museum Gallery, Bolzano (group,
project: *70 x 7 The Meal , Act XVI Bolzano*)
Cat. *To Actuality*, Ar/ge Kunst Galerie Museum,
Bolzano, texts Maia Damianovic, Sabina Gamper

'Fragilités',
Le Printemps de Septembre, Toulouse (group,
contemporary dance collaboration with Marion Musac)
Cat. *Fragilités*, Le Printemps de Septembre, Toulouse,
texts Marta Gili, Jean Luc Nancy, Manuel Delgado,
Eungie Joo

Key Speaker, INDABA International Design Conference,
Cape Town

Key speaker, 'From Material Things', international
conference exploring the new geographies of visual
culture, The British Museum, London

Selected articles and interviews
2002

Price, Matt, 'Somewhere – Places of Refuge in Art and
Life', *Artist's Newsletter*, Newcastle upon Tyne,
November

Bucci, Rachel, 'The Securing Comfort Zone Exhibition',
Shuttle Spindle and Dye Pot, No. 3, Vol. 33, Suwanee,
Georgia, Summer
Sozanski, Edward J., 'Art in the bag', *The Philadelphia
Inquirer*, 3 January

Dister, Gili, 'A Conversation About Contemporary
Photography with Museum Curator Marta Gili',
Connaissance des Arts, No. 598, Paris, October
Patrick, Keith, 'Toulouse: Printemps de Septembre',
Contemporary, London, November

Ariane, Bavelier, 'Blanca Li : Rester en famille', *Le
Figaro*, Paris, September
Bavelier, Ariane, 'Rires et grincements de dents',
Madame Figaro, No. 18071, Paris, 14 September
Braddock, Sarah; O'Mahony, Marie, *Sportstech
Sportswear: Revolutionary Fabrics*, Thames and Hudson,
London
Dalbard, Agnès, 'Borderline, la folie de Blanca Li', *Le
Parisien*, Paris, October
De Haro, Sarah, 'Habitat de fortune', *Mixt(e)*, Paris,
Apri–May
De Martrin, Maia, 'Sans rêves il n'y a pas de projets', *Art
Actuel*, No. 19, Paris, March–April
Emprou, Frédéric; Giquel, Pierre, 'Sous aucun
prétexte', *303*, Nantes, July
Frimbois, Jean-Pierre, 'Bulles d'Art', *Art Actuel*, No. 19,
Paris, March–April
'L'oeuvre de Lucy Orta', *Enjeux les Echos*, Paris, May
'Le village mobile de Lucy Orta', *Intramuros*, Paris,
June–July
N.L.C. 'Connector IX-Village Mobile', *L'Express le
Magazine*, Paris, May
Quinn, Bradley, *Techno Fashion*, Berg, Oxford
Racconti d'identita, La Generazione delle Immagine 7,
lecture transcriptions, Commune di Milano, Milan

Sirvin, René, 'Divertissement coloré', *Le Figaro*, Paris,
19 September
Smith, Courtenay; Topham, Sean, *Xtreme Houses*,
Prestel, Munich
Such, Robert, 'Out of the Woods', *Blueprint*, No. 194,
London, April
The Super Modern Wardrobe, V&A publications, London,
interview with Andrew Bolton
Thual, Frédéric, 'Passionnée par les innovations
technologiques', *Le Journal du Textile*, No. 1703, Paris,
15 April
Yokel, Nathalie, 'Blanca Li', *LaTerrasse*, No. 101, Paris,
October

2003
Kent, Sarah, 'Xtreme Houses', *Time Out*, London,
15–22 January

Johansen, John, 'Det creative laboratorium pa
Cicignon', *Fredrikstad Blad*, No. 25, Fredrikstad, 26
January

2003
Fluid Architecture II,
Delux, London (solo, installation and online
workshop)

'Kaap Helder',
Den Helder, The Netherlands (group)

Collective Dwelling Act VIII,
Cicignon School Fredrikstad, Norway (community
workshops and sculpture commission)

Synoecismic Dwellings,
Angel Row Gallery/NOW/APT, Nottingham (public
sculpture commission and community workshops),

Institute for Contemporary Art, Brisbane (group)

'Doublures',
Musée national des beaux-arts du Quebec (group)

'Body Architecture',
Lothringer 13, Munich (solo)

'Micro UTOPIAS, Art and Architecture',
Biennale de Valencia, Spain, (group)

'Fashion, The Greatest Show on Earth',
Bellevue Art Museum, Bellevue, Washington (group)

70 x 7 The Meal, Act XX,
UNESCO, Paris (with Jorge Orta)

Lecture, 'Contemporary Issues', Kingston University
School of Art and Design, United Kingdom

Key speaker, 'Women in Design', symposium,
University of Pennsylvania Graduate School of Fine
Arts

Caretta, Enrica, 'Meglio condividere', *Marie Claire
Italia*, No. 5, Milan, May
Mulholland, Neil, 'All You Need to Know', *frieze*,
London, No. 73, March

www.fluidarchitecture.net

A., A., 'Urban Armor', *Dwell*, San Fransisco, December, 2002

Aberle, Marion, 'Wohnkleider und Hosenzelte für die Nomaden des 21. Jahrhunderts', *Frantfurter Allgemeine*, Frankfurt, 15 January, 2000

Adamson, Zita, 'From Street to Chair', *The London Institute Review*, 25 February, 2002

Anne & Julien, 'cc costumes', *Nova Magazine*, No. 39, Paris, March, 1998

Ardenne, Paul, *Cité de Refuge*, Paris, 1993

Ariane, Bavelier, 'Blanca Li : Rester en famille', *Le Figaro*, Paris, September, 2002

Arie, Altena, 'Over de gastvrijheid van kunst', *Metropolis*, No. 5, Utrecht, October–November, 2002

Bamberger, Nicole, 'Des vêtements déclarés d'utilité politique', *Jardin des Modes*, No. 19, Paris, 1996

Bavelier, Ariane, 'Rires et grincements de dents', *Madame Figaro*, No. 18071, Paris, 14 September, 2002

Berwick, Carly, 'Clothes Encounters', *ARTnews*, Vol. 100, No. 10, New York, November, 2001

Bokern, Anneke, 'Lucy Orta, Fluid Architecture', *Bauwelt*, No. 35, Berlin, September, 2002

Bolton, Andrew, *The Super Modern Wardrobe*, V&A publications, London, 2002

Bone, Ili, 'Map of the Human Art', *The City Weekly*, No. 13, Melbourne, 18 April, 2002

Borchhardt-Birbaumer, Brigitte, 'Soziale und strukturale Strategien', *Wiener Zeitung*, Vienna, 16 July, 1999

Boucault, Vincent, 'Lucy Orta habille le monde de ses vêtements refuges', *Le Monde*, Paris, 17 June, 2002

Braddock, Sarah; O'Mahony, Marie, *Sportstech Sportswear: Revolutionary Fabrics*, Thames and Hudson, London, 2002

Bralic, John, 'Corporeal Limits', *Monuments*, No. 42, Darlinghurst, June–July, 2001

Braunstein, Chloe, 'G-Y'm', *L'Architecture d'Aujourd'hui*, No. 328, Paris, September, 1999

Bucci, Rachel, 'The Securing Comfort Zone Exhibition', *Shuttle Spindle and Dye Pot*, No. 3, Vol. 33, Suwanee, Georgia, Summer, 2002

Budney, Jen, 'Who's It For?, The 2nd Johannesburg Biennale', *Third Text*, London, February, 1998

Budney, Jen, *Lucy Orta Process of Transformation*, Editions Jean-Michel Place, 1999

Cabasset, Patrick, *Vogue France*, No. 754, Paris, March, 1995

Castro, Anna Maria, 'L'architettura del corpo nomade', Vol. 40, No. 57, 1999

Coleman, David, 'In Soho, Art and Fashion Are on the Outs', *New York Times*, 15 September, 1996

Corrigan, Susan, 'Orta go to the g-y'm', *i-D Magazine*, No. 197, London, 2000

Creux, Philippe, 'Dieuze se prépare aux agapes du siècle', *Le Républicain Lorrain*, Metz, 2 May, 2000

Cristina Morozzi, 'Wearing vs. Inhabiting', *Intramuros*, No. 73, Paris, 1997

Crosling, John, 'Body Architecture', *Architectural Review*, No. 65, London, Spring, 1998

Dalbard, Agnès, 'Borderline, la folie de Blanca Li', *Le Parisien*, Paris, October, 2002

Damianovic, Maia, *To Actuality*, Ar/ge Kunst Galerie Museum, Bolzano, 2002

De Haro, Sarah, 'Habitat de fortune', *Mixt(e)*, Paris, April–May, 2002

De Martrin, Maia, 'Sans rêves il n'y a pas de projets', *Art Actuel*, No. 19, Paris, March–April, 2002

De Santis, Sophie, 'Les formes de Lucy Orta', *Figaroscope*, Paris, 13–19 May, 1998

De Vandière, Anne, 'Éthique dans l'esthétique', *Avenue*, No. 1, Paris, 1995

Diawara, Manthia, 'Moving Company: The 2nd Johannesburg Biennale', *Artforum*, New York, March, 1998

Dister, Gili, 'A Conversation About Contemporary Photography with Museum Curator Marta Gili', *Connaissance des Arts*, No. 598, Paris, October, 2002

Douglas, Michael, 'Like a thump on the head', *Real Time*, No. 49, Melbourne, June–July, 2002

Emprou, Frédéric; Giquel, Pierre, 'Sous aucun prétexte', *303*, Nantes, July, 2002

Ergino, Natalie, 'Living Room', *Documents*, No. 2, New York, February, 1993

Eshun, Kodwo, 'Refuge Wear', *i-D Magazine*, No. 179, London, September, 1998

Fayolle, Claire, *Archicrée*, No. 260, Paris, Autumn, 1994

Fitoussi, Brigitte, 'Robe'n'Nobel', *Numéro*, No. 8, France, November, 1999

Florez, Maricruz Jiménez, 'Connector Gardien', *Cronica*, Mexico City, 31 March, 2001

Frimbois, Jean-Pierre, 'Bulles d'Art', *Art Actuel*, No. 19, Paris, March–April, 2002

Gauville, Hervé, 'Tremplin pour debutants', *Libération*, No. 42, Paris, 9 November, 1994

Giroud, Michel, 'Vêtements de Lucy Orta', *Kanal*, No. 4, Paris, October, 1993

Giquel, Pierre; Emprou, Frédéric, 'Sous aucun prétexte', *303*, Nantes, July, 2002

Goldberg, Roselee, *Performance: Live Art Since the 60's*, Thames and Hudson, London, 1998

Guillaume, Valérie, interview, *Art Press*, Special edition, Paris, October, 1997

Haagsma, Lotte, 'Beschermende kleding als symbool', *Tubelight*, No. 22, Rotterdam, September, 2002

Halliday, Claire, 'The Art of Social Activism', *The Age 1st edition*, Melbourne, 23 April, 2002

Hanru, Hou, *Lucy Orta*, Secession, Vienna, 1999

Harmel, Francoise, 'Process of Transformation', book review, *L'Architecture d'Aujourd'hui*, No. 225, Paris, March, 1999

Hay, Ashley, 'Fluid Architecture', *The Bulletin*, Melbourne, April, 2002

Hazout-Dreyfus, Laurence, 'Recette de Lucy Orta', *Beaux Arts Magazine*, No. 191, Paris, April, 2000

Heartney, Eleanor, 'Mapping the Postcolonial', *Art in America*, No. 6, New York, June, 1998

Hill, Peter, 'Deconstructing Deconstruction', *Art Monthly Australia*, No. 130, Canberra, June, 2000

Hirvensalo, Virve, 'Wrap around shelter', *Frame*, Vol. 2, No. 8, Amsterdam, May–June, 1999

Hofleitner, Johanna, 'Die Landwirtschaft & das Kleinstadtische', *Schaufenster Die Presse*, Vienna, 25 June, 1999

Hufschlag, Inge, 'Im Overall das Wohnen wagen', *Handelsblatt*, Dusseldorf, 18 January, 2000

Ishiguro, Tomoko, 'Creating a future from voluntary social action', *Axis*, Vol. 90, Tokyo, January 2001

Jan Ben, Angelika, 'Die bewegte frau – Multitalent in motion', *Luftansa Magazine*, Frankfurt, August, 2002

Jeffrey, Moira, *Sunday Herald*, Glasgow, 3 December, 2000

Johansen, John, 'Det creative laboratorium pa Cicignon', *Fredrikstad Blad*, No. 25, Fredrikstad, 26 January, 2003

Kent, Sarah, 'Xtreme Houses', *Time Out*, London, 15–22 January, 2003

Lebaillif, Denis, *Cité de Refuge*, Paris, 1993

M., O., 'Une artiste textile crée des vêtements abris', *Journal du Textile*, No. 1606, Paris, 17 January, 2000

Marger, Mary Ann, 'Lucy Orta: Fashioning Change Through Art', *St. Petersburg Times*, 18 November, 2001

Martin, Laurence, 'Le Refuge Wear de Lucy Orta', *Journal du Textile*, No. 1481, Paris, 13 January, 1997

Meehan, Karen, 'An Agent for Exchange', www.dramaticonline.com, Australia, 17 April, 2002

Milani, Joanne, 'Lucy Orta: Global Gear', *The Tampa Tribune*, 25 November, 2001

Mohal, Anna, 'Der Kunstler als Dandy', *Atelier 1*, Germany, 1995

Morozzi, Christina, *Lucy Orta Process of Transformation*, Editions Jean-Michel Place, 1999

Morozzi, Cristina, 'L'Art à Porter', *Intramuros*, France, No. 73, October–November, 1999

Muchnic, Suzanne, 'Eat, Drink and Be Cultural', *Los Angeles Times*, 25 November, 2001

Mulholland, Neil, 'All You Need to Know', *frieze*, London, No. 73, March, 2003

N.L.C, 'Connector IX-Village Mobile', *L'Express le Magazine*, Paris, May, 2002

Neradil, Barbara, 'The Art of Connection', *The Oracle*, Tampa, 21 November, 2001

Noé, Paola, 'Transforms', *Teme Celeste*, Milan, March, 2001

O'Doherty, Fiona, 'Funding Knockback', *Melbourne Yarra Leader*, 15 April, 2002

O'Mahony, Marie; Braddock, Sarah, *SportTtech Sportswear: Revolutionary Fabrics*, Thames and Hudson, London, 2002

Orta, Lucy, magazine project, *Zing Magazine*, New York, Fall, 1995

Orta, Lucy, magazine project, *Dazed & Confused*, No. 29, London, March, 1997

Orta, Lucy, magazine project with Harriet Quick, *Vogues Hommes International*, No. 2, Italy, 1997

Orta, Lucy, 'From the Nest to the Web', *View Points*, Vol. 1, Amsterdam, 1998

Orta, Lucy, magazine project, *Atlantica*, No. 19, Las Palmas, Canary Islands, 1998

Orta, Lucy, magazine project with Cristina Morozzi, 'Vestito da Abitare', *Amica*, No. 39, Milan, September, 1999

Orta, Lucy, magazine project, *The Tampa Tribune*, Tampa, Florida, 28 February, 1999

Pagé, Suzanne, *Ateliers 94*, ARC Musée d'art modern de la ville de Paris, 1994

Paola Bortolotti, 'Le umane tribu rivestite da Lucy', *Corriere di Firenze*, Florence, 12 January, 2000

Parent, Béatrice, *Ateliers 94*, ARC Musée d'art modern de la ville de Paris, 1994

Patrick, Keith, 'Toulouse: Printemps de Septembre', *Contemporary*, London, November, 2002

Paul Ardenne, *L'Age Contemporain*, Editions du Regard, Paris, 1997

Piccinini, Laura, 'Trovare Casa in un Vestito', *Amica*, No. 8, Milan, February, 2000

Piguet, Philippe, 'Cité de Refuge', *La Croix*, Paris, 7 November, 1993

Piguet, Philippe, *Lucy Orta Refuge Wear*, Editions Jean-Michel Place, Paris, 1996

Piguet, Philippe, 'Architectures Corporelles', *L'Oeil*, No. 478, Paris, January, 1996

Polegato, Lino, interview, *Flux News*, No. 10, Liège, August, 1996

Poncet, Emmanuel, 'L'art à l'école', *Beaux Art Magazine*, Paris, October, 2001

Posca, Claudia, 'Plug-in: Einheit und Mobiliat', *Kunstforum International*, No. 156, Cologne, August–October, 2001

Price, Matt, 'Somewhere – Places of Refuge in Art and Life', *Artist's Newsletter*, Newcastle upon Tyne, November, 2002

Quick, Harriet, 'Refuge Wear', *Frank*, London, October, 1998

Quinn, Bradley, *Techno Fashion*, Berg, Oxford, 2002

Quint, Erik, 'Kunst met een humanitaire boodschap', *UIT*, The Netherlands, 21 August, 2002

Restany, Pierre, *Domus*, No. 793, Milan, May, 1997

Restany, Pierre, *Lucy Orta Process of Transformation*, Editions Jean-Michel Place, 1999

Ribettes, Jean-Michel, *Lucy Orta Refuge Wear*, Editions Jean-Michel Place, Paris, 1996

Sanders, Mark, 'Lucy Orta', *Blueprint*, No. 150, London, May, 1998

Sanders, Mark, *Lucy Orta Process of Transformation*, Editions Jean-Michel Place, 1999

Sans, Jérôme, 'Un Sac Pour La Rue', *CAPC Magazine*, Bordeaux, 1995

Sans, Jérôme, *Lucy Orta Refuge Wear*, Editions Jean-Michel Place, Paris, 1996

Schulze, Karin, 'Zwischen Qual und Lust', *Financial Times Deutschland*, Hamburg, 17 July, 2001

Sirvin, René, 'Divertissement coloré', *Le Figaro*, Paris, 19 September, 2002

Smith, Courtenay; Topham, Sean, *Xtreme Houses*, Prestel, Munich, 2002

Socha, Miles, 'The Great Unworn', *Women's Wear Daily*, Vol. 182, No. 26, New York, 7 August, 2001

Sozanski, Edward J., 'Art in the bag', *The Philadelphia Inquirer*, 3 January, 2002

Such, Robert, 'Out of the Woods', *Blueprint*, No. 194, London, April, 2002

Sumpter, Helen, 'Art Couture', *Big Issue*, London, 27 April, 1998

Szabo, Julia, 'Wear House', *i-D Magazine*, Vol. 46, No. 3, London, May, 1999

Taroni, Francesca, 'La nuova estetica delle relazioni tra open-air buffets e banchetti senza fine', *Casa Vogue*, Milan, October, 2000

Thual, Frédéric, 'Passionnée par les innovations technologiques', *Le Journal du Textile*, No. 1703, Paris, 15 April, 2002

Tommasini, Maria C., 'Corporal Architecture', *Domus*, No. 824, Milan, March, 2000

Tredre, Roger, 'A Home for Survival', *Observer*, London, 31 October, 1993

Van Driel, Anne, 'Solidair regenjack', *de Volkskrant*, Amsterdam, 25 July, 2002

Virilio, Paul, 'Urban Armour', *Dazed & Confused*, London, No. 29, March, 1997

Virilio, Paul, *Lucy Orta Refuge Wear*, Editions Jean-Michel Place, Paris, 1996

Virilio, Paul, 'Un habitat exorbitant', *L'Architecture d'Aujourd'hui*, No. 328, Paris, June, 2002

Warr, Tracey; Jones, Amelia, *The Artist's Body*, Phaidon Press, London, 2000

White, Lisa, *View On Colour 18*, Paris, 2001

William Jeffett, *NY Arts*, Vol. 6, No. 12, December, 2001

Wright, Bruce N., 'Fabric Interventions', *Public Arts Review 12*, Minneapolis, Summer, 2001

Yann, C., 'La Street Life de Lucy Orta', *Jalouse*, Paris, No. 8, March, 1998

Yokel, Nathalie, 'Blanca Li', *LaTerrasse*, No. 101, Paris, October, 2002

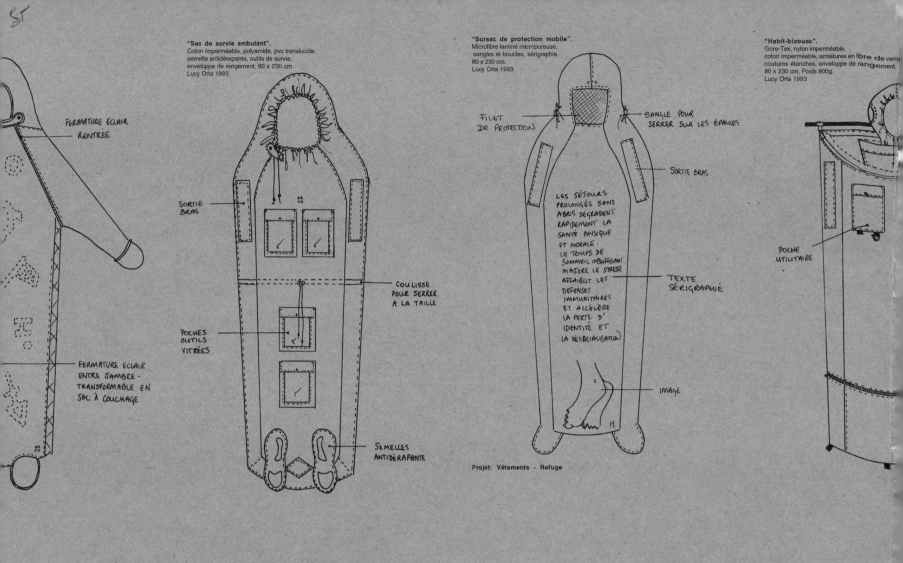

FERMATURE ECLAIR
RENTRÉE

FERMATURE ECLAIR
ENTRE JAMBRE -
TRANSFORMABLE EN
SAC À COUCHAGE

"Sac de survie ambulant".
Coton imperméable, polyamide, pvc translucide,
semelle antidérapante, outils de survie,
enveloppe de rangement. 80 x 230 cm
Lucy Orta 1993

SORTIE
BRAS

COULISSE
POUR SERRER
À LA TAILLE

POCHES
OUTILS
VITRÉES

SEMELLES
ANTIDÉRAPANTE

"Sursac de protection mobile".
Microfibre laminé microporeuse,
sangles et boucles, sérigraphie.
80 x 230 cm.
Lucy Orta 1993

FILET
DE PROTECTION

SANGLE POUR
SERRER SUR LES ÉPAULES

SORTIE BRAS

LES SÉJOURS
PROLONGÉS SANS
ABRIS DÉGRADENT
RAPIDEMENT LA
SANTÉ PHYSIQUE
ET MORALE.
LE TEMPS DE
SOMMEIL INSUFFISANT
MAJORE LE STRESS
AFFAIBLIT LES
DÉFENSES
IMMUNITAIRES
ET ACCÉLÈRE
LA PERTE D'
IDENTITÉ ET
LA DESOCIALISATION

TEXTE
SÉRIGRAPHIÉ

IMAGE

Projet: Vêtements - Refuge

"Habit-bivouac".
Gore-Tex, nylon imperméable,
coton imperméable, armatures en fibre de verre
coutures étanches, enveloppe de rangement.
80 x 230 cm, Poids 800g.
Lucy Orta 1993

POCHE
UTILITAIRE

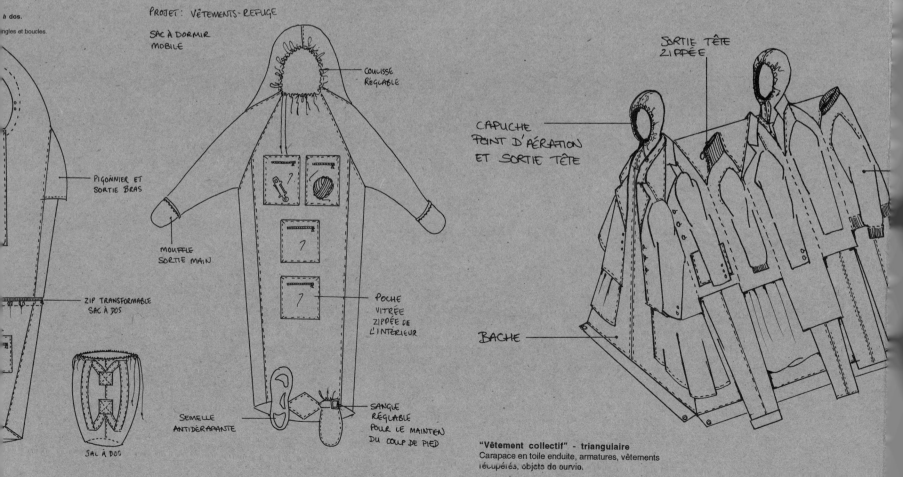

à dos.

ingles et boucles.

PROJET: VÊTEMENTS-REFUGE

SAC À DORMIR
MOBILE

PIGONNIER ET
SORTIE BRAS

COULISSE
RÉGLABLE

MOUFFLE
SORTIE MAIN

ZIP TRANSFORMABLE
SAC À DOS

POCHE
VITRÉE
ZIPPÉE DE
L'INTÉRIEUR

SEMELLE
ANTIDÉRAPANTE

SANGLE
RÉGLABLE
POUR LE MAINTIEN
DU COUP DE PIED

SAC À DOS

CAPUCHE
POINT D'AÉRATION
ET SORTIE TÊTE

SORTIE TÊTE
ZIPPÉE

BACHE

"Vêtement collectif" - triangulaire
Carapace en toile enduite, armatures, vêtements
récupérés, objets de survie.